1934
Students' Sketch Club
Graham Robertson Collection **Blake, Robertson**
Professor Chytil's Collection of Chinese Art
East End Academy
Society of Essex Artists
Toynbee Art Club
Students' Sketch Club

1935
Cricket and Sporting Pictures
Mural Decorative Pictures
Spinning, Weaving and Dyeing
East End Academy
Society of Essex Artists
Toynbee Art Club

1936
Students' Sketch Club, Charing Cross Bridge, designs and models
Punch Cartoons
Harvey Collection of Old Masters
Powell Collection of early engravings, watercolours and drawings
Byra Art Club
East End Academy
Society of Essex Artists
Toynbee Art Club

1937
Students' Sketch Club
Photographs of National Trust Properties and of Buildings in all parts of the World
Contemporary Art Society's Paintings and Drawings **Nash, Bell, Roberts, Meninsky**
Isaac Rosenberg
Rovinsky: Pictures of Spain
Hackney Art School Students Work
East End Academy
Society of Essex Artists
Toynbee Art Club

1938
Local School Children's Work
Contemporary British Art
Byra East End Academy
Essex Artists & Toynbee Art Clubs

1939
Spanish Art **Picasso's Guernica**
Artists International Association **Gill, John, Moore, Nash**
Wyndam Vint's Collection of Oil Paintings
Angela Antrim
Contemporary French Painting
Herbert E West Collection of English Watercolours
East End Academy

1940
Gregory Brown, British Watercolour Collection
John Outram Collection of Paintings
Photograph 'Might of Britain'

1941
Dr WM Crofton Collection of British Masters **Turner, Constable, Gainsborough**

1942
British Painting Today **Williams, Ben Nicholson, Moynihan, Hitchens, Jones, Medley**
Graphic Art: Czech, French, Spanish
East End Academy

1943
Wings of Victory
Artists Aid Jewry **Mrs Churchill's Fund**
Marine Pictures
Czechoslovak Art
Poster Designs for Wartime Britain
Stepney Reconstruction Plans
Hogarth and Early English Caricature

1944
Salute the Soldier
East End Academy
Russian Photographic Displays of 3 Heroic Cities: Leningrad, Stalingrad and Sebastopol
Modern French Pictures from Algiers and North Africa **Dufy, Marquet, Puy**
East End Academy

1945
Aspects of Jewish Life and Struggle
Engineers' Art Society
Modern Brazilian Painting **Tarsila do Amaral, Lazar, Segall**
This Extraordinary Year
Artists' International Association
American Art
Toynbee Art Club

1946
Stepney Borough Council: Road Safety
Soviet Graphic Art **presented by the Embassy of the USSR**
East End Academy

1947
Czechoslovak Modern Art
Pictures for Schools
Stepney in War and Peace: Rose Henriques
East End Academy

1948
Five Centuries of European Painting **Cook, Bearsted and other collections: El Greco, Hogarth, Titian, Memling, Rembrandt**
Pre-Raphaelites **Ford Maddox Brown, Rossetti, Burne-Jones**
East End Academy
Prints and Sculpture **Dürer, Duccio, Rembrandt, Goya, Dalou, Whistler, Moore**
London School Paintings

1949
Design Fair
Arts and Crafts by Members of Bnei Arivah
Manchester Group **Lowry**
East End Story: History and Life of East London from Roman Times to 1920
Mark Gertler **memorial exhibition**
Pictures for Schools **Lowry, Weight, Hilton, Uhlman, Tunnard**
East End Academy

1950
English Sporting Pictures **Alken, Morland, Satorius, Stubbs**
Painters' Progress: Lives and Work of Some Living British Painters **Grant, Lowry, Hitchens, Clough, Armstrong**
East End Academy
Pictures for Schools **Berger, Napper, Winifred Nicholson, Moody, Soukop**

1951
East End Academy
Eighteenth Century Venice **Canaletto, Guardi, Tiepolo**
East End 1951
Black Eyes and Lemonade (Festival of Britain-related exhibition of popular and traditional art)
William Powell Frith

1952
The Arts of India and China
Setting Up Home for Bill and Betty **a shopping guide with Oxford House – furniture, wallpaper**
Looking Forward: British Realist Pictures **Clough, P George, Minton, Moynihan, Rogers**
East End Academy

1953
James Goldsmith
JMW Turner
Twentieth Century Form **Braque, Colquhoun, Heron, Kandinsky, De Staël, Picasso, Gropius, Lasdun**
James Gillray and Thomas Rowlandson
John Martin
East End Academy

1954
Pictures for Schools **Rie, Feddon, Weight, Lowry**
Barbara Hepworth Retrospective
George Catlin
British Painting and Sculpture **Vaughan, Frost, Turnbull, Paolozzi**
East End Academy

1955
Pictures for Schools
Bearstead Collection **Gainsborough, Cuyp, El Greco, Breughel, Bosch**
American Primitive Art 1670 – 1950
Piet Mondrian
Michael Ayrton
London Group
East End Academy

1956
Pictures for Schools **K. Williams, Bratby, M. Hughes, Coper**
Josef Herman
Nicolas De Staël
Charles Howard
This is Tomorrow
Merlyn Evans
Jewish Artists in England 1656 – 1956 **Adler, Wolfe, Freedman, Kestelman, B Cohen, H Cohen**
East End Academy

1957
George Stubbs
Bernardo Bellotto
Sidney Nolan
Women's International Art Club **Blackadder, Redpath, Ayres**
SW Hayter
East End Academy

1958
Guggenheim Painting Award
Recent Paintings by 7 British Artists
Pictures for Schools
Robert Colquhoun
Alan Davie
Women's International Art Club
Jackson Pollock

1959
Pictures for Schools
East End Academy
The Graven Image: Recent British Prints and Drawings **Ayrton, Hermes, Piper, Richards**
Jack Smith
Kenneth Armitage
Kasimir Malevich
Cecil Collins

1960
Ceri Richards
Women's International Art Club
Pictures for Schools
East End Academy
Ida Kar
Roy de Maistre
Prunella Clough
Henry Moore Sculpture 1950 – 1960

Continues on inside back cover

The Whitechapel Centenary, 2001

The Artists' Party 10 March and *Opening Reception* 19 March 2001

The Centenary Review

Published 10 March 2001

Commissioned by Catherine Lampert and Andrea Tarsia

Editing and production also organised by Candy Stobbs with Anthony Spira, Monica Portillo and Laurence Sillars. Artists' pages organised by Alistair Raphael and Clare Roberts.

Designed by Herman Lelie

Typeset by Stefania Bonelli assisted by Tristan de Lancey
Printed by Westerham Press

The Whitechapel Centenary Exhibition

21 March – 20 May 2001

Selected by the artists Anish Kapoor and Rosemarie Trockel, and an internal Whitechapel team, led by Catherine Lampert and Anthony Spira

Exhibition also organised by Clare Roberts, Candy Stobbs, Monica Portillo and Laurence Sillars, with the involvement of the whole Whitechapel staff and all those mentioned in the acknowledgements.

Indemnity by re:source the Council for: Museums, Archives and Libraries

Live Events and Artists' Commissions

Extending throughout the centenary year
Programmed by Catherine Lampert and Alistair Raphael

Events and commisions also organised by Alison Digance, Russell Martin and Andrea Tarsia with Sanna Moore

Worst Art Work Ever Competition
Bob and Roberta Smith

The Lino Project
Sharon Beavan, Maggie Jennings, Ana-Laura Lopez de la Torre

Workshops led by Sally Booth, Anna Boggon, Keran James, Bernadette Maloney, Amy Plant, Robin Whitmore, Dilek Winchester

Sunday Sightlines with Sacha Craddock, Janeen Haythornthwaite, Catherine Lampert, Felicity Lunn, Lorcan O'Neill, Anthony Spira, Juliet Steyn, Andrea Tarsia

Front Cover: **Patrick Caulfield** *Portrait of Juan Gris*, 1963 (detail), oil on board, 122 x 122 cm. St. John Wilson Trust. © Patrick Caulfield 2001. All rights reserved, DACS 2001

Back cover: *Carl Andre*, installation view, Whitechapel Art Gallery, 1978
Centenary logo based on original artwork by R.Anning Bell, 1901, re-designed by Herman Lelie

ISBN 0 85488 126 3

Whitechapel Art Gallery
80–82 Whitechapel High Street
London E1 7QX
Tel +44 (0)20 7522 7888
Fax +44 (0)20 7377 1685
email info@whitechapel.org
www.whitechapel.org

Distributed in the UK by
Cornerhouse Publications
70 Oxford Street
Manchester M1 5NH
Tel +44 (0)161 200 1503
Fax +44 (0)161 200 1504

LONDON ARTS

The Whitechapel Art Gallery Centenary Review

WHITECHAPEL
ART GALLERY

1901 **2001**

Contents

Overview

Issues

Installation Views

Individual Shows

Artists' pages

MOTHERWELL

paintings
collages and
drawings 1941–1965

Whitechapel Gallery
18th March–17th April
Daily 11–6 Sundays 2–6
Closed Mondays and
8th–11th April inclusive

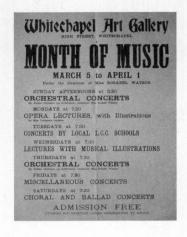

Whitechapel Art Gallery
HIGH STREET, WHITECHAPEL

MONTH OF MUSIC

MARCH 5 to APRIL 1
Under the direction of Miss ROSABEL WATSON

SUNDAY AFTERNOONS at 3.30
ORCHESTRAL CONCERTS
By Miss Rosabel Watson (in performance) Conductor Miss Rosabel Watson

MONDAYS at 7.30
OPERA LECTURES, with Illustrations
By Miss Georgette Gullière

TUESDAYS at 7.30
CONCERTS BY LOCAL L.C.C. SCHOOLS

WEDNESDAYS at 7.30
LECTURES WITH MUSICAL ILLUSTRATIONS

THURSDAYS at 7.30
ORCHESTRAL CONCERTS
By Miss Rosabel Watson (in performance) Conductor Miss Rosabel Watson

FRIDAYS at 7.30
MISCELLANEOUS CONCERTS

SATURDAYS at 7.30
CHORAL AND BALLAD CONCERTS

ADMISSION FREE
Children not admitted unless accompanied by adults

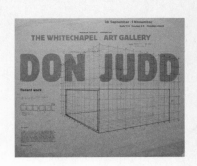

THE WHITECHAPEL ART GALLERY

DON JUDD
Recent work

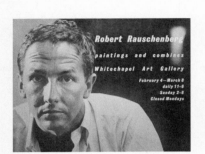

Robert Rauschenberg
paintings and combines
Whitechapel Art Gallery
February 4–March 9
daily 11–6
Sunday 2–6
Closed Mondays

WHITECHAPEL ART GALLERY

1949
East End Academy
1949

CATALOGUE

The Whitechapel Open and East London Open Studios

A programme of art in East London

KASIMIR MALEVICH
1878–1935
WHITECHAPEL ART GALLERY
15th OCTOBER – 15th NOVEMBER
DAILY 11–6 SUNDAYS 2–6 CLOSED MONDAYS
ADMISSION FREE
ADJOINING ALDGATE EAST STATION

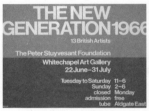

THE NEW GENERATION 1966
13 British Artists
The Peter Stuyvesant Foundation
Whitechapel Art Gallery
22 June–31 July
Tuesday to Saturday 11–6
Sunday 2–6
closed Monday
admission free
tube Aldgate East

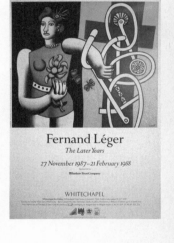

Fernand Léger
The Later Years
27 November 1987–21 February 1988

WHITECHAPEL

6d
GUIDE
DESIGN FAIR
A TRAVELLING EXHIBITION
Sponsored by
The Council of Industrial Design

THE BIG SHOW
TOWER HAMLETS ARTS PROJECT
COMMUNITY
ARTS
WORKSHOPS
EXHIBITIONS
SHOWS &
EVENTS

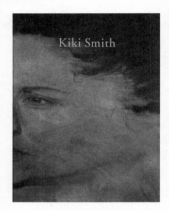

Kiki Smith

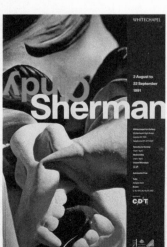

WHITECHAPEL

Sherman

2 August to
22 September
1991

CDT

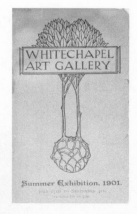

PATRICK HERON
Recent paintings and related earlier canvases
21 June–16 July 1972
The Whitechapel Art Gallery

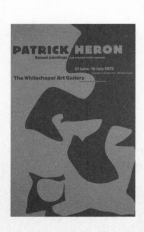

WHITECHAPEL
ART GALLERY

Summer Exhibition, 1901.

Arts of Bengal The Heritage of Bangladesh and Eastern India
The Whitechapel Art Gallery 9 November–30 December 1979

Finding our territory

by Catherine Lampert

From its beginnings the Whitechapel has had such a strong sense of autonomy and location that we have long resisted translating this into short 'strap-lines'. All the adjectives — major, cutting-edge, acclaimed, pioneering and even the original trustees' expression 'the finest art of the world for the people of the East End' — seem too vapid to describe the formidable achievements of a modest scaled organisation, with sparse financial resources but beautiful spaces, frequently making great exhibitions. Admittedly, until the sixties the Whitechapel had less competition in the field of modern art. Occasional exhibitions were made in galleries, for hire or run privately, like the Burlington, Lefevre or Grosvenor Galleries and later there were Arts Council shows staged at the Tate or a few forward-looking Royal Academy Winter Exhibitions. In 1901 we had physical advantages – for example, the Whitechapel was built with electric light when the national museums were still closing at dusk. What some then and now may consider disadvantages, an audience that spans social classes, with a high proportion of immigrants, and a location next to rough, partly industrial neighbourhoods where artists gravitate, have become inseparable elements of the gallery's non-conformist tradition.

Charles Aitken, the first director, countered the founder Canon Barnett's and the Board's preference for uplifting history pictures by adding 'difficult' works made by the proponents of the modern movements — Fauves, Cubists, Vorticists and members of The Hague School. His programme also embraced didactic shows with information on shipping, sporting art and especially, non-Christian cultures like *Muhammadan Art and Life* [sic.] in 1908. The gallery participated in national life and in both wars organised exhibitions to promote solidarity and understanding — they ranged from *War Cartoons and Photographs* in 1916 (from nine different countries including Serbia), to *Artists Aid Jewry Exhibition* in 1943 and *Soviet Graphic Art* (presented by the Embassy of the USSR) in 1946. Today the political shows are thematic, like *Speed* and *Protest and Survive*.

Trying to escape from the self-regard of claiming or gleaning only 'firsts', the Whitechapel has shaped the celebration of the centenary in a deliberately disparate and un-encapsulated way. The calendar begins with a party for, and to honour, the artists from solo shows stretching back to the early 50s. If there were room and budgets we would gladly extend the face-to-face hospitality to a longer list of those who have contributed so much – artists, curators, authors of essays, former staff, lenders, teachers, sponsors, benefactors and good friends. Our deep gratitude to these and others who have contributed are expressed in the end pages of this Review. On March 21st we open an exhibition of over 70 works, publish the Review, share the initial results of the artists' commissions and begin a programme of live events. Built into our approach is an expectation that during the spring programme, word of mouth and media coverage should entice from others more memories, archives and ideas. This leads our gallery to thoughts of a centenary 'year'.

To choose and request the art for the exhibition we made a few simple decisions. We wanted everything to have been in the galleries before. The installation would serve to allow individual works to exert their own power in sympathetic company, free of curatorial brackets. Since we've presented 725 exhibitions and an excess of 10,000 exhibits and the Whitechapel's upper and lower galleries measure only 550 sq metres, we decided to narrow the field to work made by professional fine artists whose reputations survive, as well as a few masterworks from ancient China, Japan and India. Large installations (or sculpture), applied art, didactic shows, art societies, art classes and workshops and other parts of our history are represented by slide projections and documentation. We sought a number of iconic works that have changed the course of art while avoiding the game of even identifying the 100 greatest works. Personal choice is honoured for the benefits of subjectivity and association.

Two artists, Rosemarie Trockel and Anish Kapoor, were asked if they would select around twenty works each. Our wish to involve them arose from the way their art has touched universal cultural questions while seeming both 'auto-generated' and intimate. Like other artists they carry a repository of art by others, whether seen in the flesh or studied in reproduction; moreover both collect work by gift, exchange and purchase. After reviewing our catalogues and archives, Trockel and Kapoor made lists and marked catalogues along fairly instinctual lines. They coincided with several people that have been touchstones for their generation born in the fifties – like Hesse and Nauman – and both found personal and gender affinities in the work of Freud, Fontana, Michael Andrews and

Street front from architectural analysis, John McAslan & Partners, 1999

others. Their contribution is the back-bone of the show and greatly valued.

At the same time the Whitechapel team began investigating what would be possible to borrow with rather short lead-time. We decided our part of the selection should focus on landmark exhibitions, especially those that entered new territory, and visually they should complement the artist-selectors' tastes. The list of possibilities was augmented by suggestions from two eminent former directors, Bryan Robertson and Nicholas Serota. The temptation to carry on adding works from the last forty years had to be resisted (and I lament the absence of formidable artists, many personal favourites). The Whitechapel boasts having shown world-famous art like Picasso's *Guernica*, Pollock's *Blue Poles* or paintings on panel by Brueghel, Rubens, Giotto and others that are now deemed off bounds for lending (or reserved for museum-to-museum exchanges). Frequently works were impossible to identify precisely or to locate from archival information. Nevertheless we are delighted with the results and greatly in debt to the people who have facilitated the searches and to the sympathetic resp-onses of collectors, not least national museums in Europe and the US, most particularly Tate.

The articles that follow, the lists and the extended captions point to several of the 'landmark' shows. Sometimes titles are uninformative – *Dutch Art* in 1904 had splendid paintings by Hals, Koninck, and Ruisdael in addition to a very con-siderable number of paintings and drawings by Rembrandt. Later *Modern Dutch Art* in 1921 placed an oval *Composition* by Mondrian owned by the formidable collector Mr Slijper adjacent to still lifes by Jan Sluyters. It was the latter who was expected to 're-juvenate and beautify' the tradi-tion of Van Gogh. Through cultural institutes and bi-lateral committees the Whitechapel regularly showed work by significant foreign artists – for example, *Brazilian Art* in 1945 with Tarsila do Amaral or *Russian Arts and Crafts* in 1921 included Natalia Goncharova.

Convincing departures into new territory need the passionate advocacy of one person. Bryan Robertson insisted on the vitality of Australian

painting and he staged outstanding exhibitions of Arthur Boyd and Sidney Nolan as well as a show of young artists introduced by a fellow exhibitor, Robert Hughes. In some ways their idiom matched the British painting on the margin of representation/abstraction he esp-oused in the solo shows of Prunella Clough, Keith Vaughan, Gertrude Hermes and John Craxton. Robert-son was also a master of timing and with a keen intelligence in securing important shows which originated elsewhere. Between 1969–71 Mark Glazebrook had time to present the work of David Hockney, Donald Judd and to plan Richard Long. By the late 70s Nicholas Serota was fre-quently initiating shared international projects with institutions with similar aims, especially those connected to German and New York artists like Richter, Baselitz, Kiefer, Marden, Ryman and Schnabel. They were interspersed with very well judged shows of the spiritual predecessors as happened with the unforgettable assembly of triptychs by Max Beck-mann in 1980.

The milestones are subtler as one moves on and credits are dispersed after a marked increase in the number of spaces for contemporary art. I wanted extensive one-person shows by living women artists, new media like video, and art that sat deliberately off-centre, courageous and singular. This was evident in the work of Boltanski, Uglow, Sherman, Viola, Morimura and Schütte; qualities which also ran through other art, not least the quiet, minimal work of the thirty-six women, both famous and hardly known, presented within *Inside the Visible*.

Curators, frequently advised by artists and writers, have long tried to redress the neglect of superb artists not in public collections in their own country. Working from Britain, a region under-represented is Latin America. In 1969 the Brazilian Hélio Oiticica created a legendary installation at the Whitechapel. The international celebrity of Frida Kahlo (whose paintings first appeared at the Tate in 1953) and Tina Modotti was launched at the Whitechapel in 1982. The gallery continued building on this historic Mexican generation by adding David Alfaro Siqueiros' works of the thirties to the earlier

monographic shows by MOMA, Oxford of Orozco and the Hayward of Rivera. Political threats and indi-genous populations have rubbed into the art of the Chilean Alfredo Jaar whose Whitechapel catalogue took the form of passports attached to images demonstrating the cheapness of life in Brazil, Nigeria and Viet-nam. The Argentinian Guillermo Kuitca's ghostly images of stadia and empty seats were within a show called 'Burning Beds'. And there are others working in Latin America – Tunga, Kcho, Toledo and Alys – whose subtle shifts between media and between vernacular culture and elusive, philosophical ideas have begun attract-ing growing numbers of admirers.

Of course, there are exhibition fields not tapped and regrets. The White-chapel has unfinished business in the Indian subcontinent and Africa, for example, as well as at home. In a centennial event it is especially hard to represent the excitement of art fresh from nearby studios. Or to imagine from an isolated loan the exhilarating effect of an entire show within the grand space of our galleries. Many frequently cited events would need to be revisited, memories improved by research and by consulting partici-pants and eye-witnesses, to complete a properly staged palimpsest approach to the Whitechapel and the invention of a contemporary art gallery. Mean-while we are in debt to the people who agreed to contribute articles for this Review, especially given its deliberately unhomogenised contents, matching other parts of the Centen-ary, intentionally neither academic, tightly structured nor trying to cover the entire ground.

Jeremy Millar tackled *This is Tomorrow* by asking us to locate the surviving participants, the majority architects and their razor-sharp memories make the story (and the origin of 'Pop') far richer. Marysia Lewandowska and Neil Cummings, who recently examined the Design Council pho-tographic archives at Brighton University, undertook one of the artists' commissions by deciding to connect the elegant display of *Modern Chairs* in 1970 with our bustling café. Some commissions will be realised in the next months – Diego Ferrari's photo documentary collages, evening events that stretch to spoof histories of the White-

chapel and a print-making project for families.

The visual contributions of twelve artists conformed only to a page format. It was refreshing to receive in the post 'wet' work as well as CD roms. We asked Herman Lelie and Stefania Bonelli, the *Review* designers, to cope with dozens of images of work shown in the gallery assembled in a short period. The task of our small staff was aided by the dedication of several well-informed interns and colleagues. A list of ack-nowledgements and very sincere thanks comes in the last pages.

The project that returns most closely to the founding of the Whitechapel Art Gallery is that initiated by Rachel Lichtenstein and Alan Dein last year. They are highly regarded as artists and as authors of oral and written histories of East London. In early 2000 they began a project on the Whitechapel Library with the aim of capturing a living memory of the library's place in the community, made by engaging in conversation users and past and present staff. Their contacts go back to the Yiddish-speaking generation of Meyer Bog-dansky and Bernard Levine that led to the library being known as 'The University of the Ghetto'. They continue to the present-day local Bengali community, with accounts by the Bengali and Urdu language specialist Kanai Detta and the library outreach worker Zoinul Abidin.

Along with many others I am con-vinced that the Whitechapel Art Gallery, beyond 2001, has a larger role to play in releasing the potential of the visual arts by a reinvention of the Whitechapel Library when the borough's general service moves to Mile End. For several years we have experimented with short-duration events like *OOOzerozerozero*, opened the door to partnerships across the arts and with schools and identified much-desired printed and new media resources. Acquiring the library site is the first overt step in its becoming our other half, as finely designed and as fitted to its new purpose as our own building has proved to be in its first century. As the departing director, my hope has to be that an inspirational team and board embraces high aims and garners imaginative and generous allies.

The University of the Ghetto: Stories of the Whitechapel Library

by Rachel Lichtenstein &
Alan Dein

I've always respected books. I never turn over the corners of a book. When I'm on the tube and I see people doing it I really want to go and tell them off. I'll never write in a book, or bend its spine.
(Denise Bangs)

Denise Bangs joined the Tower Hamlets Library service in 1984 and is now team librarian at the White-chapel library. At first she found the place very eccentric. It took her a while to get used to the extraordinary range of characters who regularly used the place. From workers in the city to Jewish ladies, beefeaters from the Tower and people with no fixed address. Her colleague Zoinul Abid-in said, 'to me that's one of the best elements of having a library service, its accessible to all, regardless of their class, their race, religion, wealth, whatever.'

We used to have a lady who came in every day to look at our huge atlas and then go home. We gave her a nickname, Atlas Annie. There was another person who came in and planted books in the library shelves, perhaps a frustrated librarian. I'd see a book in the Russian literature sec-tion, placed just in the right place. Never found out who they were or why they did it. We once had some-one turn up, walking down the hallway in a gorilla outfit, she walked straight into the lending library, took the gorilla head off and I sat her down and gave her a glass of water. There's some sort of silent consensus in this library. Nobody batted an eyelid, we accepted her. You learn tolerance. You hear stories from one extreme to the other. Lots of people come in here with problems. I realise

this could happen to me, you just need someone to talk to. Some people come in at nine o'clock and stay all day. Perhaps we're their only port of call and we're here to listen. This sort of patience and tolerance is not in the job description.
(Denise Bangs)

One of Denise's longest standing and most regular visitors is Deborah Cohen. She chats with Denise every Thursday on her regular weekly visit to the library. She has been coming the same day each week since her sixteenth birthday in 1934. Like many Jews of her generation she had little formal education although she was always encouraged to read. Most of the books she borrows are roman-tic fiction novels. Deborah's parents came from Romania but she was born here, unlike Meyer Bogdansky, another long-term visitor to the Whitechapel, who was born in Poland. Meyer Bogdansky is one of the last surviving Yiddish-speaking

intellectuals still living in East London. Meyer's route to Whitechapel is a sad one. He was born in Lodz and joined the Polish army as a young man. In 1938 he was captured by the Rus-sians and spent three years in the gulags. He lost his wife and entire family in Auschwitz and arrived in Whitechapel in 1946. He's been visiting the library ever since.

I had almost no education, except Cheder, which was strictly religious. When I was eleven years old my mother wanted me to become a tailor because it was a clean job and you could wear a tie. Cabinet making was filthy. We didn't have any money to continue my schooling. I started school when I was seven. The tuition was free but the family had to supply the books. We didn't have any money, so I went into the world of work at thirteen. My real education began when I joined the Bund youth organ-isation. The emphasis was on self-education, read, read and read.

When the great East End Yiddish poet Avram Stencl died, Meyer took over as Chairman of the Friends of Yiddish Group, which still meets on Saturday mornings at Toynbee Hall. Rachel Lichtenstein's grandfather regularly went to these meetings and it was her fascination with her grand-father and the people he spoke of that made her want to live in East London. Through a chance intro-duction she met oral historian Alan Dein, who had been researching and documenting the social history of the Jewish East End. They had both been inspired by Professor Bill Fishman's legendary walking tours and with his encouragement became tour guides themselves. They have found that the Whitechapel library is one of the most talked about stops on their tours.

The Whitechapel Library has served a vital role for Whitechapel's immi-grant population for over a century now. Starting with the Jewish com-

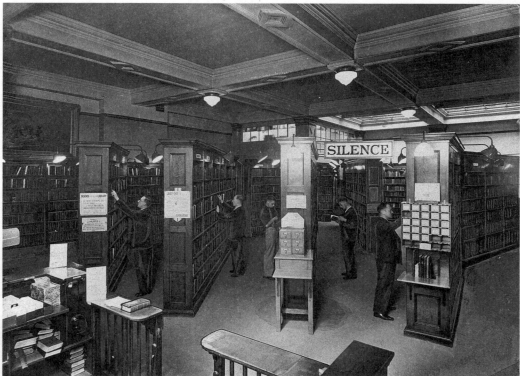

Whitechapel Library Lending Department July 1937. Original photo-graph generated by Stepney Borough Council, ©Tower Hamlets History Library

munity who were its main users from its opening in 1892 to the start of WWII. During this time the library's reading room was one of East London's liveliest spaces. It was filled with the sound of schoolchildren discussing their homework and their parents and grandparents arguing in Yiddish over politics, literature and religion. It had a strong ghetto feeling about it, most of us being Jews coming from the same part of Russia. I started going to the library when I was about nine or ten, when I was already reading Dickens and Shakespeare. I was brought up with a love of books. I remember the marvellous reference library where I'd research all sorts. The staff were fantastic, you'd get all the help you needed. We knew the library as the University of the Ghetto. We all went. My father would go to read Yiddish newspapers; for us literature and history. The Whitechapel Arts group used to meet there in the reference library. Joseph Leftwich told me this, he was a survivor and he told me he met Jacob Epstein the sculptor there, Rosenberg the poet. They all met there, it was a marvellous training ground for these young immigrants, they got a higher education there that most couldn't afford.

The group started about 1905/6, a period with a lot of flourishing literary circles in the East End. The intellectual elite among the Jewish immigrants met in the library not in the synagogues: Rosenberg, Mark Gertler, Bomberg, the poet Rodker and the scientist and writer Jacob Bronowski.
(Bill Fishman)

Bill Fishman grew up in Nelson Street, Whitechapel in the 1920s. One of his neighbours was Harold Rosen. Both Bill and Harold regularly visited the library and became academics in later life. Alan went to visit Harold in his North London home to record his memories of the Whitechapel Library.

It was a treat to go with my mother into this lovely place, getting hold of the books. Although I wasn't religious there is something about the Jewish respect of books that stays with me. I always remember when I saw an old man drop a prayer book and he kissed it when he picked it up. That love of books has always stayed with me.

I came from a poor working class home. The library was an institu-

tional building that was both awe-inspiring and daunting. The grand staircase, with an iron balustrade, it was like a mansion I'd only seen in films. And on the landing there was this Samurai in full gear in a huge glass case. You'd go past the Samurai into the library's own museum, it was beautifully kept, lots of natural history, rabbits, weasels, they were all labelled. There was this stand that I adored labelled 'in bloom this month,' flowers of the week, in test tubes filled with water. The library was a lovely place to go. I stepped into the library with anticipatory pleasure.

In the reference library there were really long tables, six to eight foot, with seats on each side, set in double rows. We all had our favourite place to sit. It was like claiming territory. There was decorum, self-imposed respect, a bit like going to shul. All those auto didact Jews, I can see them, still see them going round the shelves. There was a general mood and atmosphere about the place, which I liked. And the smell of books, not a second hand bookshop smell, because the library books weren't damp, they had a smell all of their own. The oak tables must have been

polished every day, I can imagine an old lady shining and rubbing the tables in the night after we'd gone home.
(Harold Rosen)

In the 1930s the library's Yiddish and Judaica sections were the largest in the country and the library employed a specialist Yiddish librarian called Mr Bogdin. He was the first specialist ethnic speaking librarian in Britain. He is remembered fondly by Bernard Levine: 'Mr Bogdin was a scholar who came from the Crimea. He'd fought in WWI. He was a brilliant and wonderful man, my mentor at the library.' Bernard Levine joined the Whitechapel Library's staff in 1929 and retired in 1973. He was born in Bethnal Green in 1913, one of eleven to Lithuanian parents. His father saw a job advertised as junior library assistant in the Jewish Times and encouraged Bernard to take the job. He started work at the library aged sixteen.

When I started the library was a hive of industry. Some of the most popular authors at the time were Israel Zangwill, John Galsworthy, Robert Graves, and Arnold Bennet. Those were always in demand. When a book was mentioned on the radio, there was an immediate demand for it. *All Quiet on the Western Front*, we had about forty copies of it. People paid a penny to reserve the book.

Everyone was so keen on learning. Our parents didn't push us; we were just dead keen to learn. Almost everybody borrowing from the library at that time were children of immigrants. We had a collection of Yiddish books, Hebrew books and Judaica and people came from all over the country to borrow them.

When I came back to the library after the war I arranged to buy books in Urdu, Gujurati, Hindi all that and the Asians came along and it took me right back to when the Yiddish borrowers stood chatting away in their own languages, in exactly the same way fifty years before and I was there for both those happenings. The Yiddish speaking borrowers were practically non-existent by then, maybe one or two but most of the Yiddish books were borrowed through the post.

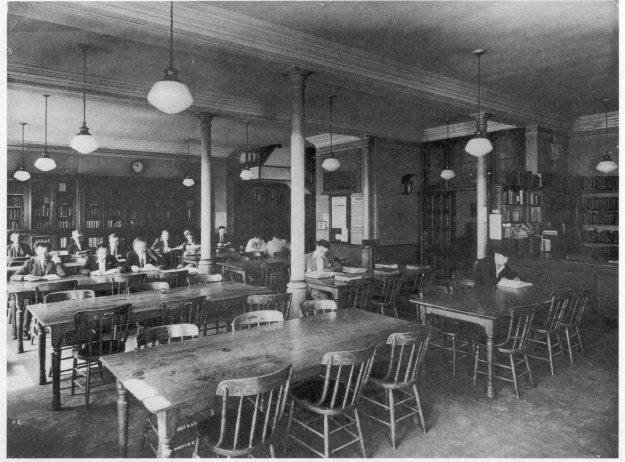

Whitechapel Library Reading Room, 1937.
Original photograph generated by Stepney Borough Council, ©Tower Hamlets History Library

Zoinul Abidin continues to buy books for the collection Bernard began. Zoinul's parents came to Whitechapel from Syhlet in the 1960s. He was born in the London Hospital in 1972,' I've lived in Whitechapel all my life, my family, my friends, everything is here.' In 1996 he got the post of outreach library worker. His special responsibilities are promoting the library to the black and ethnic minority communities, buying the ethnic stock and identifying community needs. He also runs the mobile library, delivering books to over four hundred housebound clients, many of whom are elderly and disabled. Zoinul sees a large part of his job to be talking to these people and hearing their memories. Like many of the Whitechapel Library's staff, Zoinul used to visit the building as a child.

I would walk there with my brothers and sisters on a Saturday afternoon. I remember crossing three main roads to get there and how big the library looked. We went there because it had its own special children's library. We felt welcome there and they had the best selection. When I was older, thirteen, fourteen I'd go there with my friends when we had nothing to do. My parents encouraged us all to read, they liked us to go there, it was one of the only places we were allowed to go to apart from the mosque.

Everyone knew the library; we used it as a meeting place. Particularly with boys and girls, as they're not supposed to mix, the library was an easy place, as both parents would allow them to go there. So even if they weren't interested in books, they had to take them anyway to show their parents. It is a shelter, a safe place where they won't be chucked out, and otherwise they have to go into parks, which are too visible and dangerous in terms of racial attacks. So the library was always a safe place. Probably many marriages have come out of meetings in the library.

A former Whitechapel librarian who also knew the building as a child is Pat Senior. Denise Bangs helped us track her down. Amazingly, Pat spent her childhood living next door to the library. Her father was the caretaker of the Whitechapel Art Gallery, and the family lived in the

flat above the gallery in the 1950s.

I was a shy child and spent much of my time in the library. I've always loved books. My parents encouraged us to read. They even bought us a set of encyclopædias. Mum read murder mysteries and Dad read war stories and the whole family were great readers. During the school holidays there were plenty of children next door in the library. I got to know the staff, you could just go in there and talk to them, and they let me help out behind the counter.

At the age of fifteen I applied for the junior assistant librarian post and spent the rest of my working life at Tower Hamlets Library Service, retiring in 1995. When I was living in the gallery and came home after work, I just dived in next door. It wasn't spooky or anything, but I do remember the time when I was in the Civil Defence and we used the basement of the gallery for drill. You'd hear all these scary noises, but it would just be a couple of pranksters. But there was one day when I really did get a shock, and that's when unknown to me the library stored a huge stuffed bear near the back staircase of the gallery. It caught me totally by surprise.

Some of the Whitechapel Gallery shows still stick in my mind. I remember meeting a very nice Australian artist called Sidney Nolan. Also, once there was this pavement artist drawing in the gallery. The gallery was filled with wonderful ships' figureheads. I really liked the Bill and Betty Exhibition. It was in the 1950s and it showed all these new electrical appliances and furniture. The East End Academy was where local artists could show their work. One of our colleagues used to show his paintings once a year. I don't think that this show is running any more.

Pat spent much of her working life in the children's library, 'it was lovely, we used to make sweets, paper flowers, woollen toys and of course Easter and Christmas decorations. These activities were rather noisy and the children really enjoyed themselves.' The current children's librarian, Giles Harrison, enjoys the job as much as Pat did.

I was a typical boy. I grew up on non-fiction information books. History and geography were a passion. Learning about different countries in the world, hoping I would get there some day. My parents encouraged me to read, although there were few books at school and in those days books seemed terribly expensive so I went to the library. I was fascinated by how information was collected. I started off doing research but it's very lonely, you lose touch with reality. I love being a children's librarian. I love getting the school classes into the library. To see them interact with a wider world in a public building. Watching people. I think every book has its worth and the most important job I can do is to get a child reading. One of the main roles I have is with the Bengali population. Public libraries are not part of the scene in Bangladesh. We want to get it through to the community that our library is free and safe.

Along the landing, past the children's library is the music and art collection, run by Chris Stanford. Chris joined the library in 1960, making him the current longest serving librarian at the Whitechapel Library.

In the sixties there were two generations of librarians. The pre war set, Jewish left wingers like Bernard Levine and David Grossman and also the eccentric English like Jim Cornell. They were all helpful and sympathetic and an inspiration to me. I worked forty two hours a week. By the end of Saturday I'd put in quite a number of hours, I'd really feel it. My day would start by checking and putting books in order, tidying them, straightening them; that would go on until tea break, then I'd be handwriting those dreaded overdue letters. Lunchtime was really busy, over half the issues of the day would be between twelve and two. Three or four of us would be at the counter working flat out and there would be queues of people. I'd usually just grab a sandwich as I'd work through my lunch hour but if I had a moment I'd pop down the road to Blooms.

One of my biggest memories from when I started was the newspaper reading room. There was a journal called the Lloyds list. There were

fights over this list because it was the only periodical that listed the times the boats were coming into the docks. It had news of all the shipping. Dockers often worse for drink could use it to find work. We had a ten-minute rule then, that's all you could have. I could tell you there were really interesting discussions then!

Back then there was nowhere in the building where you'd find silence. I can't remember the last time we had a sign up that said silence. There is something unique about this building, a happy-go-lucky, very friendly easygoing atmosphere. This area has always been quite liberal and I don't remember anything we didn't stock for censorship reasons. However, certain books wouldn't be placed on the open shelves, you could only locate them via the card index or by asking. One book I remember was the famous Kinsey Report on sexual practices. That one was kept under the counter. I'm sure that we stocked all the sensitive books, as long as a book was legal. Even *Mein Kampf* would go out a few times a year. However, any book that was borderline had to be approved by the Borough councillors. There's a story about how they consented to Henry Miller's *Tropic of Cancer* because they believed that everybody should know about these awful diseases!

One of the most recent arrivals to Whitechapel is the Somalian community. Until very recently their language has only existed as a spoken one. Today the Whitechapel library stocks several copies of the first book to be translated into Somalian from the English language, George Orwell's *Animal Farm*. There's a huge demand for the lending library's seven copies.

In collaboration with the Whitechapel Art Gallery, **Alan and Rachel** have spent the last year creating an audio archive documenting the Whitechapel Library's living memory. They have interviewed a wide range of people associated with the library, including former librarians and readers. Extracts of these interviews and related visual material will be presented in the documentary room of the Whitechapel's Centenary exhibition.

The Whitechapel Archive: History or Aide-Mémoire?

by Jon Newman

The Whitechapel Archive is a potent source for anyone interested in the gallery's history. To reach it you have to descend down beneath the marble cladding of the entrance foyer into a dead space – airless yet pervaded by the distant roar of the gallery's air handling unit – shoe-horned below the gallery front desk, between plant rooms and art stores, with the rumble of the District Line trains pulling into Aldgate East coming through the brickwork. For many years the archive was neglected but it never actually ceased to function; it contains a century's slow and unselfconscious accumulation of evidence. The actual series of records (the file wallets, cuttings books, catalogues and trustees' minutes) survive to tell us, by their own paucity or completeness, their tight organisation or unplanned scatter, of the changing administrative culture of the gallery and its directors over the years.

For decades this archive was a secret resource without contents list or finding aids, available only to the initiated or the determined, until in 1995 I was appointed to catalogue its contents and to manage the slow process of discovery and recovery of the gallery's past.

The very survival of the records is itself indicative of how the gallery has perceived and organised itself. The years from the gallery's opening until the departure of the first director, Charles Aitken, reflects the careful optimism of a new venture by the scrupulous retention of documents. After the First World War, without a director for over 20 years the record keeping slips; there are haphazard collections of secretaries' correspondence and incomplete series of minutes; there are catalogues but no systematic photographs, occasionally press cuttings have been kept; sometimes a poster or handbill survives. But from 1948 with a new director and a new administration the thoroughness of the historical record suggests a changing mood – cuttings and ephemera for each show carefully bound up in guard books, installation photographs commissioned, multiple sets of catalogues kept; the exhibition correspondence files burst with an excess of preserved detail – transport lists, insurance and catalogue text drafts for every show. But then between 1970 with the departure of Mark Glazebrook and 1976 when Nick Serota arrived – the interregnum when the gallery nearly closed – the breakdown in record keeping becomes a metaphor for that troubled time. In some instances, when the gallery was hosting touring Arts Council shows and was simply a venue among others, this paucity is perhaps understandable. But when the gallery was itself curating the exhibitions there is often too little documentation. There are shows for which no photographs were taken; shows for which the catalogue never progressed beyond notes on the back of an envelope; correspondence files that consist of an artist's phone number and a lunch date. This was the time when, seemingly, exhibitions could be scratched together at short notice and with almost no budget over a quick lunch with the director.

The gallery was four small separate spaces – the foyer and main gallery with the "Ideas" and "Experimental" galleries up the stairs. So a visit to the Whitechapel in the early or mid-70s could present a confusing confection of the populist and the bizarre – Spike Milligan, Beryl Cook and the Pearly Kings and Queens meet Peter Logan and Hendrik Werkman. And into these spaces, where almost anything went, came some extraordinary shows that could probably never have happened at another time. One longs for a fuller record of events like *Albion Island Vortex* in 1975 – an early collaboration between Iain Sinclair and Brian Catling. But as for many such shows, the archive refuses to confirm or deny anything; two letters and a typescript catalogue are all that survive that particular venture.

The Whitechapel has its archive and it also has its history. The two are not the same thing and while many people have a view on that history it has never truly been defined. No one has yet written *The History of the*

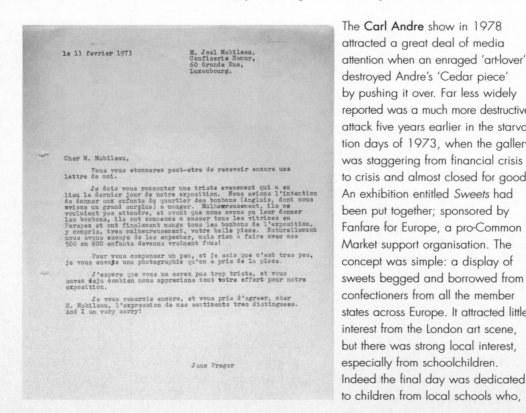

The **Carl Andre** show in 1978 attracted a great deal of media attention when an enraged 'art-lover' destroyed Andre's 'Cedar piece' by pushing it over. Far less widely reported was a much more destructive attack five years earlier in the starvation days of 1973, when the gallery was staggering from financial crisis to crisis and almost closed for good. An exhibition entitled *Sweets* had been put together; sponsored by Fanfare for Europe, a pro-Common Market support organisation. The concept was simple: a display of sweets begged and borrowed from confectioners from all the member states across Europe. It attracted little interest from the London art scene, but there was strong local interest, especially from schoolchildren. Indeed the final day was dedicated to children from local schools who,

after enduring some edifying words from the sponsors, were to be allowed to consume the English portion of the exhibition. The far more extravagant continental productions – hand-crafted chocolate, statuary and baroque sweetmeats – were due to be returned to the lenders. Unfortunately the local schoolkids became enraged when they were only offered the Liquorice All Sorts and Sherbert Fountains. The handful of security staff were no match for 500 – 600 children who rioted, smashed open the display cases and gorged themselves on the opulent confections of France, Belgium, Luxembourg and Germany. The only clue to this debacle is an embarrassed letter in the gallery archives, written in halting French on an unaccented typewriter and sent to one of the Luxembourg *confisiers*.

Whitechapel Art Gallery. Instead there are versions, studies of themes and snapshots of moments. Some, like the founding of the gallery in 1901 by Canon Barnett, are well rehearsed. Particular shows like *Guernica* or *This Is Tomorrow* have acquired a resonance and a supporting literature far beyond their original conception. The careers of individual directors like Charles Aitken, Bryan Robertson and latterly Nicholas Serota are well documented and the subjects of study in their own right. But put all these together and they still do not constitute a history. Instead, in the absence of narrative increasingly there is mythology. One current version posits the Whitechapel as the crucible of modernism in London through the century. Not content with the legacy of Bryan Robertson and his defining shows of the 50s and 60s – *This Is Tomorrow, Jackson Pollock, Australian Abstract Art* and *The New Generation* shows – this mythic history also seeks evidence of an earlier latent modernism, ideally running like a thread from the gallery's very inception, to underpin its position today.

No one seriously disputes Robertson's work in reinventing Whitechapel as *the* London public showcase for modern art. In the late 50s and 60s it was undisputed cock of the roost and 40 years on it still retains that reputation, albeit alongside a host of other, more recent competitors. Now the Whitechapel looks to other elements of its history – the Open shows, the education programme and its location within a changing but nevertheless defined community – to help redefine its distinctiveness.

But evidence that the gallery always had a modernist agenda is perhaps harder to find. The archive is trawled and the finger points. Roger Fry is found lurking among a host of half-forgotten NEAC artists in the 1903 *Artists in the British Isles at the beginning of the Century* show. Jacob Epstein lent a stone garden ornament he made for Lady Ottoline Morrell for the 1907 *Country in Town* show. In 1914 in a letter to Charles Aitken the Director of the Tate regrets "that you have to include the Cubists et al. Etchells and co. are not desirable individuals". Undeterred, the Whitechapel's *Twentieth Century Art* show

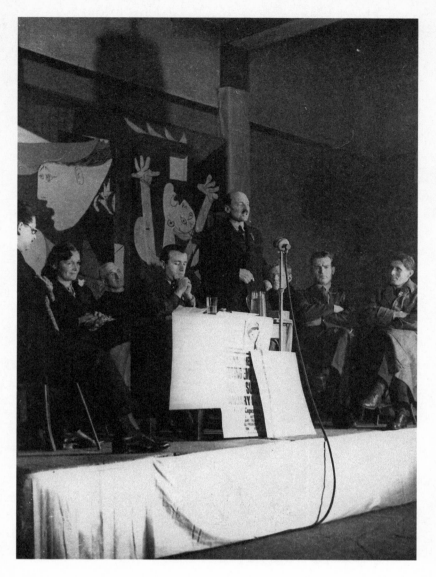

of that year also featured works by such obvious modernists as Gill, Nash, Bomberg, the Omega Workshops and Wyndham Lewis. Subsequent "modern" shows in 1924 and 1929 featured artists like Stanley Spencer "a painter unknown except to the smallest circles", Gaudier-Brzeska and Gertler, while the *Modern Dutch Art* exhibition of 1921 was an early foretaste of the gallery's later "internationalism" and introduced artists like Jan Toorop and Piet Mondrian to an English audience.

And then in 1939 came the *Guernica* show, that moment of political and art history when Picasso's work, in flight and transit from Paris to New York, made a remarkable but brief appearance in London, not just at the fashionable west end New Burlington gallery but much more appositely – as it now appears to us – at the Whitechapel too, with all the proletarian and political associations of the east end trailing upon its newly chic coat-tails. Here surely, if proof were needed, is the earlier evidence for the gallery's pedigree as a politically correct modernist showcase?

Unfortunately, this is the moment where mythical history and archival documentation definitely part company. For *Guernica* was not a Whitechapel show at all, in the sense of having been organised by the Gallery. Yes, it physically took place in the gallery, but it was a privately staged venture, a sideshow. The Whitechapel had always derived a welcome additional income from renting out parts of the gallery between shows to local groups, mostly to quite prosaic local organisations' fund raising bazaars, meetings and evening lectures. The East London Aid Spain committee of the Stepney Trades Council might have appeared one such, it was actually a local Communist Party front organisation that approached the gallery for the hire of the main space in January 1939. That its agenda had almost nothing to do with modern art and was primarily to do with raising awareness of and funds for the war in Spain is not really the point. In the first two weeks of January 1939 it pulled off a remarkable coup by getting and exhibiting Picasso's work and per-

Guernica came to Whitechapel in January 1939. Clement Attlee, MP for Limehouse and leader of the Labour Party made the opening speech. But it was a private event, organised by the East London Aid Spain committee of the Stepney Trades Council.

Even though the gallery didn't organise the show first time around, the exhibiting of *Guernica* at Whitechapel quickly acquired almost iconic significance. Subsequent gallery directors tried again and again, without success, to repeat that 1939 coup. Bryan Robertson in 1952 failed to get permission from Picasso to let the piece travel back from New York; while Nicholas Serota, in 1980, trying to intercept the work on its final return from New York to Spain, was equally unsuccessful.

suading Clement Attlee, local MP and leader of the Labour party, to open the event, flanked by the International Brigade, before the national press. But if you look in the archive for evidence of *Guernica* you will find almost nothing – no catalogue, photographs or press cuttings, as you would expect for a regular show. The annual report for the year acknowledges a show called *Spanish Art*, but its complete absence from the gallery accounts makes the position clear; all that survives is some correspondence to the gallery secretary from East London Aid Spain committee paying for the hire of the gallery for an unspecified event: £25 for the fee and £1 for the use of the telephone.*

Indeed if the archive confirms anything it is the political and artistic cautiousness of the gallery administrators in the 1930s. In 1934 Henrietta Barnett, the widow of Samuel Barnett, had urged her fellow gallery trustees in electing a new chair to seek someone "who has a large mind on Art and does not think that all the kinks and kranks of modern art movements are to be encouraged". In 1939 the

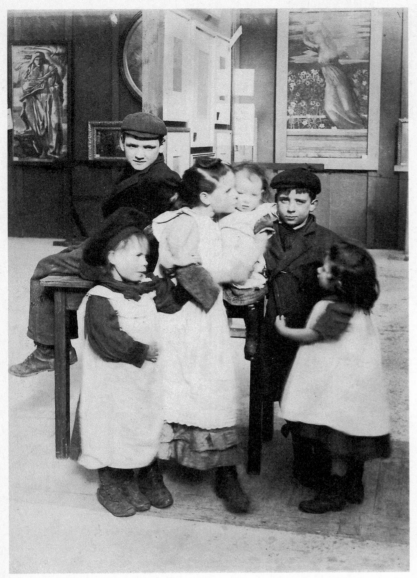

A rare photograph from the **Sports and Pastimes Exhibition**, 1912; one of a series of popular shows from the early years that targetted children as much as adults.

Whitechapel Art Gallery
HIGH STREET, E.1

Wyndham T. Vint's
Collection of Oil Paintings
and the Art of the
Unemployed

OPEN DAILY
Friday, April 14th, 1939
to
Saturday, May 13th, 1939

Hours :

12 noon to 9 p.m.
Sundays: 2 to 9 p.m.

ADMISSION FREE

Nearest Stations: Aldgate (Metro.), Aldgate East (Und.)
Trams: 47, 53, 61, 63, 65, 67, 71
Buses Passing: 10, 10a, 25a, 25b, 25c, 42, 96a, 96, 653
Near: 5, 15, 23, 23b, 40 (9 Sundays)

gallery showed an exhibition put together by the Artist's International Association, including works by Henry Moore, Paul Nash and Laszlo Peri that had Lord Balniel, the gallery's chair of trustees urging caution because of the AIA's political agenda. A proposal later the same year to include an exhibition of art by the unemployed was silently dropped while the safer option – *Wyndham T Vint's collection of oil paintings* went ahead. In retrospect *Guernica* was not so much further evidence of an early cutting edge modernist agenda, it was more a happy accident.

Myths are simple stories; and to simplify is to necessarily exclude. The archive on the other hand is prosaically inclusive; there is no more nor less documentation for the "significant" shows. The same office procedures were adhered to; the same correspondence, insurance and transport files assembled. And anyway the gallery's history was never that

simple. Even at the height of Bryan Robertson's modernist phase when the Whitechapel – with its walls stripped of grubby coffee coloured hessian and newly painted white – became the public showcase for modern British abstract artists like Merlyn Evans, Prunella Clough and Hepworth and the automatic London destination for US Abstract Expressionist shows curated by MOMA New York – Pollock, Kline, Lee Krasner and Motherwell all made the trip – it is salutary to remember that there were other sides to the gallery. For there is an alternative Bryan Robertson show list that is rarely recited but has to be acknowledged. In between the contemporary shows of the 1950s the gallery was also exhibiting a series of major historical retrospectives devoted to artists from the established canon like Turner, Rowlandson & Gillray, John Martin, George Stubbs and Bernardo Belloto. Indeed the Turner show of 1953 was the first grand

survey of that artist's work since his death in 1851.

Then in 1955, the year before *This Is Tomorrow*, Robertson had put on *The Bearsted Collection*: a show of Italian, Flemish and British old masters taken from the collection at Upton House near Banbury. Visitors to the gallery might have been forgiven for thinking they had accidentally stepped into an out store of the Wallace Collection; it was the archetypal country house contents show, even down to the National Trust sponsorship. Except there was an appropriate Whitechapel edge to it. The collection had been assembled by Walter Samuel, the second Lord Bearstead who, *inter alia*, was chair of the Whitechapel trustees up to his death in 1948. His son, the third Lord, was the current chair of trustees and had largely initiated the show. Now in the ownership of the National Trust, the Italian, Flemish and British old masters were introduced in the catalogue by an eminent committee of scholars including Kenneth Clarke and John Pope-Hennessy. And one suspects that for Bryan Robertson, simply showing such works at Whitechapel was the point. Connoisseurs of "fine art" could normally get access to similar works in west end galleries; but the Bearstead Collection had never been seen in its entirety anywhere in London before. There must have been a glorious conceit in bringing, perhaps for the first time, the readership of *Country Life* and *The Illustrated London News* down to the East End in order to see it as a whole, complete with the splendid Breughel, Giotto and Tintoretto. As the press had said of an earlier show, "There are few new things in this show, but the old brought together in this way, at Whitechapel somehow looks different... They take on a new importance from the location".

The mistake is to see a show like *The*

The poster for the
**Design And Workmanship
in Printing** exhibition,
one of a number of 'trade'
shows targeted at future
apprentices, is a
rare survival from 1915.

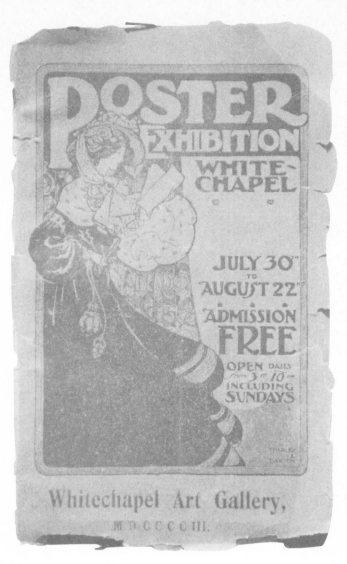

left:
The proposed handbill for
**Wyndham T. Vint's Collection
of Oil Paintings**, 1939,
before *Art of the Unemployed*
was cancelled.

Bearsted Collection as peculiar; in fact it was part of an ongoing White-chapel tradition of patronage by owners of works. It looks back to the very first *Fine Art Loan* exhibitions held in Canon Barnett's school-rooms at St Jude's Bethnal Green in the 1880s; and forward in a way, to later eclectic shows like *Drawing the Line* which instead posit the artist as curator in place of that earlier medi-ation by the owners of works. The gallery's founding fathers had always relied on their peculiar and penurious position as a public art gallery bring-ing improving works of art to the disadvantaged to attract loans of works from sympathetic middle class patrons.

A typical Whitechapel show in the first decade of the gallery's life might start with an appeal in the national press for works conforming to a par-ticular theme. These advertisements in the *Times* and the *Morning Post* were normally placed just three or four weeks before the opening of a show and elicited a tremendous response. The paintings exhibited in shows like *Scottish Artists, The*

Cornish School, Shipping and *Dutch Art* ["to assemble a heterogeneous collection of works by well known artists" was how Charles Aitken defined the gallery's exhibition policy in these early years] came largely from above the drawing room mantle pieces of sympathetic patrons in the Home Counties, who were generally delighted to be associated with such a worthy undertaking. As their titles suggest, many of these shows merely confirmed the predictable artistic tastes of the owners of the works. Other gallery directors might snort derisively, but it was certainly a cost-effective way of achieving the trustees' stated aim: "to widen the thoughts and pleasures of east Londoners through objects of art."

"I do not see how so many exhibi-tions can be carried on each year, without charge for entry, in the present circumstances. I cannot think that in the East End they can profit by so many [exhibitions] except as mere sources of amusement… The patience of private owners is being sorely tried, as I know myself how unwilling some owners are to begin

leaving anything, knowing that there will be no peace for them afterwards"
Director of National Portrait Gallery, 1907

What is interesting about the White-chapel is that although it commenced within a fine art loan tradition, it quickly found and adopted other models for shows alongside this, many of which developed into traditions peculiar to the gallery. The early ethnographic *Life and Art* exhibi-tions – *Chinese, Japanese, Indian Empire, Muhammadan* (sic) and *Jewish* – had their roots in an imperial and didactic tradition, but the Whitechapel's take on this tradition transformed them to something much more unique and pertinent. They began as rather pre-dictable educational displays using the colonial acquisitions of museums like the V&A and the Pitt-Rivers as their core. But by 1927, when the gallery reprised its original 1906 *Jewish Art and Antiquities* exhibition, it had become a quite different enter-prise and much more relevant – in the sense of attempting to chime in with both East London and inter-

national Jewish culture. The 1927 show focused on contemporary and local artists, with works by Mark Gertler, Horace Brodzky and Isaac Rosenberg replacing the prayer scrolls and candlesticks of its earlier incar-nation. Another local artist, David Bomberg, had already organised the Jewish section of the 1914 *Twentieth Century Art* show; and the 1923 *Jewish Artists* had included works by Kramer and Pissarro. One can follow this tradition of trying to provide ethnically and culturally relevant events for the immediate community through post-war shows like *Seven Israeli Artists, Shaffique Uddin, Woven Air, Seven Stories about Modern Art in Africa* and *000zerozerozero* and see the Whitechapel revising its commit-ment to local minority groups within an area of constant migration and constant change.

At the same time particular artists emerge in the process and move beyond their initial role as "cultural representative". Having first been exhibited as "Jewish Artists" in these early group shows, individuals like Mark Gertler, Jacob Epstein and David Bomberg return to White-chapel in the second half of the century with retrospectives in their own right.

That art on display in galleries should be "accessible and relevant" sounds a particularly contemporary mantra. But it clearly informed the White-chapel trustees' policy a century ago, for alongside the fine art shows and the ethnographic exhibitions, a third kind of show emerged. Partly com-ing out of the Arts and Crafts tra-dition, partly from a broader didactic urge, shows as diverse as the three *Country in Town* shows of 1905, 06 and 07, *House and Home* [1911], *Engineering* [1912] and *Design and Workmanship in Printing* [1915], while diverse in subject matter still shared a common approach in trying to be relevant to the concerns of their audience. The three *Country and Town* were early examples of environ-mental shows that presented various very practical takes on the "greening" of East London – with proposals for model housing schemes and parks, window box competitions, and practical information on garden plants and how to get out to the countryside by train. [The Barnetts were them-selves important advocates of the

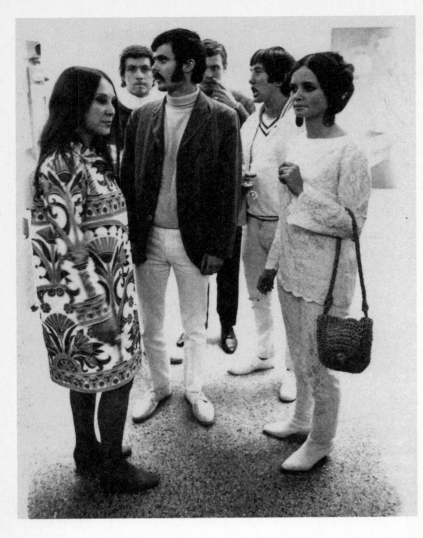

In the 1960s the Whitechapel private view became a destination in its own right – almost regardless of the content of the show. The *Australian Art* opening saw the gallery festooned with antipodean palm trees; while in 1968 it was Princess Margaret – the representative of sixties "regal cool" – who opened the *New Generation* show. David Hockney at his 1970 show was a far cry, sartorially, from the preceding generation, when a Whitechapel opening had meant an East London mayor in a post-war suit reading his prepared speech from a platform. Pictured: opening for the *New Generation*, 1966.

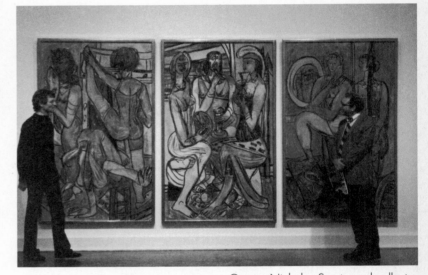

Curator Nicholas Serota and collector Robert Gore-Rifkind stand before **Max Beckmann**'s *Ballet Rehearsal* triptych at Whitechapel in 1981. The relaxed smiles give no clues to the curatorial triumph of will involved in assembling 9 of the Beckmann triptychs in one place for the first time ever.

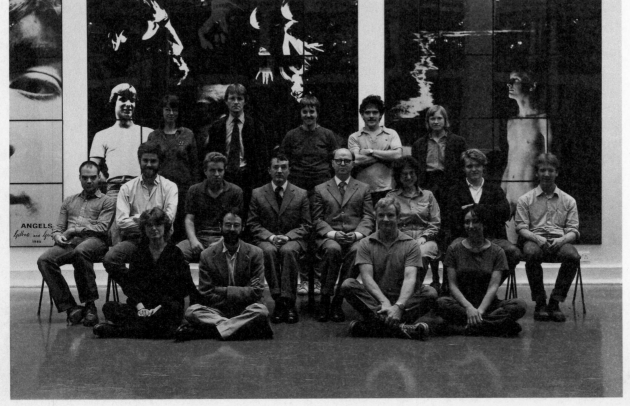

Nick Serota and gallery staff with **Gilbert and George** for a team photo, 1981

The trajectory of **Jacob Epstein** across the Whitechapel century could almost serve as a paradigm for the way the gallery has served as a changing space for artists. From carver of birdbaths to the landed gentry in 1906, to 'Jewish artist' in 1914, to 'British Sculptor' in 1981 (pictured here) he finally received a major retrospective show in his own right in 1987.

Garden City movement.] *House and Home* was equally a pragmatic show devoted to fitting out the interior of the house in an arts and crafts tradition, "simplicity and utility with severity". While *Tuberculosis* in 1909 was quite simply a public health exhibition, backed up with a series of practical lectures on "The white plague and how to prevent it".

The early "trade" shows about engineering and printing sought to reinforce the craft and design tradition of art as both an end and a means of employment. The gallery continued this theme in the 20s and 30s with exhibitions like the three *Knox Guild of Design and Craft* shows (motto: "the encouragement of art as a daily part of life"), *Household Things, British Handicrafts* and *Spinning Weaving and Dyeing;* and it can still be detected half a century later in 1970s shows like *Printed In Watford* and *Modern Chairs.*

Another way of staying relevant to the local community was the gallery's early espousal of children both as producers and consumers of art. From a very early date the artwork of local schools was exhibited at the gallery. This was in part a requirement of the funding received from the LCC – who also used the upstairs gallery for local children's art classes right up to the 1950s. But with shows like *Stepney Children's Pageant* in 1909 (with music specially composed by Gustav Holst!) *Sports and Pastimes,* 1912 and *Toys* (an extraordinary display of "industrial patriotism" staged at the height of the First World War – including a section of toy anti aircraft guns, motor ambulances and "war dolls" dressed as soldiers, sailors and nurses) it was clear that the gallery was deliberately appealing to children as well as adults. Sometimes their efforts were not well received. A mail shot to local schools in 1927 inviting classes of children to visit the exhibition of L Pilichowski's "great historic painting" of the *Opening Ceremony of the Hebrew University in Jerusalem by Lord Balfour* received an apologetic reply from the head of one local school:

> "I regret to say that my children having discovered that the Picture is *not* a cinema show, do not wish to come to the art gallery tomorrow."

What is interesting is that this demotic tradition never entirely disappears. Immediately post-war *Black Eyes and Lemonade* (a show of popular culture linked to The Festival of Britain) and *Setting Up Home for Bill and Betty,* (a 1950s post-war austerity Design Council show) are both clearly linked back to early shows like *House and Home.* In the 1970s a whole raft of populist shows – *Tower Hamlets Flower Show, Fair Ground Art, Banners Bright* and *Sweets* continued the tradition. Such shows may have almost disappeared from the main gallery now, but they survive still in the showcase exhibitions in the Foyer and the artists in schools programme. Occasionally we can see a playful re-conceptualising of this tradition, as in the recent *Protest And Survive.*

For all its lacunae the Whitechapel archive is important, not just for itself, but as a reminder of the alternative approaches that exist for an organisation's history. Such history can be approached from the present moment back, seeking patterns and tracing configurations that may be purposive or may just be retrospective serendipity. Or we can view this history from the past forwards and find a different version where earlier traditions, now dropped from sight, are still found to inform the recent past. The archive enables either approach while standing aloof from any single interpretation. For ultimately it stands as an uncompromised record of and source for the sheer diversity and eclecticism of the gallery's first century.

Jon Newman was archivist at the Whitechapel from 1995–1998.

* In fact there is now a considerable additional archive of *Guernica* material including photographs, thanks to the deposit of Norman King's papers by his widow in 1998. King was one of the organisers of the East London Aid Spain committee.

Roller-Coasters and Helter Skelters, Missionaries and Philanthropists. A History of Patronage and Funding at the Whitechapel Art Gallery

by Janeen Haythornthwaite

The one pernicious issue associated with the Whitechapel Art Gallery over the years would seem for many to be that of funding – a persistent struggle for survival. Some see it as a helter-skelter, tumbling rapidly to earth. Perhaps the more accurate analogy would be as a roller coaster; yes there have been downs but also ups. The reasons are many.

One of the most obvious factors determing funding and the intimately linked struggle for patronage is the Whitechapel's location. When Canon Barnett, the founder of the gallery, made his decision to 'go East' in 1872 to take up the position as vicar of St. Jude's, Whitechapel, he did so not so much out of a philanthropic concern but rather with the zeal of a missionary. In fact at that time, as little was known of the land and people living east of the City of London as of some distant foreign parts.

By the time that they moved to Whitechapel, Samuel Barnett and his wife Henrietta were already well connected, with philanthropists and social reformers amongst their acquaintance. They continually expanded this base, so that when their exhibitions in the St. Jude's schoolroom were started, there was a ready source of picture loaners, guides and supporters. These free exhibitions, held over the Easter school holidays, ran for twenty years.

The Barnetts' projects in the East End included Toynbee Hall – a residence for university graduates that enabled them to live, work and get to know the East End. There was also the Passmore Edwards Library, opened on Whitechapel High Street in 1892 and funded by John Passmore Edwards. When the land next to the library became available, Barnett purchased it with the intention of building an art gallery. Once again, Passmore Edwards provided the initial funds (£6,000) to buy the land and kick start the building fund. He promised a further donation of £1,200, which was later withdrawn when Barnett refused to name the building the Passmore Edwards Gallery.

City businessman Edgar Speyer was another generous contributor; he filled the hole left by Passmore Edwards' rescinded promise, giving £2,550 to the building fund alone. He became a Trustee of the new gallery, providing the essential link to the City, both people and institutions. Donations were received from others who became Trustees: H. Lawson of the London County Council and W. Blyth, the latter becaming Secretary and Treasurer to the Board. Further names on the list of donors to the building fund include those from prominent Anglo-Jewish families and also from the City (for example, Schroeder, Hambro, Samuel, Rothschild and Lazard). There were also contributions from industry, particularly brewing (Ind Coope & Co., Truman, Hanbury & Co.); somewhat ironic given that one of Barnett's aims with the free 'Picture Exhibitions' was to keep people out of the pub!

The donations ranged from the thousands (Passmore Edwards, Speyer, A.F. Yarrow, Lord Iveagh and an anonymous donation of £1,000) to a guinea or so (Toynbee Art Students' Club, the literature class, High School for Girls, Exeter, per Miss Turner). The City Guilds made their first of many appearances on the supporters' lists – the Drapers' Company gave £250 and the Fishmongers £52 10s. The donation by the Drapers was to ensure them representation on the Board of Trustees. Further places on the Board reflect supporters of the running of the gallery such as the City Parochial Foundation and the Sir John Cass Foundation.

The fundraising appeal for the creation of the Whitechapel Art Gallery reflects the Barnett's missionary zeal: 'this attempt to fill the minds of the people with thoughts to exclude those created by gloom or sordid temptation.'[1] The approach contrasts with the philanthropic founding of a building or organisation with plans and funding for present and future. The Whitechapel Art Gallery was a privately funded organisation but without an endowment or any other such long-term funding. The consequences of this have dogged the gallery throughout its history.

With a full-time Director, Charles Aitken, as well as an active and involved Board of Trustees, the first Spring Picture Exhibition at the newly built gallery was opened on March 12th, 1901 'attended by a large number of visitors – old friends and others from the West End.'[2] The exhibition in the new gallery was just as popular as the exhibitions in St. Jude's school had been – in total 206,000 visited in six weeks, with the largest daily attendance being 16,000. It seems safe to assume that with this scale of attendance, large numbers were from the local community. Certainly the local schools brought many children to the exhibition. However, Barnett was disappointed that only £100 was raised through the donation boxes.

1901 also saw exhibitions of Chinese art and of Scottish pictures, organised and funded in a way that became standard for the gallery for many years; a specialised committee offered expertise, art, money or connections. Perusing the lists of exhibition committees reveals a range of well-known names from the art world and beyond. The *Shakespeare Memorial and Theatrical Exhibition* of 1910, for

example, involved a committee including George Bernard Shaw, Sir Arthur Pinero and Winston Churchill. Vice patrons of the exhibition of spinning and weaving included the titled (e.g. The Dowager Lady Northbourne) and names familiar from elsewhere (Miss Lilian Baylis). The one exception to this was the 1914 exhibition 'Twentieth Century Art', almost entirely organised by Gilbert Ramsey, the Director of the Whitechapel at that time, and his predecessor, Charles Aitken, who had become Director at the National Gallery of British Art (Tate Gallery). Henrietta Barnett, a Trustee from the beginning (and who remained so for many years, long after her husband's death), wrote to Ramsey: 'May I plead however that you do not get too many examples of the extreme thought of this century, for we must never forget that the Whitechapel Gallery is intended for the Whitechapel people, who have to be delicately led and will not understand the Post-impressionists or the futurists methods of seeing and representing things.'[3]

From the very beginning, however, the gallery struggled to find day-to-day funding, although even Barnett was aware of the need for what he described as 'a small regular income.' City Guilds and charities were continuing to donate and, through the efforts of Edgar Speyer, the Bawden Trust had laid the foundation for an endowment; nevertheless, the gallery needed £500 per annum to cover its running costs. The request letters went far and wide: 'It seems incredible that such a far-reaching benefit to hundreds of thousands of persons should fail for want of so, comparatively, small a sum.'[4]

The Trustees went as far as to discuss surrendering the gallery to public management – the Education Committee of the London County Council (L.C.C.): 'The feeling, however, of the majority is that independent management is more likely to discover new ways of usefulness and to adapt the Gallery to the varying demands of a new age.'[5] The L.C.C. awarded the gallery an annual grant in 1909.

The death of Canon Barnett in 1913 and the move of Charles Aitken to the Tate Gallery considerably inten-

Gilbert Ramsey
Director of the Whitechapel
Art Gallery 1911–1914

sified the struggle for patronage. This was increased further by the outbreak of the First World War and the loss of the two subsequent Directors. (Both were killed at the Front in France although Ramsey had moved to the Glasgow Corporation Galleries shortly before enlisting.) Crisis truly hit in 1922, by which time the annual subscriptions raised less than £200 and the L.C.C. withdrew its grant. An appeal went out for 'First Aid for the Whitechapel Art Gallery' to find new annual subscribers to replace 'the many who were lost in the war'.[6] The City Parochial Foundation bailed out the gallery by doubling its grant for 1923; whilst the appeal had the effect of bringing back many of the previous subscribers, individuals and organisations such as the Rothschilds, Lord Duveen, the Drapers', Fishmongers' and Grocers' Guilds.

One of the ways in which the Whitechapel has been able to raise funds, right from the start, was to hire out the gallery. It is a spectacular space, not just for showing art, but suitable for many other purposes. By the time of the cash crisis of 1922/23, hire of the gallery was

earning nearly £500, an invaluable contribution to the precarious finances.

The rise in subscriptions which resulted from the 1922/23 fundraising campaign did not last long. The gallery was somewhat lacking in inspiration. The role of Director was combined with that of Secretary and exhibitions tended to focus on local arts and student sketch clubs along with school children's work. Nevertheless, the East End Academy was well established and much visited. Comparisons were made in the press with the Royal Academy: 'We are hearing a lot about art and the Academy these days, but how many of you know that in London there is an art gallery outside of which butchers and bakers leave their vans while they go in for a peep at the pictures?'[7] The gallery was becoming known as the 'Working Man's Academy'.

This role, however, did not attract the level of patronage that was necessary, either for the day-to-day running of the gallery or with the provision of funds to mount exceptional exhibitions. By the time of the 1939/40

Trustees Report it was noted that 'the maintenance of this free gallery is a great anxiety to the trustees and it is hoped that subscribers may be found who will take the place of those of whom the gallery has been robbed by death and other causes. This gallery is unique; it is the only one in the Kingdom that is maintained solely by voluntary effort and its exhibitions open free to all.'[8]

The gallery space was still being used by other organisations. In 1939 it was used to spectacular effect to show Picasso's *Guernica*, which attracted an enormous audience and raised funds for the 'Aid Spain' campaign in support of the Spanish Republican cause; the exhibition was opened by Clement Atlee.

The years of the Second World War saw the gallery devoting its space largely to war-related exhibitions and, not surprisingly given its East End location, the building suffered bomb damage. Particularly significant during this period was the appointment in 1943 of Lord Bearsted, an enthusiastic art collector, as Chairman of the Trustees. He served in this role until his death in 1948 and is described in the 1947/48 Trustees Report as no less than the 're-founder' of the Whitechapel Art Gallery. 1947 also saw the appointment of a full-time director, Hugh Scrutton, who, with Lord Bearsted, saw to the rehabilitation and re-establishment of the reputation of the gallery. Financial records are sparse for this period. It would appear, however, that Lord Bearsted was not only generous with his time and energy but also with his money – the success of the Whitechapel meant a great deal to him. His son, the third Viscount Bearsted, succeeded him in the role of Chairman of the Trustees, remaining in post until 1973.

Nevertheless, by 1949 the gallery finances were once again precarious. The assured income at this time was just £899 whereas it was judged that in order to run the gallery £5,000 per annum was realistically required. The City Parochial Foundation was still giving an annual grant of £500, although in 1947 it gave an additional £1,000. Also in 1947, the newly formed Arts Council appears for the first time in the records with

ment of a complex relationship. The Whitechapel Gallery Society was founded in 1948 to encourage private subscriptions and instantly increased the funding received in that way. However, the major change at this time was the awarding of annual grants by the L.C.C. and the East London Boroughs (Stepney, Hackney, Shoreditch, Bethnal Green and Poplar). The search for a funding solution was at this time seen as just one aspect of a larger issue – that of the relationship between the East London public and the gallery: 'It has been recognised that our first duty and privilege here is to give the people of East London exhibitions which enrich their experience and which they enjoy.'[9] The Trustees felt that to fulfil this role adequately it was absolutely necessary for the gallery to receive financial contributions from local government.

The upturn in the gallery's finances was reflected by a huge increase in visitors, as the Whitechapel mounted more ambitious shows for longer runs. (The annual figure for visitors

went from 12, 715 in 1947 to 40, 978 in 1953.[10]) The Whitechapel Gallery Society had a firm core of members once again including names from the art world and the aristocracy. There were a number of corporate members; it was noted in the Trustees Report of 1953/54 that the exhibitions audience included many business people from the City.

The finances were further improved by an increased number of special donations from a range of sources; Queen Mary in 1951, familiar names from the City (Schroder, Rothschild, Samuel) as well as banks such as Lloyds, Midland, Barclays, and regular donors including the City Parochial Foundation, the Bawden Fund and the Drapers' Company. The breweries had also returned, with donations from Charrington, Courage and Truman, Hanbury and Buxton in 1954.

In 1952 Hugh Scrutton left to take up the position of Director at the Walker Art Gallery, Liverpool. Bryan Robertson, a young man with very

big plans for the Whitechapel Art Gallery, replaced him. The gallery was at this point in a relatively stable position financially, achieved through an enormous dedication of time and effort by the Trustees and Director. To keep it in these circumstances would require even more. Robertson's skills were much more biased towards artistic content, rapidly proving his curatorial vision and raising the gallery's profile both nationally and internationally. Robertson's programme focused on emerging and mid-career British artists as well as contemporary art from Australia and the United States.

The costs of putting on exhibitions that involved bringing large numbers of exhibits from overseas were enormous, even those such as the Pollock show of 1958, organised with the International Council of the Museum of Modern Art, New York. Organisations such as the United States Information Service certainly assisted with funding, printing of materials and so forth. Robertson organised a number of exhibitions

through the artists themselves. A regular occurrence at this time, therefore, was for the artist concerned to donate one or more works to the gallery that were then sold to cover the costs of the show. Whilst this approach raised a lot of questions about the gallery's role and was considered iniquitous by a number of the Trustees, it was indicative of an activity that was to occur on occasions throughout the history of the Whitechapel, with artists helping the gallery out financially. This happened more and more as a large artistic community grew up in East London.

This exciting, wide-ranging exhibition programme ultimately left little time for the local art shows, previously the core of the gallery's programming. So whilst the audience expanded way beyond the confines of the East End and City, the core funders began to feel left out. The L.C.C. and East London Boroughs had been persuaded to fund the gallery because of the relationship between the Whitechapel and the

Complimentary dinner for Mr Charles Aitken (Director of the Whitechapel Art Gallery) June 16th 1910, Trocadero, London

David Hockney
at *Paintings,
prints and
drawings
1960–1970.*
April–May 1970

local population. Whilst Robertson was convinced that this invigorating art was what East Enders wanted, those who made the funding decisions were not. Robertson reintroduced shows of local art to forestall the halting of grants from the local boroughs. He also tried to bring in a professional fundraiser to help augment the annual income and create a capital endowment fund. This was not successful and having lost the support of a significant proportion of the Trustees, Robertson resigned in 1968.

Mark Glazebrook took over as Director and struggled for a short period to try and equate an appalling financial situation with a desire to put on challenging exhibitions. As Viscount Bearsted expressed in a letter to *The Times*:

We have a beautiful gallery that during its history has contributed much to the enjoyment and education of people of all walks of life. From its beginning, which was to bring the Arts to the poor of East London, it has become internationally known and we believe there is still a useful part for the gallery to play in the artistic life of England.

Its problems are almost entirely financial… but interrelated are the problems of whether to be parochial or international, to charge admittance or not to charge.

To become parochial might mean taking a following role rather than a leading one in the appreciation of the Arts. To charge admission could keep out seekers after knowledge. Not to charge could alienate some of our main supporters…'[11]

It appeared that the gallery might have to close, unable to meet its obligations. The artist David Hockney, who in 1970 donated the entire edition of a lithograph that was sold to raise funds, helped the Whitechapel over this particular financial crisis. The role of the gallery was much debated, many felt that it was no longer serving the needs of its local public – as Lady Henriques, a long-serving Trustee stated: 'The gallery has generously done its bit towards helping the work of the Avant Garde to be seen; and can with honour, turn its efforts towards homelier forms of helping the public whom we exist to serve.'[12] The role of the gallery in the context of education and the Inner London Education

Authority, and also the position of the Arts Council, were considered. Finding the task of Director impossible, Glazebrook resigned. His deputy, Jenny Stein, assumed the mantle of Acting Director. Viscount Bearsted resigned as Chairman of the Trustees in 1973, after a struggle to find a new Chairman.

What followed was an incredibly difficult period for the Whitechapel. A number of changes in personnel took place. The gallery depended almost entirely on public money, largely from the Arts Council and the Greater London Council (G.L.C.). By 1975 annual subscriptions to the Whitechapel Gallery Society had dropped to a mere £68.

1976 saw two important changes. The first was an amendment in the Constitution to allow charging for exhibitions. The second was the appointment of Nicholas Serota as Director. Serota had previously been an Exhibitions Organiser at the Arts Council and then Director of the Museum of Modern Art, Oxford and was very much seen as a 'rising star' by many people in the Arts Council. This belief in his abilities was reflected in the increase

in grants to the Whitechapel from both the Arts Council and the G.L.C. (The Arts Council grant rose from £15,000 in 1975 to £54,000 in 1978.) The Whitechapel Art Gallery was by this stage regarded by the Arts Council as the major independent gallery in London – essential amongst the flagship galleries it was supporting around the country. As galleries were gradually handed over to regional arts associations, the Whitechapel became more and more important, the largest amongst the group of six that received major support from the Arts Council. The Arts Council, however, only had an observer on the Board of Trustees, and at times struggled to have its views noted and voice heard amongst the many established Trustees, some representing organisations which by this stage made only a small financial contribution to the gallery. The appointment of Stephen Keynes as Chairman of the Trustees in 1979 meant that a formidable team now filled the leading roles.

As a result of the vast improvement in the gallery's finances and renewed stability amongst its decision-making personnel, the Whitechapel once

again returned to an innovative and exhilarating exhibition programme. Even more ambitious was the rebuilding of the gallery that took place in the early 1980s. Financing for this was sourced from a variety of places; some public, including the Arts Council and the Borough of Tower Hamlets (although this was largely 'planning gain' money); a large number of charitable trusts and smaller sums from companies and individuals. A major donation enabled the purchase of the old school building that made possible the extensive expanding and rebuilding of the gallery. Individuals and companies also donated funds for the day-to day running of the gallery – names include Bankers Trust and Saatchi and Saatchi (Charles Saatchi was a Trustee of the gallery at this time). Some of the West End galleries made regular contributions whilst a number of the exhibitions received specific funding.

The Whitechapel Art Gallery Foundation, the dream of so many past Directors and Trustees, was set up in 1984 to take in non-governmental funding – exhibition sponsorship and personal plus business donations.

The funds of the Foundation received an enormous boost in 1987 as a result of the money raised at the Whitechapel Auction. This event was staged by Sotheby's. West End galleries gave support, most notably Waddington. A number of individual artists also donated works, principally those that had exhibited at the Whitechapel in the previous ten years; examples include Howard Hodgkin and Anselm Kiefer, both giving high value works. The fund established, with the income it generated, was aimed at helping 'finance innovative programmes which do not readily attract sponsorship. The Fund will, for instance, enable the Whitechapel to present exhibitions of artists at an early point in their careers, and to pilot smaller projects in the Gallery and in the community during their initial stages.'[13] The Foundation was reabsorbed into the gallery's general funding in 1999, although the contributions are still directed to the programme of exhibitions.

Serota's achievements in attracting support can be seen in the length and breadth of the list of donors to the Whitechapel in 1987. This support now contributed twenty-five percent of the annual income.

Nicholas Serota left to become Director of the Tate Gallery in 1988 and Catherine Lampert was appointed in his place. Under her directorship the Whitechapel has continued to navigate between an exciting and challenging exhibitions policy, and the vagaries of funding policies by public bodies and increased competition for corporate and individual donations. Private support and earned income (such as gallery hire, profitable catalogues and membership schemes) have now risen to contribute fifty percent to the budget, essential given the rising cost of exhibition-making, the increase in professional salaries, the need to develop relatively new areas such as marketing and the high specification building. The gallery is particularly indebted to committed foundations, including the Henry Moore Foundation (a supporter since the 1970s) and the Morgan Stanley Foundation, along with major supporters of the arts in the corporate world, such as Bloomberg, who donated a total of £90,000 during the period of the last annual report (including funding of the Whitechapel website). The assistance and goodwill of artists has continued to be vital, often helping to keep exhibition costs low or producing fundraising aids, as did Gary Hume with his 'mini' paintings, sold during his 1999 exhibition. Shows organised by the Whitechapel raise both funds and the gallery profile when they tour overseas; there have been a number of these during Catherine Lampert's directorship. In contrast, one of her main strategies has been to exhibit foreign artists with a high profile in their own country but who are little known in Britain, for example Francisco Toledo. Exhibitions of this sort frequently attract the assistance of governments and companies from those countries. These new approaches to exhibiting and fundraising have also brought about a change in the Trustees, with an end to the historic system of nominated Trustees from such bodies as the City Parochial Fund and Draper's Hall.

The gallery continues to be an active participant within its surrounding community and as such can provide a bridge between the corporate world and community. Whilst the position of the White-

chapel from a financial perspective is at present fairly stable (neither reminiscent of a helter-skelter nor roller-coaster), the effort required to keep it so illustrates the problems facing a gallery aiming to build on its tradition and wishing to continue to show exciting, largely contemporary art. The Whitechapel Art Gallery may no longer demand the missionary zeal of Canon Barnett but certainly needs the philanthropy that backed him.

Janeen Haythornthwaite has been Archivist at the Whitechapel Art Gallery since 1999.

Notes

1 Fundraising document for the Whitechapel Art Gallery, 1906. WAG Archive

2 Annual Report of the Whitechapel Art Gallery, 12th December 1901. WAG Archive

3 Letter from Henrietta Barnett to Gilbert Ramsey, 7th February 1914. WAG Archive. She concluded: 'I am so pleased that all are working happily together in the beautiful memorial to my husband.'

4 Fundraising letter from Samuel Barnett and Charles Aitken, December 1906. WAG Archive. Not all the fundraising requests were well received. A letter from the Director of the National Portrait Gallery, noting the appeal for funds states, 'I am not surprised... for I have long been of the opinion that at the Whitechapel the pace has been too hot to last. I do not see how so many exhibitions can be carried on each without charge for entry...I cannot think that in the East End they can profit by so many [exhibitions], except as mere sources of amusement. Letter to Charles Aitken, 18th December 1907. WAG Archive

5 The Whitechapel Art Gallery, The First Five Years. 1906. WAG Archive.

6 The Manchester Guardian, February 19th 1923.

7 Glasgow Evening News, 12th December 1938

8 Trustees Report, 1939/40. WAG Archive

9 Trustees Report 1947–1949. WAG Archive

10 The modern record is 255,000 in 1998. All figures are taken from the Trustees Reports, WAG Archive.

11 Draft of letter to The Times from Viscount Bearsted, 29th October 1971, WAG Archives

12 Letter from Lady Henriques to Viscount Bearsted, 1st December 1971. WAG Archives

13 Catalogue for the Whitechapel Auction, 1st July 1987.

UBS Painting Award Launch event 2000
Photo: Stephen Congdon Party and Design Catering

Bethany 2000, 30 x 23cm, gouache on recycled paper

Wrack Wring 1997

Ripe Bananas and Stolen Bicycles

by David Widgery

My daughter is a technical Cockney: one of the last to be born at St Barts in Smithfield from which you can, just, hear the bells of St Mary le Bow. Like a lot of East End school kids she sings about Anansi, the wily spider of West Africa and thence Caribbean folklore as naturally as 'Oranges and Lemons' with its litany of London steeples or 'Ring a Ring a Roses' grim echoes of the Black Death; 'Tishu Tishu, We all fall down'. She also loves to venture inside Spitalfields Market, as have generations of East End children, darting between the heaps of fruit and the fork lifts under the mock-disapproval of the fruitiers, chattering to the tramps, looking at the different countries on the fruit labels and helping herself to the odd tangerine. And if Anansi had come to Hackney on one of the huge Geest boats as part of the Imperial Trade, he would have been unloaded in the West India Dock where the Canary Wharf obelisk now towers, carted up Commercial St and would have been set to ripen in the heated cellars beneath Spitalfields Market which East Enders used as bomb shelters during the Blitz.

But now there is no maternity unit left at Barts, no docks in Poplar. And from March 1991 no more Spitalfields Market. Going, going, gone. Harry Lackmaker, the last banana ripener, whose family came to London as part of the Portuguese Sephardic Jewish immigration will no longer work in Whitechapel and Fournier St will no more blow with the exotic litter of the world's fruit and veg. Anansi won't get to Hackney. Instead the corporate monoliths of business architecture, ugly by day, deserted by night, will continue their relentless obliteration of the ancient street patterns of the East End as the City lays claim to what it once cast out.

Well perhaps not ancient. Brick Lane is first recorded in 1550. Brick because it was where the earth was dug to make bricks and tiles, a 'noxious trade' like brewing, glue making and slaughtering which had to take place outside the walls of the City. There are archaeological traces of a Roman cemetery and a medieval priory and evidence of Elizabethan cat tracks, courtways and the Rag Fairs which were the original open air clothing markets. But it is in the mid-17th century that Spitalfields' built structure was established as London's first industrial suburb at a time when the rest of the East End remained largely pastoral. Defoe, writing in the early 18th century, remembers that in his childhood 'the lanes were deep, dirty and unfrequented, the now called Spitalfields Market was a field of grass with cows feeding on it. Brick Lane, which is now a long well-paved street, was a deep dirty road, frequented chiefly by carts fetching bricks that way into Whitechapel from brick kilns in those fields'.

The expansion rested on the rapid growth of the London textile industry which spilled over into Bethnal Green and was associated with the Pettycoat Lane Sunday clothing, fabric and second hand market, the permanent traders in Wentworth Street and, until the 1920s, Aldgate Street Market. The weaving tradition of the area had been consolidated by the Huguenot silk and taffeta weavers and brocade makers who came as refugees to Spitalfields to continue to practice their austere productive Protestantism after the revocation of the Edict of Nantes in 1685. Contrary to the impression given by the decidedly unrepresentative selection of homes restored by the Gilbert and Georgians of the Spitalfields Trust which in fact belonged to mercers, master weavers and silk dealers, the weavers were mainly journeymen: poor, often politically radical and

living in conditions of extreme overcrowding. Much like the contemporary Bangladeshi trade workers.

They were, Hawksmoor's marvellously intimidating Angelican edifice of Christ Church notwithstanding, often Dissenters. As well as the Calvinist Huguenots, there were the Quakers including the Buxton brewing family, Methodists (Westley's HQ was just up the City Road near Bunhill Fields, Blake's burial spot) and the Irish, habitual non-conformists, whose staunch Catholicism was the excuse for patriotic riot. Again contrary to those who for political expediency (that is to please the developers) claim the Market is somehow alien to the area and a nuisance to the residents, Spitalfields Market was established by the Royal Charter of Charles II as early as 1682, thirty years, thirty years before Christ Church was built and two hundred years before the driving of Commercial St through the rookeries. It is thus an integral part of the area, in some ways its heart: open at all hours, casual labouring jobs and supporting local subsidiary industries like the basket makers of Crispin St and offering its own unofficial welfare to the poor of London. For a wholesale market it is remarkably open despite the gates which were erected in 1924 after the site was finally acquired after some secretive and skilful property speculation by the City Corporation (although it remains, to their frustration, outside their geographical jurisdiction). It grew in parallel with the industrialisation of the borough but also sustained the East End's links with the countryside as it pulled in produce from North Kent, Essex and the onion fields of Hackney. And it really was an open market in which all the people of East London went to buy, to sell and to barter, a car boot sale spread over 20 acres. At least until Robert Horner took over the management of the market in 1875 and turned it towards the wholesale

trade, anyone was entitled to trade by payment of a nominal rent to the Goldsmith family who held the lease. The gypsies who still sell in Brick Lane will tell you that 'The King's Charter' guarantees their rights.

Until the clearances to build Commercial St, Brick Lane was East London's High Street. The 1772 Act of Spitalfields local government describes it as 'a great thoroughfare for carriages, and the only convenient one from the waterside, through White-Chapel to Spitalfields, Mile End New Town, Shoreditch and parts adjacent'. Already it was the major shopping and manufacturing centre of the East End: listen to the gentrifiers of the day demanding the removal of 'trees, signs, sign-posts, sign-irons, dyers' racks, dyers' scourers and barbers' poles, porches, pent houses, boards and encroaching spouts and gutters'. With the rapid growth of Victorian East London into a vast, self-contained, working class city the markets became even more important. There was Spitalfields Market and its spill overs, the animal fair at Club Row said to date back to the Huguenots' love of singing birds, the Wentworth St and Petticoat Lane clothing markets, cutlery in Cutler St, kosher poultry in Leyden St and the delicatessens of Brick Lane where the English were introduced to the delights of olives, Dutch herrings, smoked salmon and the 'continental pastries', just as we now come for samosas and beigels at all hours. The area became in the words of the historian of Spitalfields Market, John Shaw, 'the most profound centre of marketing in London'.

This was further enhanced by the opening of the graceful Italianate railway station at Broad St in 1865 (whose 1978 demolition was commenced by Mrs Thatcher Herself, radiant at the controls of the bulldozer). Then came the eighteen platforms and wondrous cast iron of

Liverpool St Station, built underground at the insistence of the City Corporation. Although designed to link with the docks it ended up bringing to Spitalfields shoppers from all over England. If markets shaped Brick Lane, immigrants shaped the markets: to get a pitch or a barrow was often the first step up into trade; East Enders have all heard of Fanny Marks who started with a barrow full of herrings and ended up a millionnairess. London is one of the oldest ports in maritime history and its docklands are an encyclopaedia of national origins.

Besides the Angles, Saxons, Jutes, Scots, Vikings, Danes and their children, there were the Huguenots who left us their rooftop workshops, the fine bow windows of Artillery St and the sundial above Eglise Neuve in Fournier St marked 'Umbra Sumus'. Then the Irish, starved from their native land to labour in London, who constructed the three remarkable East End Hawksmoor churches, Christ Church of Spitalfields, St George's in the East and St Anne's Limehouse as well as the intricate indentations of the docks. And then the refugees from the pogroms of 1882 which followed the anti-Semitic Tsarist *ukases* in Russia and Poland and were saved, in Whitechapel, from the worst Jewish martyrdom until the Holocaust itself.

Jewish Whitechapel gives a lingering flavour to the lane but only a throwback to a once powerful presence. Some traders and shopkeepers, especially in textiles, resist the NW passage. A few devout still worship at the old Synagogue, there are older Jewish inhabitants of the tenements becalmed and sometimes revanchist. The window display in Mr Weinberg's Brick Lane printing shop used to tell a typographical history of migration, adaption and assimilation in the notepaper printed for Minsky (Furs), Whitechapel, Manchester and Bradford; Elegante Fashions, Berwick St; the London Chess Conference (Chairman S. Reuben); the business cards of Labovitch the Glazier who becomes David Glassman; and the change of address cards sent out for the move from Hackney to Woodford. And the Jewish people left their places of worship, their shops, even their slaughterhouses to be used in turn by the Bengalis who have saved the street from the march of grey City concrete and kept alive its humanity, vitality and youth.

The 1986 House of Commons Select Committee, inquiring into the lives of the recently arrived in just the way their predecessors did a century ago, calculated that a fifth of all British Bengalis lived in 'heavy concentration' in Tower Hamlets. And, of course, docklands has a very historical

connection to Bengal through the East India Company who financed the building of the first enclosed docks in 1802. Although Brick Lane is no longer the sole centre of Asian culture in East London, it remains, most notably in the successful campaign against the National Front in the late Seventies, symbolic. At the height of the racist agitation on Sunday 11th June 1978 a 150-strong Fascist window-smashing squadron, bussed in from as far as Dagenham, Putney and South Ockenden, attempted a Kristallnacht on the Lane. An eyewitness wrote, 'They thought that the Asians were cowed and it would only be a few minutes before they could wave their union jacks down Brick Lane. THEY WERE WRONG. Asian youths know well how to defend themselves. Faced with this strength and courage the racists had no option but to run back to where they had come from'. We do not yet know the identity of the Bengali Gertler, the Sikh Bronowski or the Vietnamese Piratin but they will come.

So what is the Lane nowadays? Still a long, busy squeal of a street which commences in a modern council estate full of noisy kids on mountain bikes in Bethnal Green and ends – a mile later at the wrought iron gates of Altab Ali Park, re-named in 1990 after a 25 year-old clothing worker

who was stabbed to death by racists in 1978. Walking down it you pass a brewery, a mosque, an ultramodern health centre, numerous fine restaurants, food shops, travel agents, sari centres, leather clothes outlets, scrap dealers and several shipping agents. Charlie Forman rightly calls it 'an extraordinary paradox – an area in constant change and yet unchanging'. You will see the rooms where the first ever Jewish Socialist Manifesto was drawn up, the street where Arnold Wesker's Auntie Sara lived and agitated and the place where Jack the Ripper's last victim was found in 1888. In those days of Jack (and Jack London) the southern part of the lane consisted mainly of cheap lodging houses, thieves' kitchens and the 'doubles' used by prostitutes. These were demolished by the markets' westward expansion under Horner, who rebuilt and re-roofed it and converted it from a free market to the restricted wholesale exchange it is today. The mirror fronted Trumans brewery is still manufacturing its Budweiser and Fosters. And as ever in the small workshops and homes, the East End rag trade, through the same old system of sub-contracting and piece-work, manages to outprice the new world centres of clothing manufacture. And while the fur trade, so important for the East European settlers, is largely gone, Brick Lane now leads in leatherwear both in price and quality. So the heavy sweetness of hops and the whirr of sewing machines from the upper rooms still hang over the Lane's intimate mix of manufacture, dwelling and leisure. And the markets draw all London to their great public recycling of goods by gargoyle-faced traders; the quintessence of an East End Sunday.

It is the mother of all the London markets and there is no other thoroughfare so rich in metaphors of history and memories of struggle, bravery and desperation as Brick Lane. It is the original lorry that something fell off: anarchic, disinhibited, stoic and clamourous. And nowadays heart-rendingly poor. 'And it's a crap hole when it's raining' says the boy in search of his stolen mountain bike.

David Widgery was a doctor and writer. This is an abridged version of the text that appeared in the Luskačová catalogue 1991.

Markéta Luskačová Knave of Clubs pub, Club Row, 1976

From Masculinity to Androgyny: the Whitechapel Art Gallery

by Juliet Steyn

[A]s soon as art becomes culture, is the means, the instrument of a culture, it can no longer belong to itself; it falls prey to travesties and servitudes: the wheel of values and knowledge.[1]

The last 20 years have been a time of acute upheaval in the museum and gallery world. Nowhere perhaps has this been more evident than in Britain, where the exigencies of an entrepreneurial culture continue their head-banging test of social viability. The key objective of current economic liberalism is to reduce and privatise public services thereby presenting a grim challenge to public service ethics and values. Questions such as entry charges, de-acquisitioning and funding mechanisms have polarised the artistic community but no longer on traditional party political lines. Museums and galleries have had to acquiesce to Conservative and more recently Labour Government pressure to 'reform' and make themselves become more accountable to audiences, sponsors, trustees and public funding bodies such as the Arts Councils, while at the same time offering 'consumer guarantees'. Accountability is the shibboleth of our day. In this setting, visitors' figures are collated and evaluated. The success of an exhibition becomes a measurement for its own sake, rather than let's say vigilant criticality that had been the yardstick for modernism and in some cases even the institutions themselves.

During this period, that happens to coincide with my living in the East End of London, I have become a resolute Whitechapel Art Gallery (WAG) observer: viewing its exhibitions, researching its archives and writing about the gallery[1]. What strikes me now as we celebrate its centenary, is how successful it has been as an institution at adapting its original goals to the particular demands of the

different and changing moments that its work spans. In this context, let us consider the last two decades. In the 1980s the director was Nicholas Serota and in the 1990s Catherine Lampert. However, before discussing their respective approaches, we should first make a voyage to 1901, the year of the Gallery's opening at its permanent site on Whitechapel High Street.

WAG was inspired by the Christian Socialism of Canon Samuel Barnett who conceived of art as a means of encouraging working-class people to aspire to forms of life and attitudes that matched the values of middle-class England. In a speech that inaugurated WAG, Lord Rosebery made this plain:

If you offer this civilizing agency, these rooms, this gallery as a place where a rough fellow who has nothing else to do can spend his time, you offer him an option which he had not had before and which if he avails himself of it cannot fail to have the most favourable results[2].

His address is to the male subject since it is he especially who needs subjugating in the sense of moulding and 'civilizing' his idle coarseness. In pursuit of this mission, mixed programming characterised the Gallery's early work that included loans from national museums of historical art and 'high class' modern works; exhibits of art and industry; work by school children and students. All exhibitions had a high moral purpose and the show *Jewish Art and Antiquities* (1906) was exemplary in this respect. It had a double message: to assimilate the new immigrants into English bourgeois values and to show the bourgeoisie that Jews were civilised and indeed open to assimilation. In *People of the Abyss* (1903), Jack London reports on a trip to the gallery, although he is scathing about its founder's attempt at social engineering; London himself would

prefer political action[3]. The same period also promoted modernist art with shows such as *Twentieth Century Art (A Review of Modern Movements)* (1914). A review in *The Times* suggests that it had become a rival to the Royal Academy for the vitality of its exhibitions' programme:

This exhibition in Whitechapel seems like a challenge to the other in Piccadilly. The Piccadilly artists would say, no doubt, that Whitechapel is the proper place for it and Billingsgate the proper language. Art, like life, is at any rate more exciting in Whitechapel than in Piccadilly. Something is happening there and nothing at all in Burlington House[4].

We might argue that WAG from its inception straddled two worlds: one that catered for its local population and another for a wider constituency of art lovers.

WAG's current policy quotes this history: its stated aims always refer to this past. It now claims to break class and national barriers – at once faithful to Barnett's intention and in line with the current political agenda – it wishes to extend the audiences for art. And yet the Trustees' Reports, from the first decade, record by today's standards extraordinary viewing figures. To take *Jewish Art and Antiquities* as one example, it had over 150,000 visitors between 12 noon and 10pm for six weeks (7 November – 16 January, 1906)[5]. While the most popular recent show by far of work by Lucian Freud (1993) records figures of 106,493 for a similar length of time (10 October – 21 November)[6].

In 1993, WAG's objectives were to increase the number of visitors with the caveat that the quality of the visitors' experience should not be diminished. WAG's negotiations between a populist ideology that equates 'access' with democracy and an 'elitist' aesthetic are complicated.

Present government rhetoric works to preserve this spurious binary.

Without doubt, the most publicly celebrated director at present is Nicholas Serota, who first established his reputation there as curator of modernist and current art practice. His directorship escaped many of the more overt financial and ideological imperatives now confronting arts organisations. This is not to say that he did not have to face political pressure, for instance from the Borough of Hackney as one of the local authority funders, to produce a 'popular' programme. In this phase, an education service was developed that effectively catered for local people and left enough space for Serota to develop his project. In 1985, when WAG triumphantly reopened after extensive refurbishment, Serota claimed that it 'can now take its place alongside the best of European modern art museums and at the same time discharge its responsibility to its local community'[7]. Among its exceptional modernist shows were exhibitions of the late works of Fernand Léger and the Beckmann triptychs.

The 1980s were a financially buoyant time of Arts Council increases to its grant. After the Royal Academy's *New Spirit of Painting*, Serota (who acted as co-curator) arranged shows of work at the Whitechapel by Baselitz, Twombly, Hodgkin and Kiefer, and cemented the concordat between public institutions, European and American *kunsthalles* and the market place: a relationship that has by now become common as we witness in the relationship between Tate, Royal Academy, Hayward and a powerful collector like Saatchi. The story from the 1990s is completely different. WAG faces growing financial challenges as basic revenue funding in itself has not been sufficient to cover core costs and contemporary art has never attracted large corporate sponsorship in the East End. What can we now note concerning

Lucian Freud installation view, 1993

WAG's standing in the current art world? I would say that the gallery holds a paradoxical position. But it has negotiated the difficult and contradictory demands in ingenious ways. The contribution of WAG to the cultural life of London under the directorship of Catherine Lampert has not, I think, been adequately recognized. The programme has been broad – from one person shows including Renato Guttuso (1996) Rosemarie Trockel (1998) and Boetti (1999) to thematic exhibitions such as *Inside the Invisible* (1996), *Lines from Brazil* (1997) and *Live In Your Head* (2000). This arbitrary selection is also an accurate representation of the conceptual scope of WAG in the last decade.

Among the strategic responses to Government policy has been the extension of the educational provision. Examination of this educational programme reveals that it taps into a particular idea of culture that stems from a stalwart English tradition, indeed precisely Barnett's notion that art is 'good for us'. Unlike other major British institutions, such as Tate, staff from the education department work *with* the curatorial team. This, a recent structural change, clearly shows a commitment to an integrated programme in which education is given equal standing to that often thought of nowadays as the more glamorous side of gallery work, curation. However can we really continue to

believe that the current market economy governing arts funding, recently peppered with New Labour's populism, shares anything with WAG's founder, Canon Barnett's high-minded philanthropic zeal? Are these not completely incompatible ideologies?

Government policy towards the arts highlights a turn in our understanding of traditional democracy. In the last century, two notions of democracy prevailed. In the liberal tradition, it signified the open elections of representatives; while in the Socialist tradition, majority interests were deemed paramount under the banner of popular power. The regulating discourse has changed. Electioneering is what we now have in a US-style Presidential promotion – 'party political' hardly means what it says. As for 'majority interests' or 'popular power', these have seceded to underclass consumerism. Nevertheless, in the case of WAG there is still an insistent reference to its history. What can this mean against all the economic, social and other mutations we have endured? Can 'history' withstand the present trends? What can our expectations, understanding and indeed our experience of art itself be after all? WAG's Three Year Plan (1998–1999) quotes from Demos declaring[8]:

Londoners are strongly attached to inner-directed values. They seek

complexity, hold relatively androgynous values and are open to other cultures and ways of life … If people are not to become increasingly introverted, we must encourage expression of these values which turn their gaze outwards (1997).

Does the shift of its address from the male subject to the androgynous figure signify anything? Accountancy renders individuals invisible. We now witness a merging of these different identities with mutually exclusive ideas as virtual democracy. Art institutions have had perforce to translate this vague imperative into an obligation to create exhibitions that attract large audiences. Access in and for itself offers no promise of enlightened experience. However unfashionable Barnett's ideas now seem they at least offered the gallery-goer the prospect of contemplative experience – something that the spectacular promotion of the art of the 'cultural industries' now forgoes.

The passage from Maurice Blanchot that heads this article demands that we think about the incommensurability of art and of culture and alludes to the 'cultural industries'. The dialectic between art and culture takes on new meanings today. We are bystanders to a change in the ontology of the art gallery from that of history to the hyped economics of entertainment. Chris Smith's clarion call that art must 'deliver access, excellence, innovation and educa-

tional opportunity in accordance with the Government's wider social, educational and economic objectives' is mere persiflage, particularly if taken as it must be in the context of WAG which is just about able to manage its aesthetic accounts (but we must ask for how long?), while it is forced to maintain a vulnerable financial state.

For Rosa and special thanks to Richard Appignanesi

Juliet Steyn is Course Leader of Arts Criticism in the Department of Arts Policy and Management at City University, London and is originating editor and contributor to *Other than Identity: the subject, politics and art*, Manchester University Press, Manchester 1997.

Notes

1 See my book *The Jew: assumptions of identity*, Cassell, London & New York 1999, pp.79–115.

2 *East End Observer*, 16 March 1901 (Whitechapel Art Gallery Archive).

3 Jack London, *People of the Abyss*, Journeyman Press, London 1977, p.122.

4 Anon. *The Times*, 8 May 1914 (Whitechapel Art Gallery Archive).

5 *Trustees' Report*, Whitechapel Art Gallery, 1906, p.9 (Whitechapel Art Gallery Archive).

6 List of Attendance Figures and Chronological List of Exhibitions, (Whitechapel Art Gallery Archive).

7 Nicholas Serota, *Annual Report*, Whitechapel Art Gallery, 1986, p.1.

8 Whitechapel Art Gallery *Three Year Plan*, 1998–1999, p.7.

Reshaping The Whitechapel: Installations from *Tomorrow* to Today

by Marco Livingstone

During the 1990s installations became such a dominant form for artists working in a wide variety of mediums – sculpture, painting, film-making, video and performance – that most gallery visitors born after 1970 would find it difficult to remember a time when exhibitions consisted of collections of discrete objects, rather than displays in which all the elements were in dialogue with each other as constituent parts of a single work into which the spectator could enter.

In 1956, just over halfway into its hundred-year history, the Whitechapel Art Gallery presented *This is Tomorrow*, an exhibition that stands as a landmark in the history of installation art and which heralded the gallery's future role in establishing the taste for complete environments. *This is Tomorrow* was the most ambitious of a series of exhibitions organised by members of the Independent Group, a select band of artists, architects and critics based at the Institute of Contemporary Arts. Members of the group had already mounted such shows as *A Parallel between Life and Art* (ICA, 1953), a cooperative effort by the architects Alison and Peter Smithson with Nigel Henderson and Eduardo Paolozzi, and *Man, Machine and Motion* (Hatton Gallery, Newcastle upon Tyne, 1955), largely the work of Richard Hamilton, as ways of guiding visitors through particular themes and immersing them in a complete experience. For *This is Tomorrow*, twelve teams (consisting

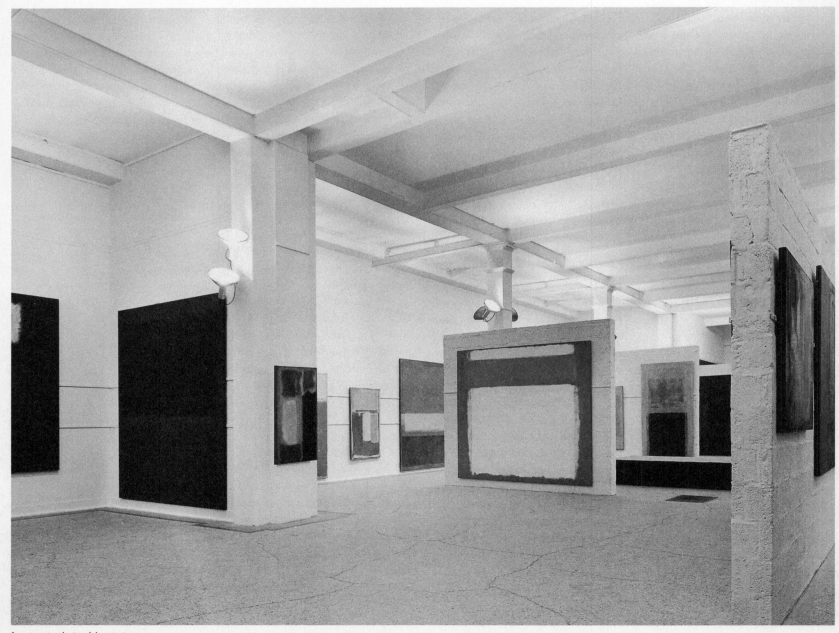

fig 1 **Mark Rothko** 1961

ideally of an artist, a sculptor and an architect) went one step further, each creating a total, coherent space prompted by a particular vision of the future. Paolozzi, again working with the Smithsons and Henderson, created a kind of primitive hut that, housing detritus from modern civilisation, suggested the bare necessities for human shelter and a new start after a nuclear holocaust. Most memorably, Richard Hamilton, working with John McHale and John Voelcker, created a dazzling proto-Pop environment redolent of the fun-fair which assaulted the visitor with a barrage of sensations; the elements ranged from eye-popping optical patterns and photographic enlargements of cinematic imagery on a billboard scale, to the top twenty hits playing on a juke box. Though the term 'installation art' was not to gain currency until three decades later, it was here that the new art form had one of its most auspicious and influential beginnings.

Under the directorship of Bryan Robertson from 1952 to 1969, the Whitechapel presented some of the most important exhibitions of contemporary art to be seen in England after the War. Among these were exhibitions of paintings and sculptures selected and installed with such coherence and sensitivity that the display itself was elevated to the status of an installation in its own right, the total effect seeming greater than the sum of its parts. In her MA dissertation on Robertson's American shows, Janeen Haythornthwaite has discussed the attention that was given to the installation of exhibitions; for the Jackson Pollock retrospective in 1958, for example, the architect Trevor Dannatt was hired and a number of changes were made to the gallery. These included the construction of freestanding breeze-block walls that enabled paintings to be hung singly and the use of muslin to cover and soften the texture of some walls. For the 1961 Mark Rothko retrospective, there was close consultation with the artist, who supplied detailed advice on the wall colour, lighting, hanging height and groupings of works. The paintings were hung very low on both the permanent load-bearing walls and on temporary freestanding screens so that the entire space was saturated in, and activated by, the surfaces of

floating colour (fig 1). Rothko wrote to Robertson thanking him 'for the sympathy and co-operation with all the vagaries and uncertainties of hanging the pictures', asking also for detailed measurements about the hanging heights so that he could pass the information on to other museums planning to show his work.

Important though these shows were in shaping visitors' expectations of a high standard of exhibition display, it was only in the early 1970s that the idea of the installation as the work of an artist, rather than a brilliant curator, began to take hold. The American Minimalist sculptors were among the first to place as much emphasis on the relationships between one object and another as on the presence of each individual work, and consequently to pay close attention to their placement in articulating the space in which they are shown. Donald Judd's Whitechapel exhibition in 1970, organised by the Stedelijk Van Abbemuseum in Eindhoven, was a revelation in this respect, as was Carl Andre's retrospective in 1978. Director Nicholas Serota's decision to delay publication of the Andre catalogue until after the show had closed, so that the reproductions could document the installation, raised eyebrows at the time, but this strategy proved a subtle and powerful way of reinforcing visitors' memories of Andre's use of simple, repeated units to call attention to the architecture of the rooms themselves.

Richard Long's first show in a public space, held at the Whitechapel for a period of barely two weeks in 1971, was an audacious demonstration of the Minimalist and post-Minimalist concern with site-specific works. Having previously worked in remote natural locations, producing sculptures that could be viewed by a wider public only in the form of photographic documentation, Long here created two large floor sculptures in elemental shapes – a spiral and a huge X, suggestive of a marker claiming the territory as his – as a way of translating the terrain of nature into the urban setting of the white-walled contemporary art gallery (fig 2). Presented in the form of ephemeral installations that would be discarded at the close of the show, rather than as permanent sculptural objects that could be packed up and re-housed

elsewhere, they were physical manifestations of the transience at the heart of nature itself.

Such concerns with the fragility and brevity of life resurfaced as prominent aspects of some of the most affecting installations presented in later years at the Whitechapel, such as the carpet of pollen created by

Wolfgang Laib in 1982 (fig 3). Looking at a surface which seemed so vulnerable it could be blown away by one's own breath or a gasp of appreciation, and knowing that it would exist in that form only for the duration of the exhibition, accentuated the poignancy of the experience. Like many of the most powerful works of installation art, its effect was depen-

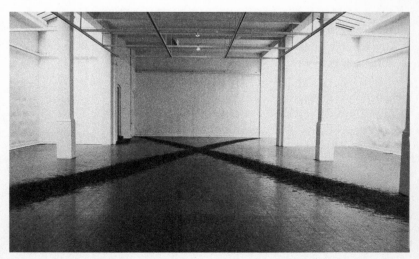

fig 2 Richard Long 1971

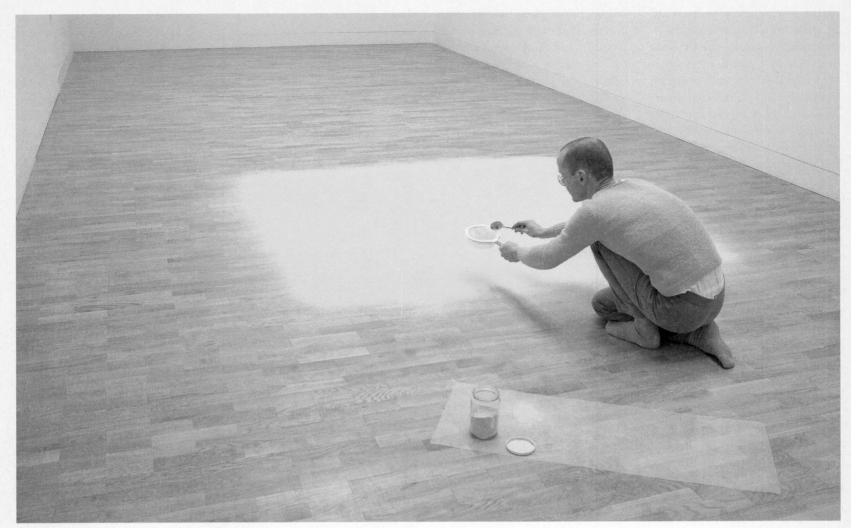

fig 3 **Wolfgang Laib** pollen installation, 1985

dent not just on the way it looked or was arranged but also on the knowledge that it would have such a brief existence as a physical entity. In justifying installation art as a form with its own properties and possibilities of expression, distinct from conventional sculpture, works such as this have heightened one's excitement about exhibitions as unique, unrepeatable, experiences, set apart from the displays of permanent collections offered by museums. In so doing, they have also helped confirm the need for galleries which are devoted exclusively to temporary exhibitions, such as the Whitechapel, as a complement to museums charged with the collecting and preservation of art for future generations.

During Serota's years as Director (1976–88), the Whitechapel's interior was comprehensively refurbished (1984–5) and repeatedly reinvented in a succession of stylishly installed shows. These featured, notably, the works of Minimalist painters (such as Robert Ryman in 1977, Bob Law in 1978 and Brice Marden in 1981), a variety of sculptors and object-makers (including Mario Merz in

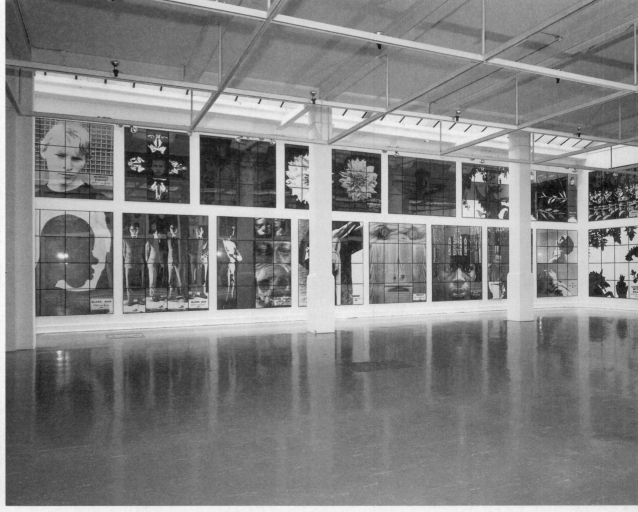

fig 4 **Gilbert & George** 1981. Courtesy of the artists

1980, Antony Gormley in 1981 and Bruce Nauman in 1987) and a new generation of figurative artists (among them Anselm Kiefer in 1982, Francesco Clemente, with his *Fourteen Stations* cycle of paintings in the Upper Gallery in January – February 1983, and Georg Baselitz later that year). Joel Shapiro's exhibition in 1980, his first major show in Europe, dramatically juxtaposed his tiny floor sculptures, suggestive of houses and items of furniture, with much larger drawings; by bringing together the two poles of his work in this way, the gallery was turned into an installation that served to instil in viewers an overwhelming physical sensation of their own presence and scale.

Tony Cragg's show in the Upper Gallery in 1981, which did much to establish his reputation as one of the most inventive and original sculptors of his generation, consisted of wall-mounted arrangements of found objects in plastic or other mundane materials, forming immediately legible configurations such as the Union Jack and a map laid sideways of

Britain seen from the North. The emblematic quality of these sculptures, their intense visual presence even when viewed from a great distance, and the thrill of apparently random accumulations coalescing into such concentrated images, has never been more tautly expressed than in this memorable installation.

Of all the exhibitions presented at the Whitechapel during the 1980s, none was more visually thrilling than the Gilbert & George retrospective in 1981, which transformed the two floors of the building into a cathedral-like space ablaze with colour and teeming with imagery of confrontational impact and heraldic directness. This was the last leg of a European tour, initiated by the Stedelijk Van Abbemuseum in Eindhoven, of the photo-pieces they had made between 1971 and 1980. Having planned each permutation of this exhibition with great precision, by making cardboard maquettes of the galleries onto which they glued scaled-down sketches of their gridded photo-pieces, Gilbert & George knew just how to go about creating a stunning visual spectacle.

Every inch of available wall was used to maximum effect, the pictures hung very closely together, in two tiers along the side walls of the Lower Gallery, so that the spectator's entire field of vision was dominated by their way of picturing the world (fig 4). If Gilbert & George themselves learned much from the experience, adapting these methods to their later shows in New York, Moscow, Beijing, Paris and numerous other cities around the world, they also set a daunting standard for other artists offered the opportunity to show at the Whitechapel.

A number of artists presented in later years at the Whitechapel, first by Serota and since 1988 by the new director, Catherine Lampert, rose to the challenge presented by that exhilarating Gilbert & George exhibition. Prominent among them are Michael Craig-Martin, especially his inclusion of drawings made directly on to the wall, in his 1989 retrospective; Alfredo Jaar and Jeff Wall, with their exhibitions of back-lit photographic transparencies in 1992 and 1996 respectively; Christian

Boltanski, in the floor-to-ceiling arrangement of haunting photographic portraits for his *Reconstitution* exhibition in 1990; and Bill Viola, with his network of video installations in 1993, each creating its own dynamics of space and vision.

Perhaps closest in spirit and impact to Gilbert & George's use of the space was the Lower Gallery for Gary Hume's 1999 retrospective. The long side walls were again fully exploited in the manner of the aisles flanking the nave of a church. This time these walls housed a series of abstracted angels painted in bold, luscious colours with gloss paint on aluminium panels. However bold each picture was in its own right, the effect of seeing so many large and bright-hued paintings close together was intoxicating. Both critics and ordinary visitors alike were won over by the sight of the gallery as a 'white chapel' of unaccustomed – even heavenly – beauty (fig 5).

The highlight of Tim Head's exhibition in 1992, not so much a retrospective as a show of recent paintings and photographs, was the ground-floor installation of thirteen enormous ink-on-canvas pictures collectively titled *Thirteen Most Wanted* (fig 6). Each of these scanned ink-jet paintings bore naggingly familiar but unidentified shapes. By hanging them on walls painted sky blue, over a floor carpeted in a lawn of green plastic, Head transported the viewer from the overcast and sombre London winter into an unnatural summer and metamorphosed the interior architectural space into an open but self-evidently synthetic landscape. Here, as in so many of the successful installations that have been presented at the Whitechapel since the ground-breaking *This is Tomorrow*, the deft presentation of the building's well-proportioned and resilient spaces convincingly demonstrates the seemingly inexhaustible possibilities of installation art when applied with appropriate sensitivity, thought and vision.

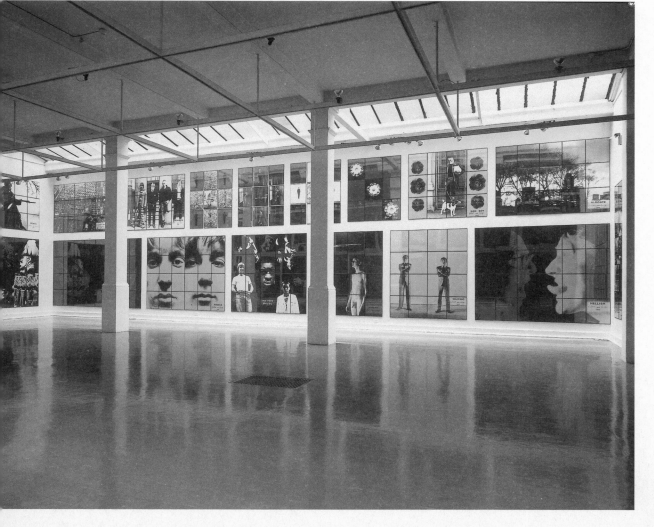

Marco Livingstone is an art historian and independent curator. Author of *Pop Art: A Continuing History*, which was reissued in paperback last year by Thames & Hudson.

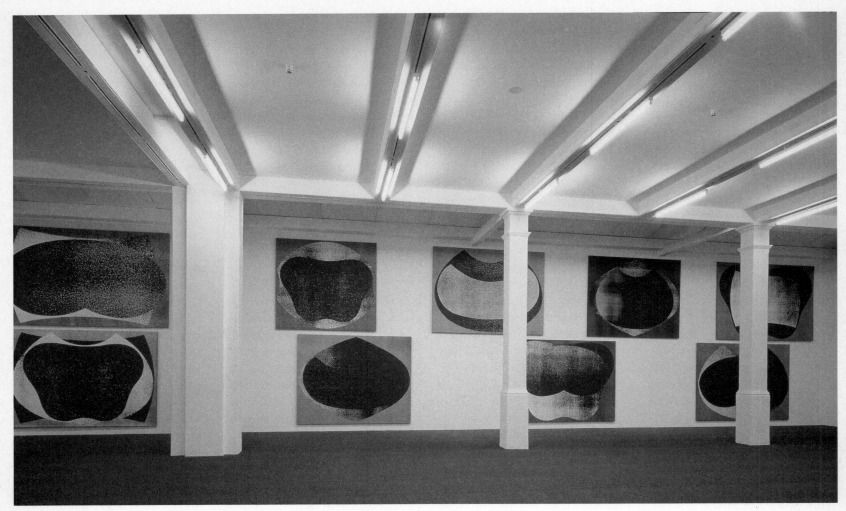

fig 6 **Tim Head** *13 Most Wanted,* 1994. Installation view. Photo: Richard Davies

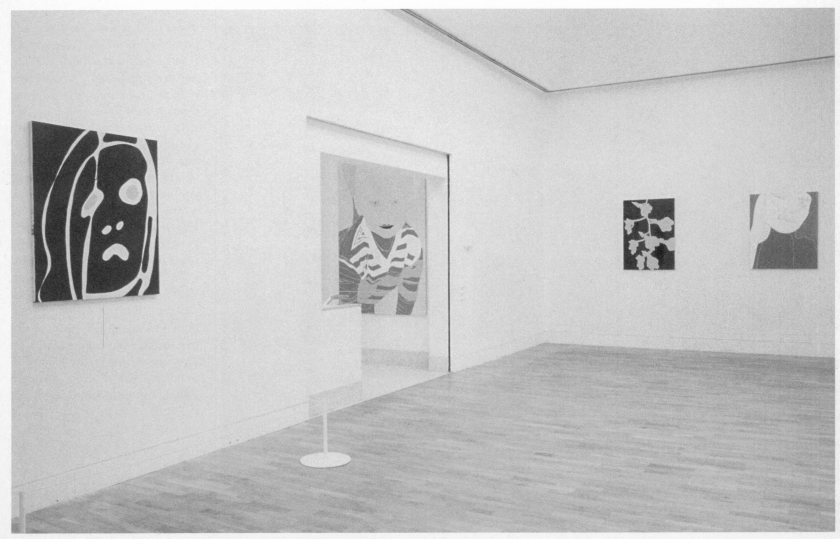

fig 5 **Gary Hume** 1999. Courtesy Jay Jopling/White Cube, London Photo: Stephen White

The Whitechapel Open

by Felicity Lunn

In response to one of the more recent Whitechapel Open exhibitions, a critic asked whether it should "as one of Britain's biggest showcases for contemporary art, be a car boot fair or a blue riband event?... Should it be as inclusive or as ruthless as possible?" These polarities have dogged the Open since it started to look more 'professional' in the late 1980s and have made it one of the most divisive exhibitions in the Whitechapel's calendar: anticipated months ahead in the studios of over a thousand artists and popular with visitors who want an overview of the current art scene, it is also dismissed by the 'art-world' for being a little homespun.

Unlike the one-person shows and the thematic coherence of curated exhibitions that have become the backbone of gallery programmes up and down the country, the Open goes to the heart of the politics of art. It is uneven and inconclusive because it serves a broader variety of communities than the majority of the Whitechapel's exhibitions. From the 100 or so exhibitors to other London based artists who have the chance to see what their peers are up to, from local visitors to the dealers and curators who still scout the exhibition for new talent, the Open essentialises the Gallery's desire to be accessible to a diverse audience; it also demonstrates in a concrete and irreplaceable form that the Whitechapel is genuinely acknowledging and supporting the large community of artists who live on its doorstep.

The history of the Open charts some of this century's widespread shifts in both artistic and curatorial practice. In its present form the Open was preceded by a series of exhibitions in the early part of the century that provided artists, professional and amateur, with the opportunity to show their work. Meeting one of the original objectives of the Whitechapel to show 'Free exhibitions of the work of schoolchildren and students working in the area, and local residents', the Society of Essex Artists was given space to show in 1910, attracting 19,000 visitors. A joint exhibition with the Toynbee Art Club was arranged the following year, with the latter organising an Exhibition of Pictures almost every year between 1912 and 1928. The change from an exhibition of art club members to one open to all took place at the end of the 1920s, when exhibitions were held by the East London Art Club. In 1932 the Whitechapel itself took the initiative, organising the first East End Academy for "all Artists living or working East of the famous Aldgate Pump". There was little selection and the exhibition was almost totally amateur until well into the fifties but its initial success ensured that it became an annual event in this period.

As well as marking the beginning of an open exhibition, the 1930s was the heyday of the Whitechapel's role, unique at the time, as a platform for a broad cross-section of artist groups. Exhibiting regularly throughout the decade, the Students Sketch Clubs catered for London art school students; the Contemporary Art Society showed work recently acquired for donation to UK collections; while the Civil Service Art Clubs, the Society of Essex Artists and the Toynbee Art Club ensured that the Whitechapel included amateur work in its programme until 1939. This year also saw the first exhibition of the Artists International Association, mounted as a "demonstration of the Unity of Artists for Peace, Democracy and Cultural Progress".

The Whitechapel's East End Academy was abandoned in 1963, following increasing comment in the press about the influence on amateur painters of recent exhibitions at the Gallery such as Mondrian (1955) and Jackson Pollock (1958) and the need to raise standards. When the exhibition re-emerged in 1969–70, it was as the East London Open and was for the first time selected by a jury but, its 'provincial' identity lagging behind its fast-changing environs, it failed to attract many of the full-time artists moving into warehouse studios in the area. In 1977 the exhibition was renamed the Whitechapel Open,

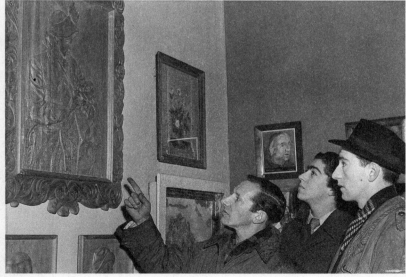

East End Academy December 1949 – February 1950

Exhibition of paintings and sculpture by artists who lived or worked in the East End. The East End Academy shows were held annually most years between 1932 and 1962. The next exhibition of local artists was the East London Exhibition in 1967, and the series would re-start in 1977 as the Whitechapel Open Exhibition.

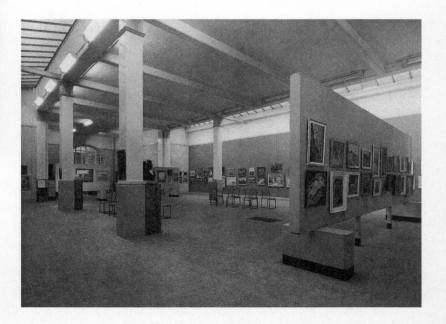

the catchment area extended, a more out-going education programme organised and a campaign mounted to persuade professional artists to participate, whilst encouraging amateurs to continue to do so.

In the context of the Open, the 1980s and 1990s present two highly distinct decades. The Opens that took place each year during the 1980s helped to consolidate the Whitechapel's role as the heart of the East End artistic community, but they also counterbalanced the Gallery's ambitions to be an actor on the international stage, demonstrating that group exhibitions of talented local artists had a place in the programme alongside presentations of the work of Anselm Kiefer or Julian Schnabel. Since the 1970s the East End has been the base of many of the UK's most significant artists and the Open exhibitions in the 1980s included figures such as Alison Wilding, Richard Wentworth and Antony Gormley. They were all gaining international reputations as fine and innovative sculptors, yet they also wanted to be part of the Open and the tradition of a broad base of artists exhibiting together in one of the most beautiful galleries in the world. During this decade every Open was selected by Nicholas Serota and Jenni Lomax, Director and Community Education Organiser at

the time, with the inevitable result that many names regularly reappeared. However, it also became the forum for the well-known to rub shoulders with the up-and-coming. In the 1980s the Open provided one of the first exhibitions for artists such as Cathy de Monchaux, Rachel Whiteread and Mark Francis, followed in the 1990s by Mariele Neudecker, Tom Hunter, Claude Heath and Paul Morrison.

Just as importantly for the tradition of the Open, however, is the participation of those who identify strongly with the area and are respected figures in the local artistic community. Bert Irvin is the obvious example of a 'stalwart', but other talented artists who have lived in the area for some years, such as Louise Cattrell, Jordan Baseman and Michael Stubbs continue to include the Open in their schedules, valuing the opportunity to have their recent work assessed by different groups of curators and artists. The policy of inviting a new panel each year to choose from the submission was introduced by Catherine Lampert soon after she arrived as Director in 1988. By this time, the Open was competing for attention with other regular jury-selected exhibitions, such as New Contemporaries, the British Art Show and East and could no longer rely on the same

tried and tested format. Just as importantly, the expectations of younger artists were beginning to increase as the Goldsmiths generation began to assert itself. As recent graduates became more confident about the exhibiting opportunities open to them, they wanted to be sure that participation in the Open would add to their CVs; otherwise, they simply did it for themselves by turning warehouses and front rooms into gallery spaces.

In 1992, in addition to shifting the Open to being a biennial exhibition, Catherine Lampert invited the artists John Murphy and John Gibbons to join herself and three other members of staff, Paul Bonaventura, Lucy Dawe Lane and myself to make the choice of painting, sculpture, installation and works on paper. Selection from slides was supplemented in many cases by visits to applicants' studios, a practice which has continued since then and is an invaluable way for Whitechapel staff involved in the process to keep in touch with at least some of the artists in the area. In an effort to attract the participation of artists who had either stopped submitting to the Open as they became better known, or had never felt the Open to be significant to them, the six selectors in 1992 added 90 'invited' artists to the list of those selected from open submission. There

had been a precedent of an 'invited' Open in 1979, when Nicholas Serota and Mark Francis chose 14 local artists to make an exhibition which would allow more work to be shown. However, this didn't prevent the bitter sense of hierarchy among the selected artists in 1992, caused by their perception of division between the two groups in spite of the Whitechapel's efforts to play down the different methods of selection. Meanwhile, the general response among press and art world was that the resulting exhibition looked more 'professional', with a more generous hang, contributed to by the two-part installation that separated two-dimensional and three-dimensional work.

The expectation that the invited artists would wish to repeat the Open experience in subsequent years was only partially met and any hopes that the Whitechapel had entertained of wooing the 'yBa' generation remained unfulfilled. Damningly described by one critic as "not 'up and coming', but a highly professional, oft-exhibited 'b stream'", the exhibitors in the Opens of the 1990s were not artists likely to be nominated for the Turner Prize. The Whitechapel Open has never been about making art stars, though, and in many ways has acted as a crucial counterbalance to the intense focus in a number of exhibitions

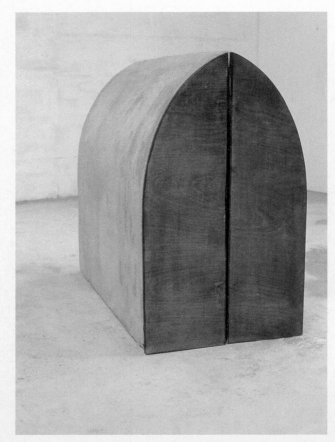

Rachel Whiteread *Ark*, 1989
concrete and wood, 73 x 85 x 41 cm
Whitechapel Open 1989

Nicky Hoberman at Cubitt Studios, Whitechapel Open 1998.
Photo: Mark Häkansson

during the decade on just a tiny proportion of London's artists. Where the Whitechapel would have benefited from emulating the Turner Prize operation was Tate's link with Channel Four. The Open is ideal material for fly-on-the-wall documentary, interviews with artists and insider views on studio life and would have been given a much-needed sharper profile through collaboration with television.

The public's curiosity concerning the lives that artists lead and the ideas and processes that go into their work ensured that the Open studios event that was added to the Open exhibition in 1988 was a huge success. Aware that around only ten percent of artists who submitted to the Open had their work accepted, but that most artists want to have their work exposed, the Whitechapel has acted since then as an umbrella organisation for the studio groups in the area, co-ordinating and publicising the open weekends that many complexes had been arranging on an individual basis for years. Though recognising that the absence of selection resulted in standards that 'vary from excellent to dire' the press began to seize on this more comprehensive event as proof of the East End's status as the 'new Bohemia'. Meanwhile the Open studios came to highlight the every-day exchanges between artists and the local communities to which they belong, gathering regular supporters and purchasers who appreciated access to a grassroots view of contemporary art in the making as an antidote to seeing art in anonymous gallery spaces. As the aesthetic has taken precedence over the social and political concerns that were once at the core of the Whitechapel's reputation, the Open studios have allowed artists and audiences to retain a sense of inclusion in the process of making art.

The growing audience for the Open and Open Studios and the increasing number of submissions inspired the other major shift in the history of the event: the expansion of the exhibition beyond the Whitechapel. While the Gallery was closed for modernisation in 1984, the Open had found a temporary home with local organisations; from 1992 until the most recent Open in 1998 the Whitechapel sought out different kinds of collaborations, depending on both the intended character of the exhibition and East End demographics. In 1992, for example, Spitalfields Market had not yet been revamped and was ideal for large-scale installation, while the addition of the space at Atlantis in 1994 allowed the three groups of selectors, each responsible for one medium, to exercise more individual choice. The variety of work shown expanded even further in 1996 when six other East London arts organisations – The Commercial Gallery, Delfina, The Showroom, Rear Window, London Electronic Arts and The Spitz – each selected work for their venues, the breadth of specialisms allowing more film and video and live work to be presented than at the Whitechapel alone. Similarly, the split-site exhibition with The Tannery in 1998 gave the selectors, Julian Opie, Lucia Noguiera and myself, the purity and elegance of the Whitechapel on the one hand and the spit-and-sawdust character of The Tannery on the other and the chance to subvert expectations about the kind of work that would be shown in each.

Not only is the Open the most difficult kind of exhibition to stage: it is equally hard to make sense of. In an attempt to read the Open, reviewers resort to spotting new talent on the one hand and, on the other, to scanning the show for indications of current trends. Responses to the exhibition always compare the current offering to previous years, and divide those who hanker for the 'strange charm (that) used to lie in the odd juxtapositions created by hanging the work of local amateurs next to those with an art school training' from others who would like to see 'far fewer than the current hundred or so exhibitors...tougher competition and...a far more prestigious event'. A more rigorously 'curated' Open would streamline the look of the exhibition with shows elsewhere but would this constitute an improvement? For a significant number of 'successful' artists who participate, as well as others who choose not to submit work to it, the Open may be irrelevant to their CVs, but it continues to be for them an intrinsic element of the Whitechapel's values and character and contributes still to their affection for the Gallery.

The Open always risks being interpreted as vaguely outdated, in danger of paying lip service to a 1970s notion of community. But isn't the art world's verdict less important than the inclusiveness that is still at the core of the exhibition, the basic tenet that anyone living or working in the huge East London catchment area can 'have a go' whether they are conforming to current notions of good artistic practice or not? The Open has never managed to please everyone. It is and should remain the most awkward of exhibitions.

Felicity Lunn, Curator at the Whitechapel 1990–98, is currently an independent curator and lecturer.

Cornelia Parker at work on *Aura*, 1992
dried fruit and wire, 100 x 100 cm. Installed at Spitalfields Market for the Whitechapel Open in 1992.

Claude Heath in his studio, Whitechapel Open 1998

Recent Art History at the Whitechapel Art Gallery

by Paul Bonaventura

The Whitechapel Art Gallery has consistently set itself the task of organising shows of local, national and international importance. Arguably, it has been at its most successful with its displays by living artists from Britain, continental Europe, and North and South America. However, the regular programme of posthumous exhibitions of work by major modern and contemporary figures,

initiated by Bryan Robertson in the 1950s and 1960s and maintained up to the present by successive directors, is also of real significance.

Importantly, the majority of these projects have been prompted by the enthusiasms of artists who, finding themselves aroused by formal or conceptual advances elsewhere, 'rediscover' seemingly neglected figures or periods of surprising individual activity. Ian McKeever's interest in the paintings of Emil Nolde, particu-

larly his 'unpainted pictures', and John Golding's fascination with the work of Arshile Gorky were certainly instrumental in the realisation of those shows in 1990 and 1994, and the impact of David Smith on a panoply of today's best-known sculptors, ranging from Anthony Caro and John Gibbons to Richard Deacon and Bill Woodrow, created a ground swell of support for that project in 1986.

Exhibitions usually offer less than complete views of their chosen sub-

ject, either because of the partial opinions of their selectors or because of pressing practical and financial considerations. Historical shows with loans from diverse international collections, worthy of ambitious publications, are particularly expensive to organise. However, with the advent of widespread commercial sponsorship, the public is now subject to a procession of blockbuster-type manifestations, few of which add much to our comprehension of their preferred subject. For its part, the Whitechapel

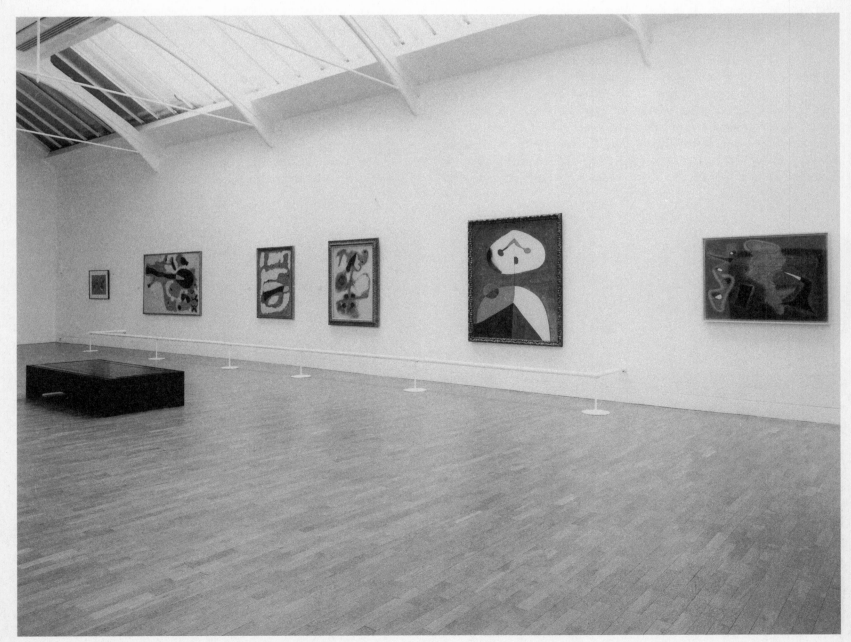

Joan Miró: Paintings and Drawings 1929–1941 1989

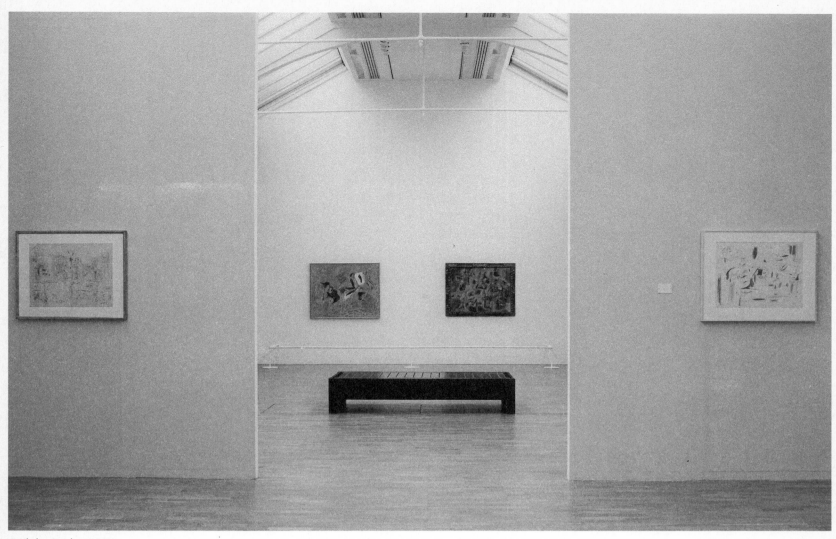

Arshile Gorky 1990

has studiously avoided such oppor-tunism, as its exhibitions never take place unless the artistic need is per-ceived to be timely and meaningful.

Furthermore, the Whitechapel has made a virtue of focusing on figures who have been overlooked, sometimes because their work has been deemed to be of insufficient consequence, or on certain aspects of a well-respected artist's work which have previously been unexposed or received with mis-givings. Up to the point at which the Gallery closed for development in 1983, the list of such shows reads like a roll-call of individuals whose elevated position in the canon of recent art history is now assured, and includes Piet Mondrian in 1955, Nicolas de Staël in 1956, Jackson Pollock in 1958, Kasimir Malevich in 1959, Robert Smithson in 1977, David Bomberg and Eva Hesse in 1979, Max Beckmann in 1980, Philip Guston in 1982, and Tina Modotti and Frida Kahlo in 1982.

Following the re-opening of the Gallery in 1985, the series of posthu-mous projects resumed impressively

under Nicholas Serota and Catherine Lampert with exhibitions of work by David Smith in 1986, Jacob Epstein and Fernand Léger in 1987, Lucio Fontana in 1988, Joan Miró in 1989, Arshile Gorky, Julio González and Emil Nolde in 1990, Albert Pink-ham Ryder and Jack B Yeats in 1991, Juan Gris in 1992, Medardo Rosso, Franz Kline and Nolde again in 1994, Renato Guttuso and David Siqueiros in 1996, Aubrey Williams in 1998, and Henri Michaux and Alighiero e Boetti in 1999.

One of the new-look Whitechapel's best-loved exhibitions was *Joan Miró: Paintings & Drawings 1929–41* which took place in London between 3 February and 23 April 1989 and attracted more than 42,000 visitors. The show was initiated by and organised in collaboration with the Fundació Joan Miró in Barcelona, and relied heavily on loans from that organisation, many of which had never been seen before outside Spain.

As Catherine Lampert mentioned in her introduction to the catalogue, Miró experienced a crisis in his work

in 1929, when he was 36, which has been identified as anti-painting because of his oft-quoted remark that he wanted to 'murder' painting. 'Naturally,' she went on, 'there was much more to this withdrawal and the story involves the overlap of a Catalan instinct for rough materials and collage, (Miró's) rôle as a Surre-alist, and the growing threat to free-dom sweeping through Spain in the 1930s.'

The artist's work from that time lacks the coherence of the works of the 1920s and his more mature output of the 1940s, and is characterised by experimentation and transformation, making it impossible to consider in conventional stylistic terms. William Jeffett, in his contribution to the exhibition publication, suggested that Miró rejected 'not only all conven-tional means of representation, but his own previous attempts to arrive at a new pictorial language. (Con-currently), he increasingly sought to achieve a new conception of poetry which affirmatively projected the artist's imagination into the world of experience.' Miró's experimental

approach to form, structure and content looked surprisingly fresh, fifty years after the event, and the White-chapel helped devise the project in the expectation that it might provide an appropriate model for the kinds of radical investigations which were then taking place in studios and art schools across Britain.

Miró's impact was also apparent in his own era, nowhere more so than in the work of Arshile Gorky, one of the twentieth-century's supreme painters. Whilst Paolo Uccello and the Armenian manuscript painters Toros Roslin and Sarkis Pidzak were his early mentors, it was to Cézanne that Gorky first turned for instruction, learning as much as he could from his work about the art of painting. 'I was with Cézanne,' he once wrote, implying that his own creativity had somehow meshed with that of the Frenchman. In the 1930s, the artist placed himself 'under' the tutelage of other innovators, firstly Picasso, then Miró, and finally Kandinsky, as he moved towards the elaboration of his own idiom. That idiom reached its finest expression

Emil Nolde
Paradise Lost, 1921,
oil on canvas,
106.5 x 157 cm.
Nolde-Stiftung Seebüll

in the late 1940s with paintings like *Charred Beloved I* and *Diary of a Seducer*, canvases which rank as some of the most consequential and transcendent images in the whole of world art.

Willem de Kooning described Gorky as a Geiger counter, and it is true that by the close of the 1930s he had detected and digested the lessons of many of his most important contemporaries. Gorky's work is a perennial favourite of other artists, and the Whitechapel elected to organise the exhibition *Arshile Gorky 1904–1948* in order to provide a comprehensive overview of the artist's output for younger generations of practitioners. The show was selected by the Whitechapel in association with the Caja des Pensiones at its Madrid venue and was shown in Britain between 19 January and 25 March 1990. In no small part, it owed its success to catalogue essays by the painter Robert Storr and the painter and sculptor Matthew Spender, Gorky's son-in-law. Spender also afforded access to a wide range of largely unknown material, which explored Gorky's relationship with his native Armenia.

A similarly ambitious project was the full-scale retrospective exhibition of work by the Spanish Cubist Juan

Gris. Conceived by the Whitechapel, *Juan Gris* took place in London between 18 September and 29 November 1992 and toured to the Staatsgalerie Stuttgart and the Rijksmuseum Kröller-Müller in Otterlo. The choice of works was made by the acknowledged Cubist specialist Professor Christopher Green of the Courtauld Institute of Art, and the text which he produced, with additional contributions from Christian Derouet of the Musée d'art moderne, Centre Pompidou in Paris and Karin von Maur of the Staatsgalerie Stuttgart, comprised the first full-scale study of the artist to appear in English since Daniel-Henry Kahnweiler's renowned monograph. (Pleasingly, the Whitechapel catalogue was published by Kahnweiler's brother-in-law, Gerd Hatje.)

Gris's career ended in 1927, while those of Picasso, Braque and Léger continued for many decades. Notwithstanding, his historical significance as a leading Cubist whose work offers particularly revealing insights into the phenomenon of Cubism, as a whole remains undiminished. Active as a painter between 1910 and 1927, Gris's dates exactly correspond with the years of

Cubism's greatest expansion so the exhibition, providing the closest scrutiny of his work, also supplied a host of new observations on the movement, from the pre-1914 period of analytical and synthetic Cubism to the post-war restoration of seemingly traditional painterly values.

Taking into account the preoccupations of the art of his own time, Green organised the exhibition thematically, analysing different aspects of the artist's work in the context of Cubism. The issues addressed included the construction of Gris's image as a Cubist, the status of his reputation as the 'demon of logic' and the painter of a new Platonism, the acceptance and then rejection of his later work, the rôle of gender, nationalism and notions of tradition in his figure-painting, and the workings of metaphorical and theatrical allusion in his still lives. 'Some eighty years after the event,' wrote Catherine Lampert in the catalogue foreword, 'Cubism is still a 'modern movement', alive to artists who continue to relish the irreducible fact that the canvas is a flat plane which can accommodate subjects that might nominally be inspired by anonymous and mundane objects, but quickly become highly metaphorical and

demanding.' Gris's preternatural design sense, and the refined, crystalline beauty of his drawing sustain the curiosity of painters, even up to the present.

The Whitechapel Art Gallery was the first non-collection based art space in Britain to give its visitors a chance to compare some of the most stimulating and inventive work from the recent history of art with current achievements in the field. The triumph of its historical projects has encouraged other non-collection based venues in Britain to incorporate into their programmes posthumous shows of work by seminal figures from the twentieth century, and those by Alberto Giacometti, Man Ray, Gordon Matta-Clark, Jean-Michel Basquiat and Piero Manzoni at the Serpentine Gallery, Barnett Newman and Peter Lanyon at Camden Arts Centre, and Alexander Rodchenko, Vladimir Mayakovsky, Guston and Pollock at the Museum of Modern Art Oxford all come readily to mind.

For CJ

Paul Bonaventura was Senior Exhibitions Co-ordinator at the Whitechapel Art Gallery from 1987 until 1992 and is currently Senior Research Fellow in Fine Art Studies, University of Oxford.

L. Pilichowsky *M. Moscovitch as Shylock*
Works By Jewish Artists 1923
The show was organised 'under the
auspices of the Society of Jewish Artists.
The object of this Society shall be that
Jewish people studying one or more
branches of Painting, Drawing, Sculpture
and applied Crafts, shall meet at definite
times for the interchange of ideas.' The
exhibition included works by Bomberg,
Gertler and Pissarro among others.

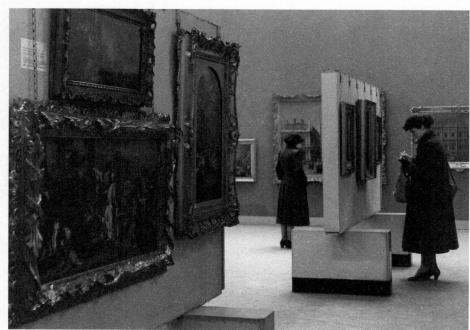

Eighteenth Century Venice 1951
Organised to celebrate the
Whitechapel's 50th Anniversary,
and later toured to the Museum
and Art Gallery in Birmingham.
Borrowed entirely from British
collections, the exhibition included
works by Bellotto, Canaletto,
Guardi, Piranesi, Sebastiano
and Marco Ricci and Tiepolo
among others.

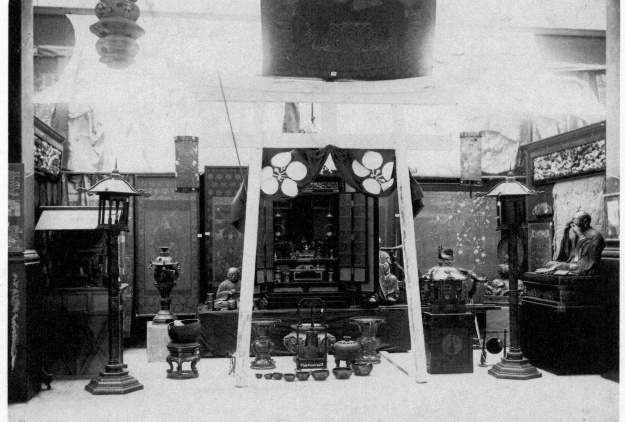

Japanese exhibition 1902
This exhibition was a vast
display of art and life in Japan, and
included porcelain, ivory carvings,
bronzes, lacquer, metal work, furniture,
books, musical instruments, armour ...
and 109 colour prints by ukiyo-e
artists. It also reconstructed a Japanese
room, a model of a tea house and
a temple, pictured here.

This is Whitechapel 1972

This is Whitechapel, 1972 consisted of 150 photographs of local people and places by Ian Berry and a number of historical photos and albums of work by other photographers. At the same time, 30 children painted a mural of Whitechapel High Street in the Upper Gallery and a number of paintings by old people from the Toynbee Hall Senior Care and Leisure Centre were also included. The Whitechapel's small gallery presented three works by Bill Woodrow and there were regular recordings of visitors' memories throughout the exhibition period.

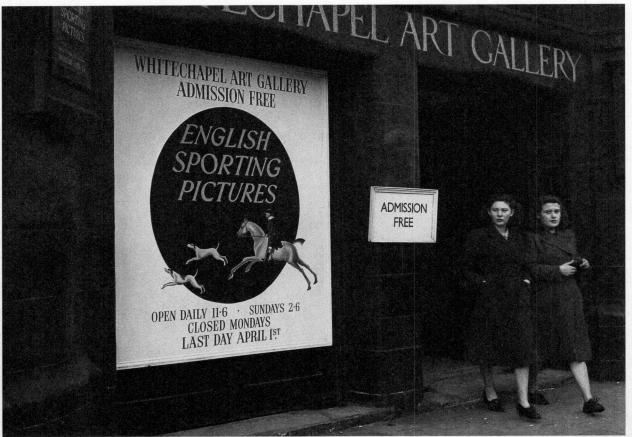

English Sporting Pictures 1950

English Sporting Pictures, 1950 was an exhibition of 95 paintings shared with the Prinsenhof Museum, Delft. It encompassed a 'distinctively English school of sporting artists who from early in the 18th Century and right on through the 19th Century, worked to supply the demands of their customers, the English sporting gentlemen, relying for inspiration on their own observation of English sporting life.'

English Sporting Pictures
1950

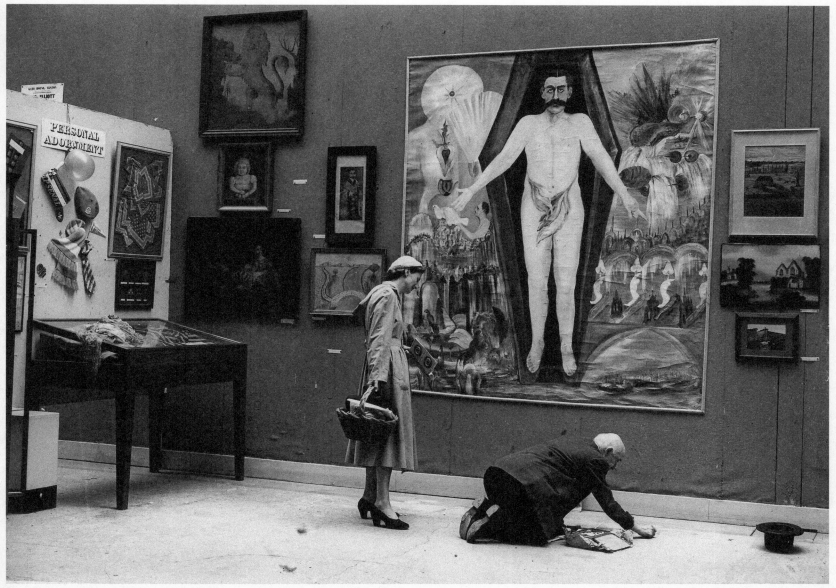

Black Eyes and Lemonade, A Festival of Britain Exhibition of British Popular and Traditional Art 1951 was an early Arts Council exhibition, presented as an inventory. Barbara Jones wrote in the introduction: 'We have not been able to find a satisfactory brief and epigrammatic definition of Popular Art. It was finally decided to set up a series of arbitrary categories which reflect most forms of human activity without creating bogus sociological implications.'

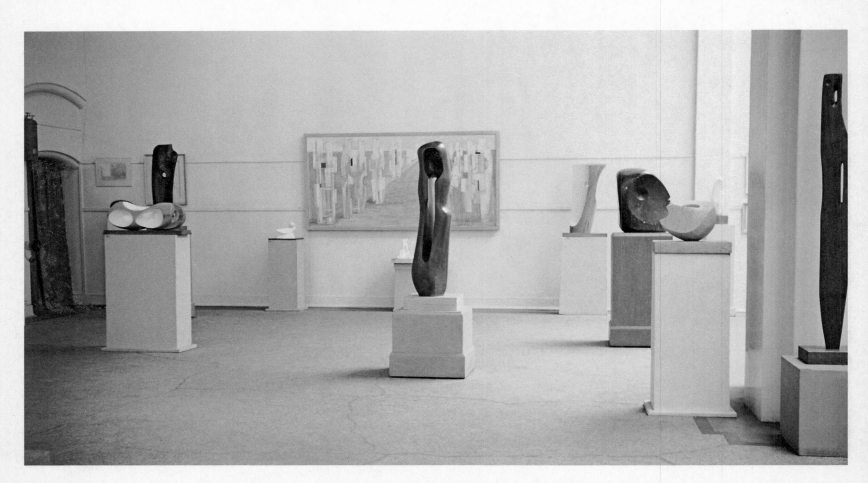

Barbara Hepworth 1954

A Retrospective Exhibition of Carvings and Drawings from 1927–1954.
Bryan Robertson writes that 'it is the first presentation in East London of a large
number of works by any artist working in an advanced idiom.'

'Hepworth completely emerged from Henry Moore's shadow and the
Whitechapel shows had something to do with this. Their preoccupations while
similar looking are very, very different. To my mind, at this scale there is just a
delicacy in her work; it is something to do with the surface.' Anish Kapoor.

The Fairground 1977
The Fairground was 'respectfully dedicated to the showmen and showwomen who maintain and transport the travelling fairs, and to the craftsmen who support them' because 'Things are already very difficult and unless something is done very soon some of the best and ancient street fairs in the world, which happen to be in this country, could be lost forever.' The accompanying publication includes interviews with showmen, a fairground painter and a collector.

British Sculpture in the 20th Century Part 2 1981–2
An exhibition in two parts that contained more than 300 works and covered over eighty years of sculpture, from Jacob Epstein to Tony Cragg. Selected by Sandy Nairne and Nicholas Serota, its catalogue was intended as an historic overview.

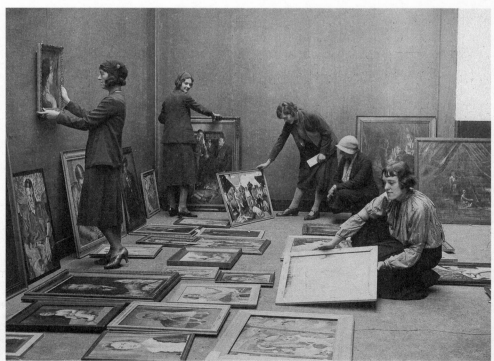

Students Exhibition 1931
The Exhibition of Works by Association of Students' Sketch Clubs, 1931 revived the Inter Sketch Club Competition, which was held annually before the War. The organisers invited applications for membership in order to continue the event.

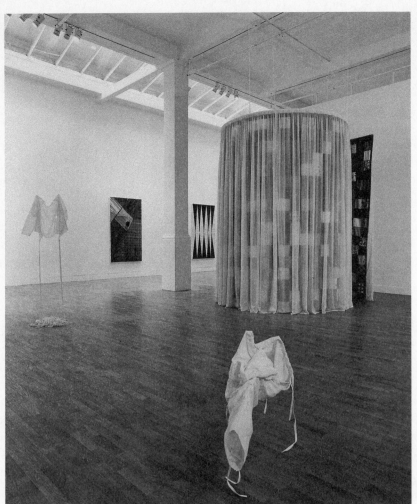

British Painting and Sculpture
1954
The aim of this show was, quite simply, to bring to the East End 'a reasonable cross-section of British art as it stands at the moment.' The catalogue introduction, written by Bryan Robertson, reads like a rallying cry for the support of contemporary work: 'British painting and sculpture has never been more vigorous or more varied than it is today and our artists need and deserve every possible encouragement. It should never be forgotten that every work of art created today represents a very considerable act of faith'.

Mudanzas 1994
Mudanzas was part of the Spanish Arts Festival in Britain, and presented work by Victoria Civera, Susy Gómez, Paloma Peláez, Joan Rom, Juan Uslé and Eulàlia Valldosera.

Pictured: Gómez's installation and Uslé's paintings.

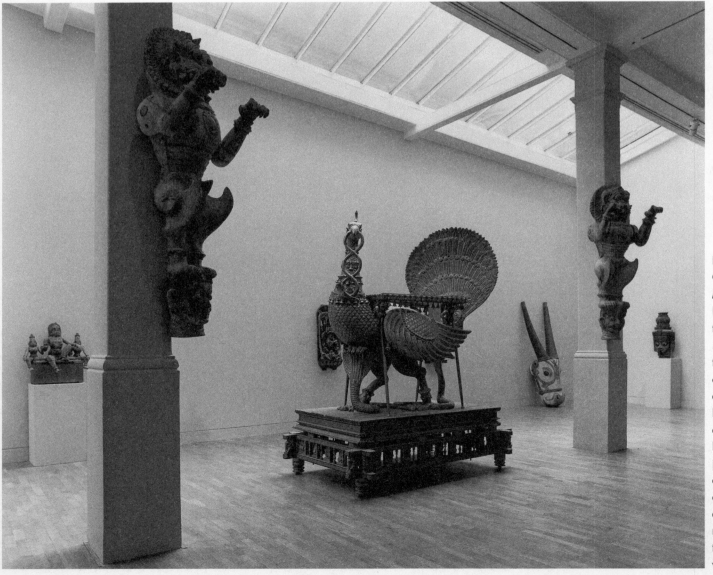

Living Wood 1992
Conceived by George Michell and Catherine Lampert (organisers of the Hayward's *In the Image of Man*, 1982) the exhibition built on a Whitechapel association with the Indian subcontinent dating back to 1904. It tackled a new subject, surveying objects and photographs of timber architecture, as well as the austere representations of the totemic spirits of Bhuta worship.

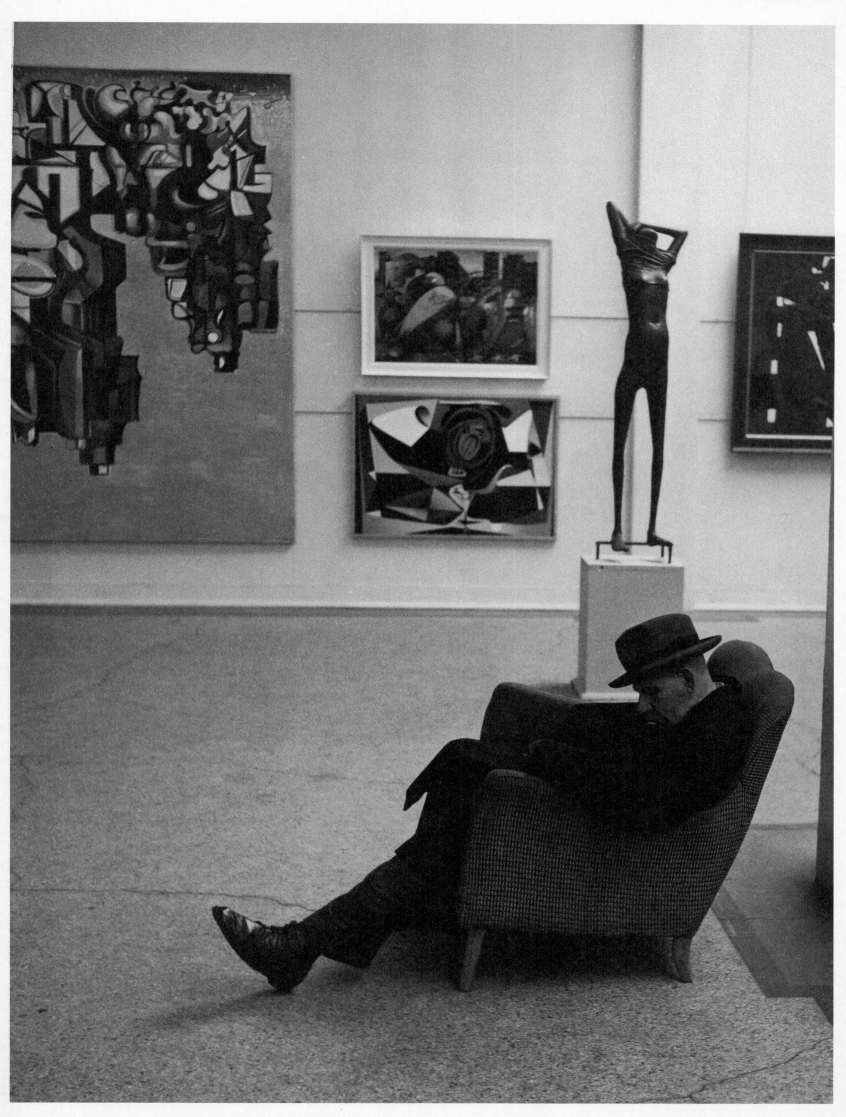

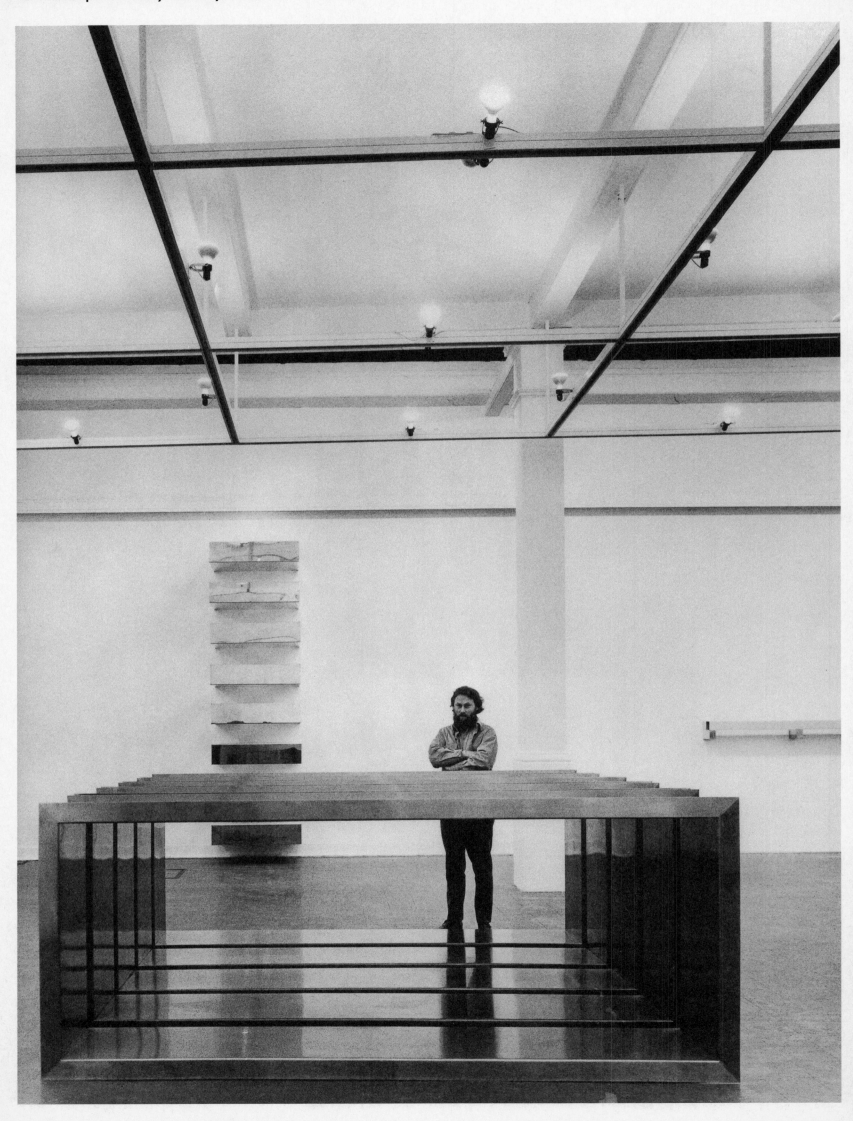

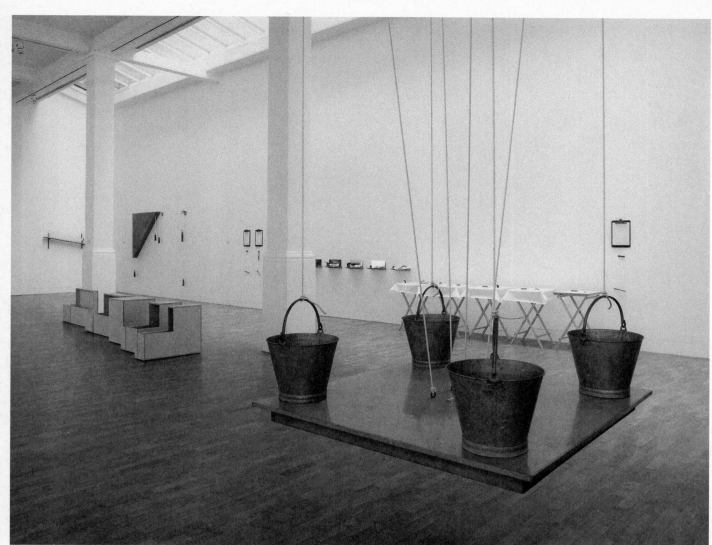

Michael Craig-Martin,
A Retrospective
1968 – 89
installation 1989

13°E: 11 Artists
Working in Berlin
1978

Pictured:
*Everything a Load
of Rubbish! Documents
of a Blockade* 1974,
by Dieter Hacker and
Andreas Seltzer.
The exhibition also
included work by K P
Brehmer, Günter Brus,
Johannes Grützke,
Ludwig Gosewitz,
K H Hödicke, Bernd
Koberling, Markus
Lüpertz, Tomas Schmit
and Wolf Vostell.

left:
Donald Judd 1970
Programmed after
Modern Chairs and
before *From Three to
Infinity: New Multiple
Art*, Donald Judd's first
large scale European
solo exhibition was
organised with the Van
Abbemuseum in Eind-
ohoven. It presented
14 steel, iron, brass,
aluminium and plexi-
glass works dated
between 1964 and
1969. The catalogue
included interviews
and selected writings
by Judd.

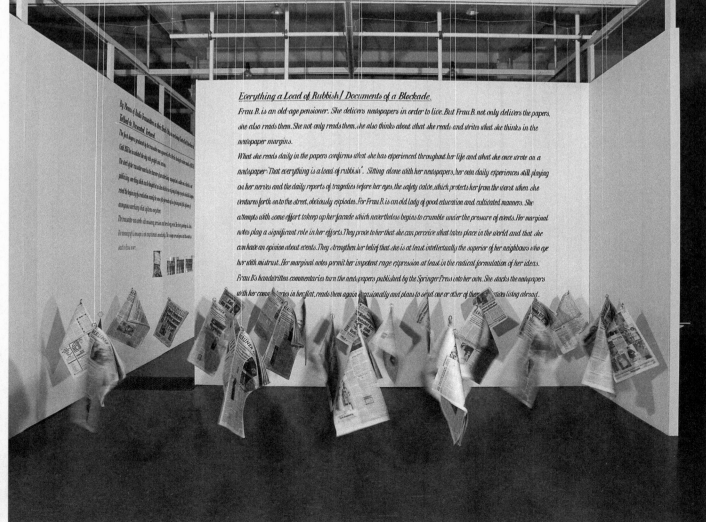

Everything a Load of Rubbish! Documents of a Blockade.

Frau B. is an old-age pensioner. She delivers newspapers in order to live. But Frau B. not only delivers the papers, she also reads them. She not only reads them, she also thinks about what she reads and writes what she thinks in the newspaper margins.

What she reads daily in the papers confirms what she has experienced throughout her life and what she once wrote on a newspaper: 'That everything is a load of rubbish'. Sitting alone with her newspapers, her own daily experiences still playing on her nerves and the daily reports of tragedies before her eyes, the safety valve, which protects her from the worst when she ventures forth on to the street, obviously explodes. For Frau B. is an old lady of good education and cultivated manners. She attempts with some effort to keep up her facade which nevertheless begins to crumble under the pressure of events. Her marginal notes play a significant role in her efforts. They prove to her that she can perceive what takes place in the world and that she can have an opinion about events. They strengthen her belief that she is at least intellectually the superior of her neighbours who eye her with mistrust. Her marginal notes permit her impotent rage expression at least in the radical formulation of her ideas.

Frau B's handwritten commentaries turn the newspapers published by the Springer Press into her own. She stacks the newspapers with her comme... in her flat, reads them again occasionally and plans to send one or other of the... ...cles living abroad.

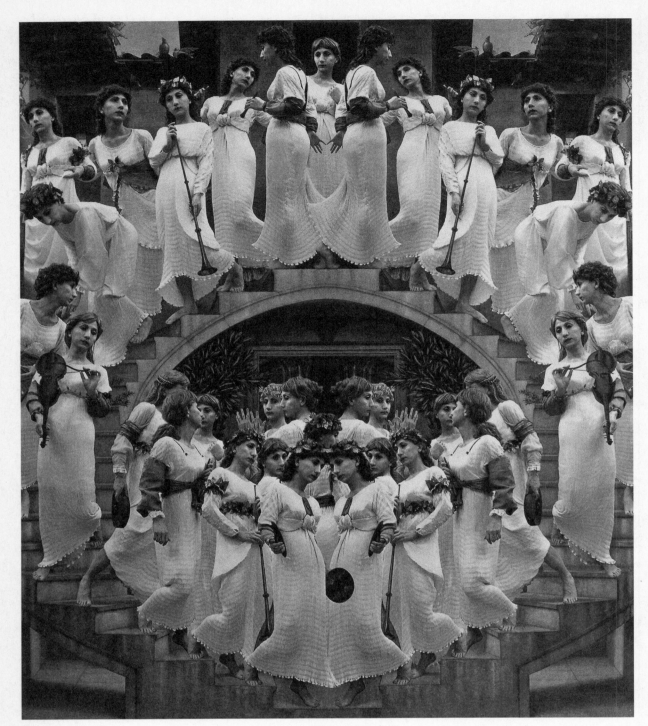

A Cabinet of Signs: Contemporary Art from Post-Modern Japan 1991–2
The exhibition organised with Tate Liverpool was one of the events within the Japan Festival 1991. It featured Hiroshi Sugimoto, Tatsuo Miyajima and Morimura.

Pictured:
Yasumasa Morimura, *Angels Descending Stair*, 1991
colour photograph and transparent medium, 240 x 226 cm. Amongst other works, the artist included manipulated transparencies of Pre-Raphaelite works in the Tate collection.

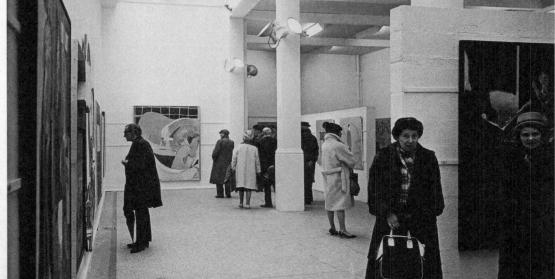

New Generation 1966
The New Generation was conceived by Bryan Robertson in 1963 as a series of annual anthologies presenting a selection of works by young British artists. The third exhibition in 1966 included Roger Barnard, Douglas Binder, Roger Brace, John Carter, Colin Cina, Roger Cook, Mario Dubsky, Eric Gadsby, Knighton Hosking, Justin Knowles, Mark Lancaster, Francis Morland and Victor Newsome.

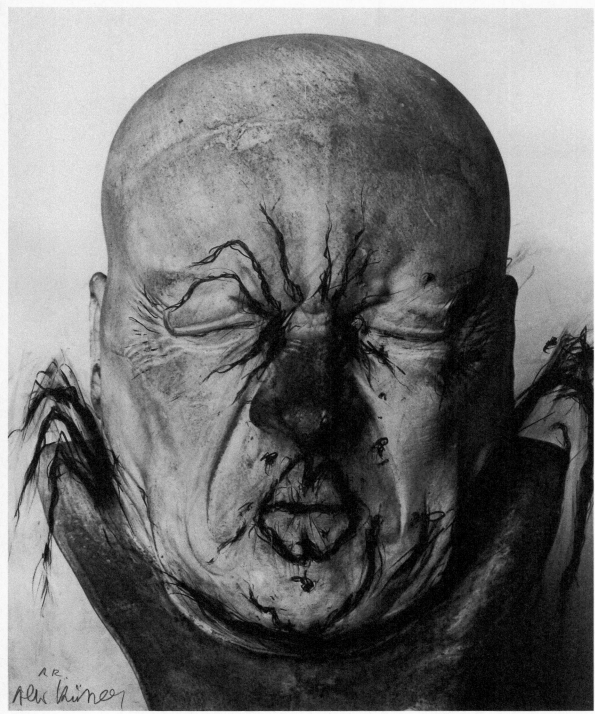

Arnulf Rainer 1980
Pictured: *Alter Küsser*, 1975/76
Organised in association with the Stedelijk
van Abbemuseum, Eindhoven, the exhibition
was selected by Rudi Fuchs and Nicholas
Serota from Rainer's studio in Vienna and
Vornbach (Bavaria). It included 139 works
dated between 1951 and 1979, organised
in 7 chronological groupings.

Tadeusz Kantor: Emballages 1960–76 1976
'Is the *emballage* theme more significant than
others and therefore sufficiently representative of
Kantor's work? I think so, for several reasons.
The most important is that the *emballage* theme
is the starting-point for many of Kantor's artistic
manifestations and therefore... documents the
work not only of the artist as a painter, but also
as an author of happenings, theatrical productions
and events. [It] also displays many characteristic
features: his attitude towards quotation from
historical paintings, his clear and provocative
view of the degeneration of modern art, and
finally his frequent use of self-irony and even
traces of humour.' Ryszard Stanislawski in the
exhibition catalogue.

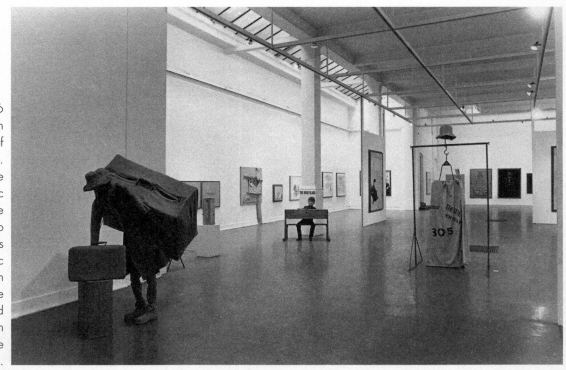

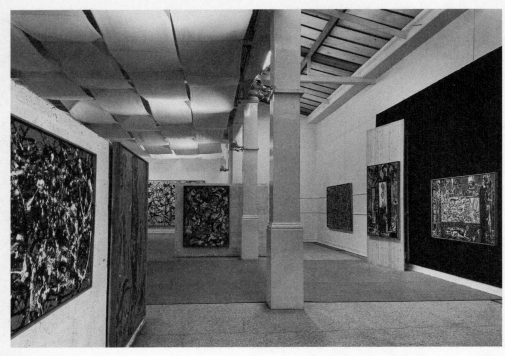

Jackson Pollock 1958
Organised by the International Council
of the Museum of Modern Art, New York,
the Jackson Pollock retrospective was the
first major solo exhibition of Pollock's work
in Europe. Twenty-nine paintings, including
Blue Poles, and twenty-nine works on paper.

Jackson Pollock 1958
Chartered architect Trevor Dannatt
designed the installation of the
exhibition with its breeze block-like
temporary walls, ceiling drapes and
pillar mounted flood lights for a fee
of £105. Bryan Robertson made the
new walls a permanent fixture for
the next seven years.

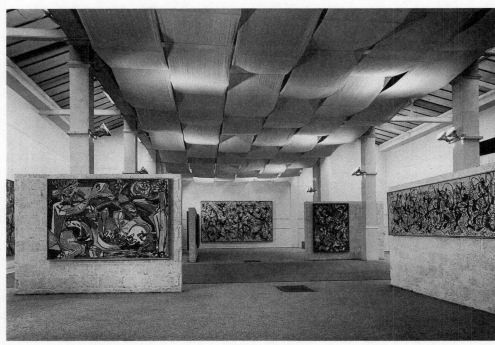

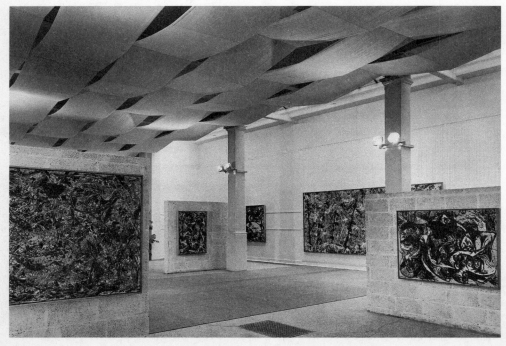

Jackson Pollock 1958

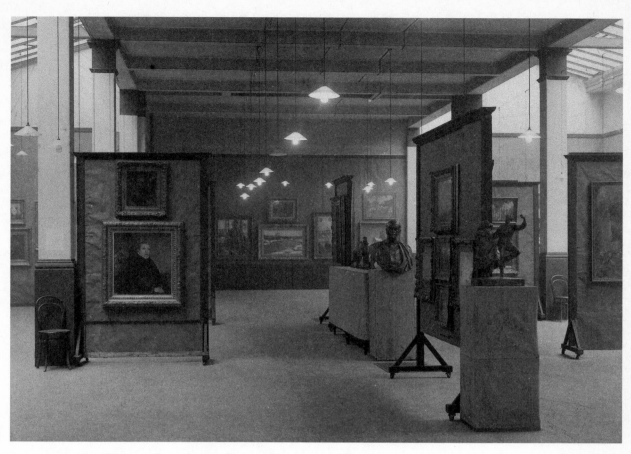

Modern Dutch Art 1921

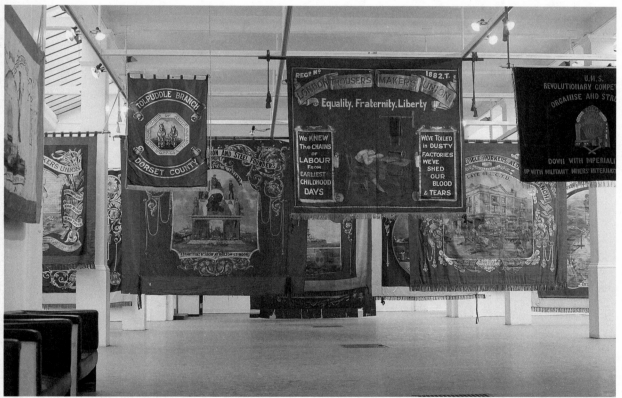

Banner Bright: An exhibition of Trade Banners from 1821 to 1973 1973
This exhibition of 48 trade banners was the result of John Gorman's research for his
book *Banner Bright*. It aimed to bring back the tradition of showing applied arts within the
Whitechapel Art Gallery, with the same educational and popular spirit of very early
shows such as *Modern Posters* in 1903.

Thomas Schütte 1998
This exhibition, curated by James Lingwood, was Schütte's first one-
person show in Britain and revolved around two of his recurrent
concerns – the human figure and the architectural model. It is especially
remembered for the *United Enemies* and *Grosse Geister* sculptures.

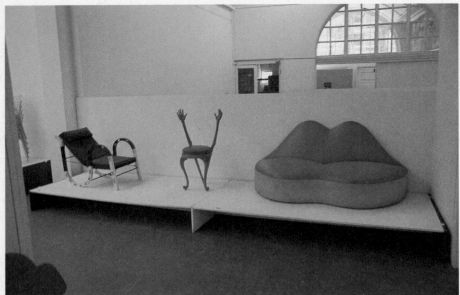

Modern Chairs 1970
Over 100 chairs were presented in this exhibition organised by Carol Hogben and the Circulation Department of the Victoria & Albert Museum, the Whitechapel and *The Observer*. Designers included Marcel Breuer (Wassily chair); Mies van der Rohe (MR chair, Barcelona chair); Le Corbusier (Basculant chair, Chaise Longue); Alvar Aalto, Salvador Dali ('Mae West's Lips' wall seat); Arne Jacobsen (3107 chair); David Rowland (GF 40/4 chair); Tobia Scarpa (Coronado chair).

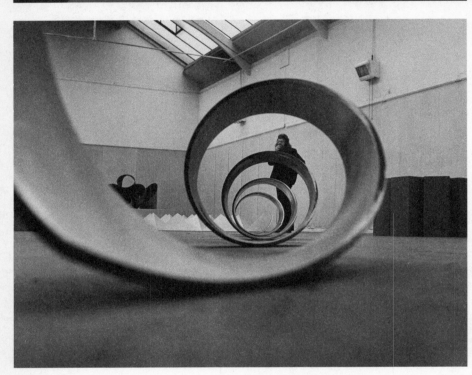

Neville Boden 1973
The artist captured within his exhibition by the veteran photographer J. S. Lewinski

John Davies Summer 1972
There were uncanny resemblances between the dressed, life-sized sculptures made by John Davies and the Whitechapel visitors. Many memorable shows arranged by Jenny Stein (Director in the early 70s) connected to the East End through photographs, murals and popular art whereas Davies' art – then and now – borders on the surreal and achieves mastery in the modelling of heads. This photograph was used in the Sunday Times.
Photo: Tony Evans

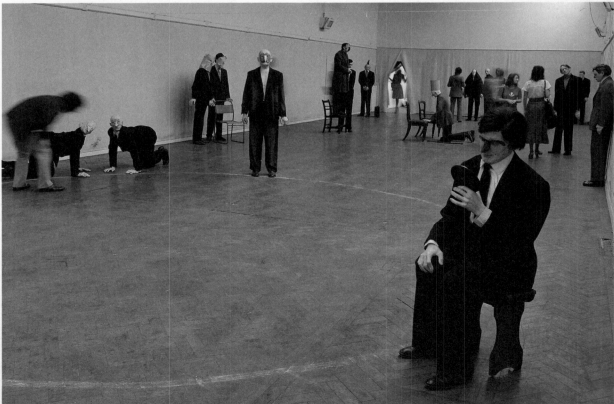

Antony Gormley 1981
Room was made of Gormley's clothes cut into a continuous 6mm strip. The sculptures *Bed* and *Natural Selection* (seen in the background) are now in Tate's collection. 'In *Room*, Gormley has expanded the idea of referring something back to its origins and also the concept of insulation… We add [clothes] in layers on top of our skin, a room is another layer which insulates and conceals us. At the same time our clothes and our rooms can also help identify us…"
Jenni Lomax, exhibition guide.

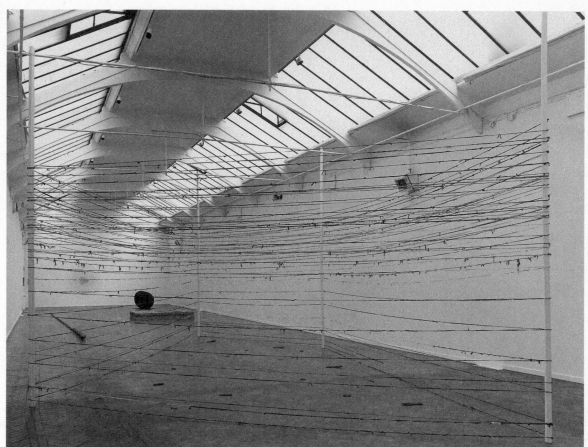

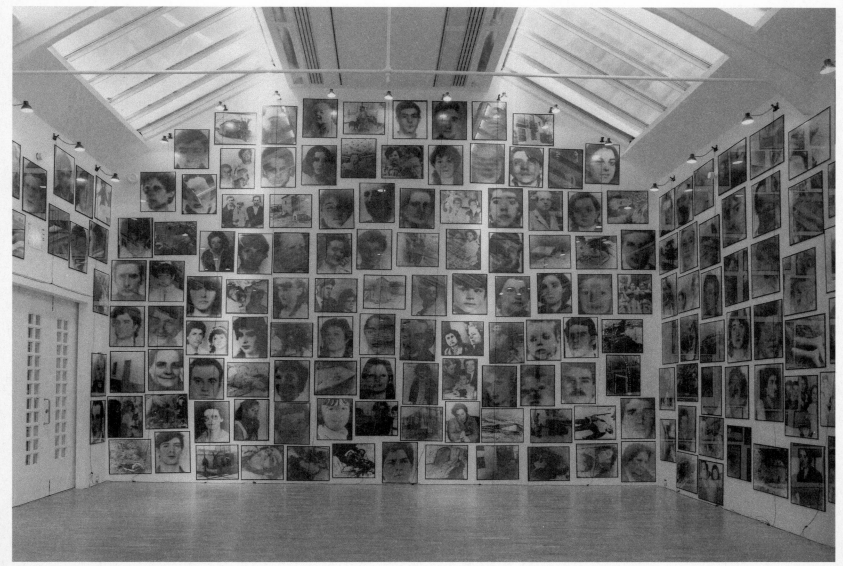

Christian Boltanski 1990
The combination of sculptures illuminated by light bulbs, candles and projectors created an extraordinary installation. To coincide with the show, Boltanski also created a site-specific work with heaped clothes in the basement of the former synagogue on Princelet Street.

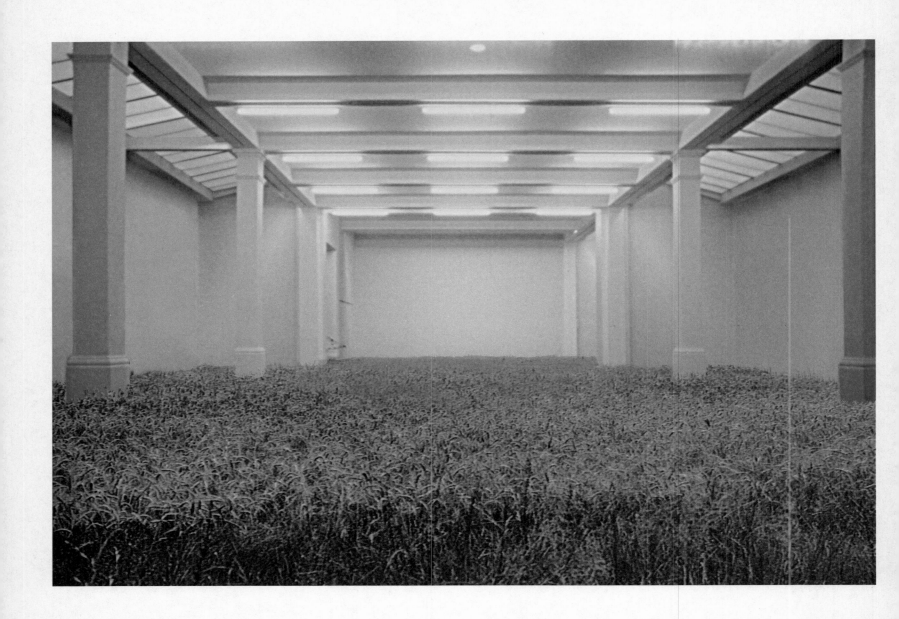

WATER

SEVENTEEN
COAST TO COAST WALKS
ON ENGLAND SCOTLAND
WALES AND IRELAND
1971-1999

Zarina Bhimji

It was in the Spring/Summer of 1989 when I was artist
in residence at Culloden Primary School. Jenni Lomax
set it up. Her approach to artists was excellent. I found
the teachers really helpful at the school too. With this
combination I was really able to work closely with
Jomilia, Ruman, Robina, Shahida, Kolsuma, Shipa and
Shully through my work and their feelings about being
women, religion, love, clothes, anger, laughter. We drew
and took photographs of what was expressed in the hot
summer of 1989.

জরিনা ভিমজি

ইহা ছিল ১৯৮৯ সালের গ্রীষ্ম/বসন্ত কাল, যখন কলোডেন প্রাইমারী স্কুলে ইহা আর্ট
করা হয়েছিল। জেনি লোমাক্স এটা সেট করেছিল। আর্ট করার ব্যাপারে তাঁর ইচ্ছা
ছিল প্রবল। আমি স্কুলের শিক্ষককেও সত্যিকার অর্থে অত্যন্ত সাহায্যকারী
দেখেছিলাম। এভাবে মিলে যাওয়ার ফলে আমি ঘনিষ্টভাবে জমিলা, রুমান,
রুবিনা, শাহিদা, কুলছুমা, শিপা এবং শিউলির সাথে কাজ করতে সমর্থ হই এবং
তারা যে মহিলা সে হিসেবে তাদের ধর্ম, ভালবাসা, কাপড়, ক্রোধ, হাসি-কান্না
ইত্যাদি অনুভূতির সাথে পরিচিত হই। সেই ১৯৮৯ সালের গরমের গ্রীষ্মকে
যেভাবে দেখেছিলাম ঠিক তার মাঝেই আমরা এঁকেছিলাম এবং ফটো তুলেছিলাম।

Association of Artists (AIA) at the Whitechapel Art Gallery, 1939

by Lynda Morris
and Robert Radford

Fighting on in Spain

In February 1939 a group of ninety or so AIA members were to be seen painting giant illustrated slogans directly on to advertising hoardings, calling for support for the campaign to send food to Spain. This device provoked a good deal of attention in the Press, notably the *Picture Post*, and so redoubled the effectiveness of the publicity. In the same month, at an 'Arms for Spain' demonstration in Trafalgar Square, the speeches from Haldane and Tom Mann were delivered against a backdrop of banners on which motifs from Goya's 'Disasters of War' were displayed. The banners had been made up by Graham Bell, Rodrigo Moynihan, Lawrence Gowing and Victor Pasmore and others of their circle, and were obviously connected with the more finished paintings from the same source which were on show at the AIA's *Art for the People* exhibition at the Whitechapel Art Gallery. The use of this imagery, the purpose of which is a graphic condemnation of the universal evils of warfare, in the context of an 'Arms for Spain' campaign, appears on the face of things somewhat perverse. According to Pasmore, it was the intention of the painters that the banners be used for anti-war propaganda rather than for an occasion of this sort.

Unity of Artists

'Unity of Artists for Peace, Democracy and Cultural Development' was the stated theme of the next AIA major exhibition although it is now most often known by the title *Art for the People*. It was held at the Whitechapel Art Gallery in February and March 1939, attracted some 40,000 visitors and showed some 200 works. The coverage of style and subject was catholic. The more established exhibitors included Duncan Grant, Ben Nicholson, Vanessa Bell, John Nash, William Coldstream, Julian Trevelyan, Frank Dobson and Henry Moore. All were showing work in their characteristic manner with the interesting exception of the Euston Road Group, or more specifically Bell, Moynihan, Gowing, Pasmore in company with Carel Weight, and probably Duncan Grant, who each took the motif of one of Goya's 'Disasters of War' etchings and transcribed them into oil paintings.

William Coldstream and Lawrence Gowing remarked in a joint interview that the Goya paraphrases were made at the Euston Road School:

'They were all 6' × 4' on banner cloth, which we bought from a banner cloth shop in Whitechapel, which the Communist painters knew about. Victor's [Pasmore] one was of a bird picking out the entrails of an animal … Graham Bell did a large number, and an associated little sketch of a man holding his nose with the smell of decomposing corpses. They were lettered on the back with the inscription 'Hitler, Mussolini, Daladier, Chamberlain did this to Spain'. It did not impress the Essex Home Guard. They were taken to Monkesbury in Essex to be stored during the War in Rodrigo Moynihan's garage and they were confiscated by the Home Guard in a spy scare in 1940 and no one ever found out what happened to them.'

The aim of the show, reinforced from the start by its choice of location, was the need to establish a popular audience for contemporary art. Graham Bell stressed in his introduction to the catalogue:

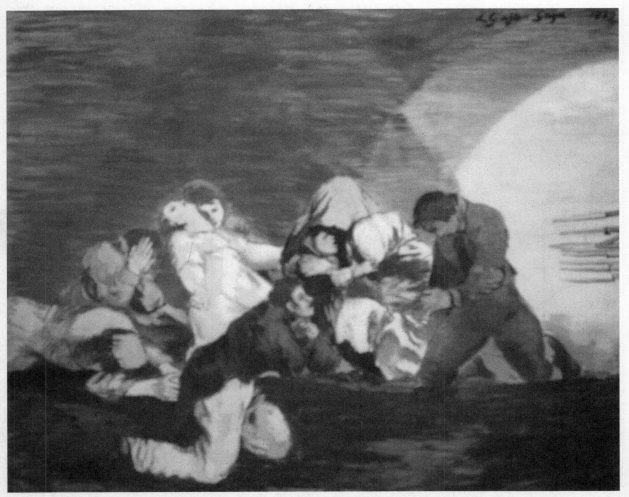

Lawrence Gowing *Non Combatants*, paraphrase from Goya's *Disasters of War*. This image, along with others by the Euston Road Group after Goya, was also made into a banner for use in anti-War demonstrations

'In the last fifty years artists, particularly those who paint pictures or do

INDUSTRY MATERNITY EDUCATION PUBLIC HEALTH NATIONAL INCOME COMMERCE

The BURDEN of ARMAMENTS | CRUSHES SOCIAL PROGRESS

The Burden of Armaments c.1926

sculpture, have, through no fault of their own, become isolated from the greater part of society which supports them. Only a small proportion of the public can afford the price of admission to the Academy and other big shows. But what is still worse from the artists' point of view is that the man in the street seems to have lost the curiosity which might once have made him want to go in.'

This wish to dissociate art shows from the social mystique which was inevitably attached to art societies and the West End dealers was demonstrated by such measures as the random selection of a passer-by to open the show, instead of the customary prestige figure, and the holding of a popularity poll of works exhibited.

Nan Youngman said it was her idea to call in a man off the street to open the exhibition: 'I went out onto Whitechapel High Street at 2 o'clock and the press were all out there waiting with their cameras, and as far as

the eye could see there was nothing but bloated capitalists in bowler hats. In the end along the road came this little chap with a fag hanging out the end of his mouth. He was unemployed. We went up to him and said, "Would you like to come in and open an exhibition?" "Oh", he said, "I don't mind if I do." And he didn't pause, really, he just walked into the gallery and took a look around and got up on a chair and said "I've got great pleasure in declaring this exhibition a great and wonderful success" and got down off the chair and went off with the pound we paid him...'

She also explained the idea of the exhibition:

'The thing about this exhibition was that it was intentionally didactic. It was hung in sections: Surrealism, abstraction and realism and so on. It was not just political; it was also educational. We had these different sections and we even laid on people

to be in the different sections to talk to the public about Surrealism and abstraction. They were there to answer questions and they did not mind saying what they were about. I do not think there was any feeling that realism was superior to any of the others; it was just another kind of art. It was a post-War idea: the superiority of realism. We just wanted everyone to use their art, whatever it was, in a political way. I remember taking a whole gang of elementary school teachers around the exhibition. They were a bit startled by some of the Surrealist pictures and they asked the Surrealist painter about them, and he turned round and said "I did that one under the influence of some South American drug." You should have seen the teachers' faces!'

Extract reproduced from AIA: The Story of the Artists International Association 1933 – 1953 (exh. cat.), Lynda Morris and Robert Radford, The Museum of Modern Art, Oxford 1982

John Berger and Looking Forward

by Jonathan Jones

What is reality in art? In Frans Hals's paintings faces from the seventeenth century look at us as freshly as if these people were with us in the room. It is impossible not to feel their presence, or to believe that Hals is describing his world as he saw it. Of course, art criticism has become adept at undermining such credulous ways of seeing.

Hals is one of art critic John Berger's most important artists. For Berger, Frans Hals is indeed a realist, a reporter, and a satirist too. In the book of his famous 1972 television series *Ways of Seeing*, Berger draws attention to the very late paintings made by Hals of the governors and governesses of the poorhouse in Haarlem. Group portraits of this kind were an established genre in the Netherlands, but Hals's *The Lady Governesses of the Old Men's Almshouse at Haarlem* (1664) and *The Governors of the Old Men's Almshouse at Haarlem* (1664) are unusual for several reasons. It's not just that Hals resorts to what has been described as pre-Impressionist brushwork, or that instead of depicting the governors and governesses in the midst of their work, he shows them formally grouped in a dark, shadowy setting in their black clothes; there is also the remarkable biographical fact that Hals was himself an inmate of the Old Men's Almshouse. As John Berger sees it, Hals's paintings are full of contempt and loathing for his social superiors; the oddly positioned hat and flaccid face of one of the male governors suggests drunkenness. This is, in Berger's eyes, a rare case in western high art of an authentic view of society from below.

Of course, the art historians came down on Berger like a ton of bricks. The man with the drooping face has been shown to be suffering from facial palsy; and then there's the unlikeliness of satire in portraits, whose subjects each paid separately for their faces to be painted and had clear views about how they wanted to be seen.

And yet. When you look at these paintings, it is against all common sense not to acknowledge the pinched, dry look of these people, a look that to contemporaries may well have had a laudable austerity – the black clothes, the melancholic expressions – but to which Hals brings none of the monumental heroism of a Rembrandt portrait. Instead, these people look knocked-about and weary, and seem to be missing something; joy, a spark

Franz Hals *The Governors of the Old Men's Almshouses at Haarlem*, 1664. Frans Halsmuseum de Hallen, Haarlem

John Berger author photograph. Photo: Jean Mohr

of life. You might think of William Blake's chimney sweep lamenting the coldness of Christian charity;

> Because I was happy upon the heath,
> And smil'd among the winter snow,
> They clothed me in the clothes of death,
> And taught me to sing the notes of woe.
>
> (*The Chimney Sweeper*, l.s 5–8, *Songs of Experience*)

Its hard not to think that Hals, who painted the exuberant *Laughing Cavalier*, knew what he was doing in so sharply recording the severity and hardness of these distributors of charity, binding with briars his joys and desires. If this was also how they wanted to be seen, the richness of the image is all the greater. It is, however you slice it, a snapshot of a parsimonious social order.

John Berger is one of the best-known and most influential art critics of the late twentieth century, a socialist and a polemicist, although most recently a writer of fictions. His life in an

Alpine village and his European-minded narratives of the lives of peasants and migrants – *Pig Earth*, *Once in Europa* – have taken him a long way from the British art world. In the 1990s his voice as an art critic, as opposed to a novelist, has pretty much faded from the scene, and the London art world has instead elevated to critic-god status his arch-enemy David Sylvester. In his book of essays *About Modern Art*, Sylvester recalls what he saw as the dread influence of Berger as an art critic in London in the 1950s, and his championing of what Sylvester dubbed disparagingly 'the kitchen sink school'. Sylvester, arguing instead for American modernism and the existentially melo-dramatic art of Bacon and late Giacometti, which for Berger were essentially tasteless. He recounts how relieved he was when Berger gave up criticism for novel writing, and spared artists his pernicious influence.

If there was one occasion that exem-plified John Berger's attempt to define British art, it was *Looking Forward*, a large group exhibition of contempo-

Cover of *Ways of Seeing*, Penguin, London 1972. Photo: Rudolph Burckhardt

rary artists which he curated at the Whitechapel Art Gallery in 1952. As art critic of the *New Statesman*, Berger argued for a socially descriptive, realist art; when the Whitechapel gave him the chance to curate his own group show, he made it a manifesto occasion, a public and political rallying-point for the art he wanted to see. The Whitechapel's press cuttings from the time are fascinating; not only did the exhibition get wide coverage but Berger made a point of writing replies to editors, getting his view across in every possible form. It was the exhibition as rhetorical platform. As the artists who were in it – John Bratby, Rodrigo Moynihan, LS Lowry, Ruskin Spear, Carel Weight – are not exactly current, this exhibition has not become one of the great, mythic post-war occasions at the Whitechapel rightly celebrated in art history, most notably *This Is Tomorrow* in 1956 and Bryan Robertson's first British showing of Jackson Pollock in 1958.

And yet there is a real comparison to be made between *Looking Forward* and *This Is Tomorrow*. Both insisted on the duty of art to represent modern life. Where they differed was in their assessment of what that life was like.

One of the criticisms of *Looking Forward* was that it looked backward. The realities painted were working-class realities, impoverished realities; as almost all critics commented, even the colours on the walls were drab and dreary. Already, in 1952, the new possibilities – if not yet realities – of consumerism made people feel that Britain was becoming less class-bound, less oppressive. Or at least art critics thought so. The first art exhibition to recognise these new actualities anywhere in the world was to be, of course, *This Is Tomorrow* with its science fiction aesthetic and Richard Hamilton poster featuring the seminal word POP.

John Berger was given the go-ahead for *Looking Forward* before Bryan Robertson was appointed director at the Whitechapel; Robertson was appointed during the planning stages. The gallery's archives include letters between them indicating their radical differences of outlook. Robertson has recalled that when he came to the East End, he felt the last thing local people wanted or needed was social realist art; what they deserved was colour and excitement. And Robertson was certainly to bring aesthetic thrills to the East End; Pollock, Rothko, Malevich. Berger was not his cup of earl grey. They briefly fell out when Robertson made the suggestion – reasonable you might think – that a show of realism in 50s British art should include Lucian Freud. As the letters in the Whitechapel archive show, Berger replied that there was no way he would include Freud; instead it would be best if he pulled out of the whole thing. Robertson instantly backed down, and appears to have given Berger a completely free hand from that moment on. Curators might wish to take note of Berger's radical method of getting his own way.

Why didn't Berger want Freud? Clearly because he was the wrong kind of realist; introspective, 'bourgeois', tainted by the Soho existentialism of his friend Bacon and, in his art's embattled individualism, all too easily seen as expressing a Cold War, *Encounter* magazine, right-wing pessimism. These were savagely politicised years; Berger's championing of realist painters had its equivalent in theatre in the criticism of Kenneth Tynan, who was suspicious of Samuel Beckett on the grounds that his endgame fitted too neatly the glib gloom of the middle class which saw social change as futile. This Cold War cultural style, high miserabilism, was rejected not just by the overtly political Berger and Tynan but, in ultimately more effective ways, by the pop artists who on the face of it had so little in common with Berger's realism. Richard Hamilton, a lifelong political activist, saw no contradiction between consumerism and socialism precisely because American-style glamour and pop culture offered a joyous release from Cold War gloom. To the pop artists, happiness was radical. They escaped from Bacon's glass box into a world of possibility within which

– for a moment, and we call that moment the 60s – consumer goods were utopian instruments. Pop was political.

This is what was missing from Berger's *Looking Forward*, and was what made it politically as well as aesthetically impotent; in spite of himself, his sensibility was too close to Cold War existential misery. Perhaps the reason he was so hostile to including Freud in *Looking Forward* was that he sniffed the danger; his aesthetic, while apparently opposed to Sylvester's formalism, in fact shared its austerity, a heaviness of heart, that was to be shattered only by pop. We can compare it to the gloom of the puritan poorhouse governors in Hals's paintings; what is oppressive about these people is their melancholy. Berger's early art criticism could not find the way out of the prison of despondency. He was to achieve this with *Ways of Seeing*, the classic example of art criticism as pop art. The appeal of *Ways of Seeing*, as a TV series and a montage-style book, is its intelligent juxtaposition of high and popular images, its radical assault on the gentility of fine art as something cut off from everyday life, and above all its emphasis on the seeing subject; or the consumer, as Richard Hamilton might have put it. Flamboyantly breaching the bounds of art and life, *Ways of Seeing* is Berger's escape from the jail of social realism.

But it is also a defence of a reasonable, and realistic, way of seeing art; Berger attempts to blow away the cobwebs of culture and refinement that stop us seeing a Frans Hals painting as a deposit of experience – as real. Today, the anti-hierarchical elements of Berger's vision have become the common currency of art, almost banally so. But his passion for realism challenges us. It feels more tasteless than ever to praise realist art. That is just *so* naive.

Jonathan Jones is art critic for the *Guardian*.

Lucian Freud *Interior at Paddington*, 1951.
Walker Art Gallery, Liverpool, Merseyside, UK / Bridgeman Art Library

This is Tomorrow

by Jeremy Millar

One of the most important, or most greatly mythologised, of post-War exhibitions was held at the Whitechapel Art Gallery in the autumn of 1956. *This is Tomorrow* was, as the critic Lawrence Alloway noted in his catalogue introduction, 'devoted to the possibilities of collaboration between architect, painters and sculptors'. Twelve groups exhibited in the downstairs gallery space, each group consisting of members from the various disciplines, each group working in isolation from one another; as Alloway also noted, it was perhaps more realistic to replace 'the ideal picture of collaboration' with 'the notion of antagonistic co-operation'. In many ways it was the resultant diversity which was seen as the exhibition's strength — the exhibitors were allowed to do exactly as they pleased, without the pressure of conforming to a group orthodoxy.

The exhibition has become so mythologised due to the involvement of certain members of the Independent Group, a loose gathering of artists, architects and critics centred around the recently formed ICA in the early 1950s. Although never an official group as such, and indeed only named as a matter of convenience by members of the ICA management (and then, originally, known as the 'Young Group'), the activities of those involved have become consolidated as the first developments of Pop Art, with *This is Tomorrow* as their most important exhibition. The truth, as ever, is considerably more complex, with their discussions as likely to cover non-Aristotelian philosophy or the proportional systems of Le Corbusier as they were fashion photography or automobile styling. And when *This is Tomorrow* opened in August 1956, the group's final meeting was already over a year past, with only 12 of the show's 26 participants having been involved in the activities at the ICA in any case.

Perhaps its greatest influence lies in that which it is said to have influenced. And perhaps this is always the way.

The following is an edited account of interviews held with participants in 'This is Tomorrow', 23 and 24 January 2001.

Colin St John Wilson – Group 10, with Robert Adams, Frank Newby and Peter Carter

This is Tomorrow was initiated when Leslie Martin — who was still head of the department of architecture at the London County Council where I was working — summoned me and said that he had been approached by Paule Vezelay, a French abstract artist, with a view to organising an exhibition (in the foyer of the Royal Festival Hall) of tiles and pottery decorated with abstract patterns. She went to Leslie Martin, whose connection with Gabo and Nicholson in the 'thirties (vide *Circle*), made him an obvious choice. But he wasn't interested. However, he thought that I might be for other reasons. I then took the idea up with Theo Crosby and a small group of us went to see Paule Vezelay — people like Victor Pasmore, Robert Adams, and the Martins [Mary and Kenneth], and one or two others — and that turned out to be a complete disaster because we said 'We're not interested in little abstract tiles'. My next most vivid memory is of a meeting in the studio of Adrian Heath in Charlotte Street. Theo had put about the idea that there would be an exhibition about 'collaboration between architect, painter and sculptor' and that Bryan Robertson had offered the Whitechapel. 'Collaboration' was an idea very much in the air — Le Corbusier was always talking about 'le synthèse des arts' — and that's when the whole gang converged on Adrian Heath's place. It started with a rabble, everybody talking at once, and then at a certain point Roger Hilton (who was supposed to be the painter in the group

Richard Hamilton *Just what is it that makes today's homes so different, so appealing?*, 1956, collage, 26 x 25 cm. Courtesy Kunsthalle Tübingen

and who got drunk very quickly) suddenly stood up and looking at [Lawrence] Alloway and [Reyner] Banham said 'Get these effing word men out of here! This is a discussion for artists, not word people'. There was a deadly silence and Banham and Alloway, white-faced, disappeared. It then became very pragmatic and someone suggested that each of us write down a list of the people we'd like to collaborate with. We then gathered the lists together and agreed that each group should have the equiv-alent of a stall-space in a market in which they could do their own thing. I read somewhere in a magazine [*Octo-ber 94*, The MIT Press, Cambridge, Mass., Fall 2000] this American guy saying that Theo Crosby got every-body into a room and issued instruc-tions as to what themes different people were going to use – absolute balls, and certainly not the case. It was a complete free-for-all. So there was a very disparate bunch. I can't quite remember how the disparate rooms were allocated except that it made sense that the first two on enter-ing were 'walk-throughs' and so was the last (my group) on exiting. Anyway, I was given the job to do the overall layout.

The two absolutely polar exhibits were the Hamilton one (with John McHale and John Voeckler) and the Paolozzi/Henderson/Smithson's one. I think our's was the one which was absolutely straight-forward in exploring the question of the lan-guage of architecture, the language of sculpture, and whether there could be a real collaboration between an architect and a sculptor, doing some-thing that they wouldn't have done unless they were working together. Everybody had their own booth, as it were, in a big fair, and could do their own thing.

Our group produced a scheme which was a 'funnel' walk-through; in other words, an architectural experience, using a theme of the curve, both in plan and in section, made by bending 8' × 4' sheets of hardboard. It was pretty rigorous formally – I was tremendously into proportional sys-tems in those days. We made a sus-pended sheet in Frank Newby's apartment where he calculated the interval of the cuts that allowed it to follow the curve we wanted. It was mostly hardboard, although some of

it had aluminium on one side, so it was shiny, and some was matt, sprayed as roughly as possible. Robert Adams devised the relief forms that articu-lated the wall-planes. We had to go out and cadge money and we got various construction firms that we'd been working with to give us the hard-board and the aluminium-faced sheet for the free-standing counter-curve object invented by Robert Adams. It was fun – at the opening Robbie the Robot walked through it. In one sense I think it was the most direct and obvi-ous response to the 'synthèse' theme.

And now everyone's suddenly think-ing that tat the mid-century there was an event of some importance: maybe you're quite right to suggest that it did become a sort of focus of ideas. What's interesting is that the approaches were so diverse. It was full of contradictions but sufficiently interesting to attract all these contra-dictory people to try to sell their wares. It created a platform for people to

Group Ten sculpture with Robbie the Robot

jump, sing and shout, and there was a lot of shouting – many shouting matches, so many fights going on. Richard and Terry Hamilton had a tremendous bust-up with Magda and McHale – who then retired to the far end of the Gallery to do their bit! And I had a terrific eye-ball-to-eye-ball with Erno Goldfinger who said that I was the rudest man he had ever met.

Now I come to think about it the most extraordinary thing of all was the sheer diversity of interests not only between design groups but between, in general, the designers and the word-men – who, of course, will always have the last word! [laughs]

Richard Matthews and David Wager – Group 8, with James Stirling and Michael Pine

Richard Matthews Theo Crosby was the editor of this magazine called *Uppercase* at this time and I'd written

something about Kurt Schwitters which was in it. I can't remember whether it must have happened just before the exhibition, and I was invited to take part on that sort of network.

David Wager But how did we end up with Micky and Jim Stirling?

RM Well, my recollection is that Michael was in touch with Jim Stirling and I was in touch with Michael and you.

DW Well, I'd known Michael since school, and we studied archi-tecture at Birmingham. Micky then disappeared. He decided rather early in his career that he'd had enough of architecture – something that most of us have thought at some time or another – and he went to St. Ives and started doing these spatial sculptures because he came under the influence of Barbara Hepworth. That is how he got involved in the exhibition because he produced this sculpture which was the centre-piece of our little […].

RM And there was James Stirling, who was already established as an architect. I think I was between jobs at the time – I had got fed-up of working at the LCC. David, you gave the back-up with the photo-graphy, with the big enlargements of the bubbles.

DW And the wire netting, which was the skeleton for Micky's papier maché forms. So, my involvement came about purely because I knew Micky, purely accidental. The exhi-bition was very much like what would be called today a workshop, where we were told to get together to produce this thing. I seem to remem-ber that when we decided to do some-thing, there wasn't much longer than a fortnight before the exhibition opened so, there was very, very little time, fortunately, perhaps, because we certainly got off our backsides.

RM I just remember the divergence of the different groups being very apparent at the time. We knew each other perhaps socially but didn't agree.

DW But that was why it was con-venient that the room divided itself into bays naturally, because all these groups of people which formed

were able to be given this territory in which to do their thing. As far as I was concerned, that was the concept of the exhibition.

RM In Lawrence Alloway's introduction he mentions the reaction against the cohesive attitude in Paris of le groupe espace, and the attempt to give it a more pragmatic, British approach. We spent a lot of the time arguing about it – there was a definite divergence of opinion and attitude with Jim.

DW I can't really understand how we got it together, but we did.

RM It got to such a point with the deadline approaching – as architects we recognised the importance of the deadline even then – and we agreed each to write our separate paragraphs [in the catalogue] and they were written quite individually, our own personal opinion. We thought them fairly divergent at the time, but reading them this morning on the train I found there was a remarkable coherence.

DW I think with the benefit of hindsight things tend to become clearer, even the most chaotic. Thinking back, I think it was very important in that it was the focus of people's attention for a couple of months – from that point of view it was a very important event. Whether one would call it an important exhibition or not I really don't know.

RM I don't think it had an effect on the public who came to see it but it did act as a catalyst for everything which came after and it activated a group of people and this was to show itself ten years later. In my opinion, *This is Tomorrow* kept its validity well into the sixties, but then things began to change. Already the seeds were there, of postmodernism. It was a pivotal moment for what it brought about, although not necessarily beneficially.

Toni del Renzio – Group 12, with Lawrence Alloway and Geoffrey Holroyd

There had been a lot of talk about exhibitions of one kind or another and one of the things that I remember with some amusement is that there had been some discussion as to what to call it, hoping to hit upon some form of acronym. And then finally

Detail of photograph of detergent bubbles exhibited with the 'bubble' sculpture. Photo: David Wager

they settled on *This is Tomorrow*, not thinking what this would become as an acronym. I think in some ways that's rather typical of the whole exhibition. It was very amateurish in a way, and nobody quite knew what you ought to do, or not do.

The theme, such as it was, seemed

to be defined by what the individual groups contributed. There was no attempt by anybody to say, no, that's not appropriate. Whatever the group wanted to do, they did. To that extent it was a very dynamic exhibition, and I think that in some ways its very dynamism captured the tabloid press. I think it was well-attended, but then part of that was the use of popular film material – the presence of the famous Robbie the Robot helped make it popular.

I had drifted away from it when they came back to me, in particular Lawrence Alloway, who wanted me to collaborate in putting up an exhibit. Geoffrey Holroyd had already designed what the exhibit was going to be, and so we discussed what we were going to do in the catalogue and then from that we took material to put on Holroyd's stand. The materials were the sort of images which excited the Independent Group, and were meant to be moved around, and juxtaposed in different ways – which was in essence our notion of pop art at that time. It was supposed to instruct people on how to use a tack-board, which was a typical Independent Group conceit.

At the time I didn't think the exhibition was all that important but I did

The Group Twelve tackboard

think that it summarised all the issues which we'd been concerned with. And although nobody knew it at the time, it was to be the swansong of the Independent Group and an appropriate one it was too. Everything that we had discussed showed up. The Hamilton exhibit near the entrance captured most of the publicity in the popular press, partly because of where it was and partly because it was so shocking in a way, it pushed one's attention to the use of popular material. There had been a lot of debate going on as to whether it was a legitimate process or not and many of us felt that the material was of great interest but that you couldn't make art with it, or shouldn't. I remember when John McHale came back from the States, purportedly with a suitcase full of material, pop magazines in one form or another, and one wondered why he had bothered to go to New York to get it since Paolozzi already had exactly the same sort of material which he bought in a little alley off Charing Cross Road. That's one of the issues I quarrel with, the degree to which one should accuse the Independent Group of having invented Pop Art. It invented the term, certainly, or Lawrence Alloway as a member did, but the notion of Pop Art as it developed over a decade or so was extremely remote from most of our interests. My own personal position was that I didn't think at any time that we were heading for the sort of thing which became known as Pop Art, nor was I personally interested in it. A lot of the later developments in New York seemed to me things which had been arrived at quite independently.

Unlike most exhibitions there was very little of it which survived beyond the exhibition. In the Smithson / Paolozzi / Henderson section there were Paolozzi works, but I've never seen those works in any other context, and so in that sense, *This is Tomorrow* is a very different sort of exhibition. It was one which existed purely and simply in relation to an ideology. I think that in itself is such a rare event in English art that that made it seem significant.

It is an important exhibition because of the interest which has been shown in it – I don't think that in itself it earned its right to be thought of as so important. I've never been quite

Interior of Patio and Pavilion with Nigel Henderson's *Head of a Man*
© Nigel Henderson, courtesy Tate Archive

clear whether the interest is a genuine appraisal or the result of a certain amount of hype.

Peter Smithson – Group 6, with Alison Smithson, Nigel Henderson and Eduardo Paolozzi

The initiative for the exhibition was a negative one in that there was a group in France called le groupe espace who thought there should be an 'off-shore' branch, and there were at least two meetings in people's studios to discuss this. The programme of the groupe espace was essentially formalistic and everybody said, no, we don't want that, we want to do our own thing. Theo Crosby, who was then Technical Editor of *Architectural Design*, was the real driving force behind getting the show at the Whitechapel and organising the money. We had £400 for all the groups – it was an amazing thing, everything was done by oneself, very shoestring. It was all Theo, his energy created the exhibition. But the impulse was a collective one, that is, we don't want the groupe espace, we want to do our own thing.

As it turned out, each group made an offering, like a market. Some, like McHale and Hamilton, were consciously futuristic, but the constructivist groups were constructivist – everybody just did what they normally did. In many ways we were special in that the co-operation was completely spontaneous, that is, there was no discussion, and it happened at a time when the friendship between us was at its peak, which I think was the crucial thing, complete accord. Our concept was completely traditional – we [the Smithsons] would provide the framework in which the citizen would live and they [Paolozzi and Henderson] would decorate it. There was a lot of play with the obsolescent and the new, symbolically represented. The lining was a dull aluminium screen so that you saw everything at any time. In a sense it was a genre piece, a combination of surrealism through Nigel and art brut through Eduardo, a genre work based on two previous generations. We [Smithsons] went away to Dubrovnik – to a CIAM meeting – and we were knocked down by it coming back – without any discussion, from nothing to the complete thing was miraculous.

It's become an icon of the period. It was also an act of affection for the gallery because it was fantastically unpretentious as a building. It was the high point of English new art when it was made and it would have been seen as very pretentious when it was new, but it was an old building – the lighting was very simple, there was no restaurant – and it suited our mood exactly. Therefore, there was a secondary stimulus from the building itself. We were at the back, under a rooflight, and we had no control over the light. When it was rebuilt at the ICA [for an exhibition on the Independent Group in 1992], we could control the windows to the park, and the light via shutters, and that was fantastic – they remade all that junk! What an act of love!

It was important for us – and the last exhibition which we did together. *Parallel of Life and Art* [held at the ICA in 1952] was the first, and both were done without money – I think we had £200 for *Parallel of Life and Art*. They were the two exhibitions which we did spontaneously because we wanted to, without resources. It happened in a time-span of about three years – it couldn't have happened before or after, and I'm sure art always works the same way. We were very confident – we were young. Our section was the best of course, all the rest were rubbish, but we were too snobbish to say so! [laughs]

Jeremy Millar is an artist, writer and curator. In 1998 he curated *Speed* at Whitechapel Art Gallery and The Photographers' Gallery, London

Alison and Peter Smithson in the *Patio and Pavilion* section they shared with Henderson and Paolozzi, 1956
Photo: Richard Hamilton

The Rauschenberg Retrospective in 1964

by Brandon Taylor

Robert Rauschenberg's retrospective in the early part of 1964 was a triumphant moment in the story of the post-war Whitechapel Art Gallery, and if good timing is the hallmark of the professional curator, then the show added considerably to Bryan Robertson's already solid reputation in the office of Whitechapel Director. But it was a risky venture too, because the exhibition ate up the entire exhibition budget for 1964. The critical response was extensive, and symptomatic. And the success of the show can be measured by the fact that a daily average of 1,876 people saw it throughout its two-month run, a record in the recent history of the gallery. [1] Many more saw or heard it being discussed on radio or TV.

The story of that success is one worth recounting today. The Whitechapel's traditional association with Christian philanthropy, and its place in a neigh-bourhood where socialist activism had the status almost of a tradition, made the introduction of American and international modern art not always straightforward in the period after World War II. A Picasso show projected by the young Bryan Robertson shortly after his appointment in 1952 had come to naught, on account of the unwillingness of Kahnweiler, Picasso's French dealer, to support the project. He seems to have thought the Whitechapel insufficiently well-known as a modern art venue. It was also felt by the Whitechapel Trustees that Picasso's well-known Communist Party sympathies might lead to a narrowly 'political' interpretation of the show. [2] The spread of Cold-War attitudes meant that a selection of contemporary American art to be entitled *Fifty Years of American Painting* was also scrapped, in 1956, following protests by anti-Communist groups in America. [3] The Jackson Pollock exhibition at the Whitechapel in 1958 was the consolation prize. Yet following a success-ful Rothko exhibition in 1961 and a show devoted to Mark Tobey in 1962, Robertson became identified in his own and others' eyes with a mission to bring contemporary American art to London. To extend this pattern, Robertson met Leo Castelli and Robert Rauschenberg in New York in the fall of 1962, and began to discuss the possibility of a large solo exhibition in London. It was not until a year later, at the end of September 1963, that he broaches the subject with Castelli again. 'Dear Leo', he writes, 'you must have wondered about my silence over the Rauschenberg since my return to London a year ago ... We've had to go through a very intensive and arduous phase of fund-raising — this Gallery has an inadequate income and we've always had a tough time in reconciling the necessary standard of exhibitions with this low income ... I've been working with a depleted staff, without an assistant ... Anyway, the situation is now, at last, tremendously improved'. Robertson had heard of the success of Rauschen-berg's retrospective at the Jewish Museum in New York, organised by Alan Solomon in the spring of 1962. He asks Castelli to send a catalogue over. Then he proposes a show in London 'of about 50–70 works, including the Dante series' (a series of 24 drawings that Rauschenberg had recently made based on Dante's *Inferno*). But above all he urges upon Castelli the urgency of acting immediately: 'A Rauschenberg show is tremendously important for London', he says, 'and the mental climate is now exactly right'. He'll postpone a Franz Kline show until later, if need be. 'I want to present Bob (Rauschenberg)'s work here before the Kline show ... *at the right time*, which is now ... Could you be very generous and understanding, dear Leo', he pleads, 'and let me know as quickly as possible whether the plan is feasi-ble?' [4] Another letter to Bill Lieberman of New York's Museum of Modern Art stresses that 'there is a right

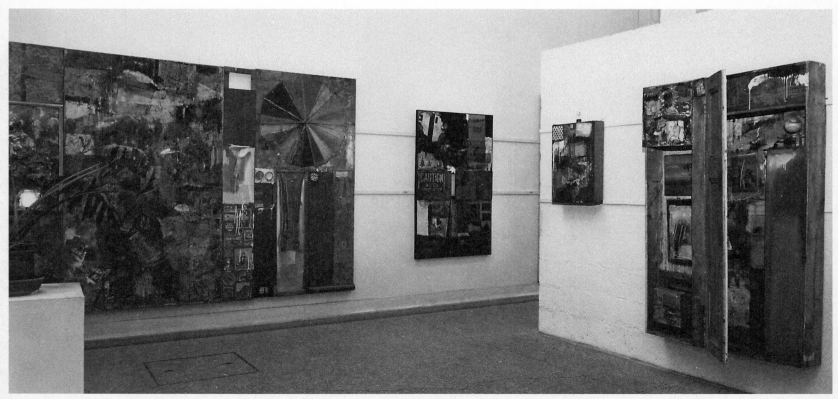

fig 1 (from left to right) *Charlene* (1954), *Trophy I (for MC)* (1959), *Untitled with Light Bulb* (1954), *Interview* (1955)

moment and a wrong moment for exhibiting works of art; and ... this is the perfect psychological moment for what will, in effect, be Rauschenberg's first exhibition in London'. [5]

So Castelli was to help obtain 'combine' paintings, the large assemblage-like constructions made of found objects, and some of the very new silk-screen paintings. Lieberman was to supply the Dante drawings, recently donated to MOMA's growing collection. But why was 1964 the 'right moment'? Perhaps two or three factors contributed. The allure of Abstract Expressionism had inevitably waned since the impact of seeing Pollock, De Kooning, Kline and others in *Modern Art in the United States* of 1956 and *The New American Painting* exhibition of 1959, both at the Tate. Since then the spread of large-scale 'drip' painting had been rapid, perhaps too rapid; it was no longer *au courant*. By the same token the emergence of something called 'Pop' in the later 1950s was well past its first flush of success, and many English critics viewed its shiny surfaces and too-frequently celebratory mood as decidedly superficial – I summarise a long and complex history here. But most importantly, a dilemma had arisen in both the studios and in critical thought about the arts. How was large-scale *belle peinture* to be brought back into contact with the materials of low culture, even of

kitsch? How could the photographic or commercial surfaces of, say, Independent Group avant-gardism – especially the American enthusiasms recently developed by John McHale and Richard Hamilton – be reconciled with the format of modernist or colour-field painting? Another form of the same question was to ask how the Duchampian ready-made could 'combine' its paradoxes and conundrums with the highly invested semantics of modernism's autobiographical mark? Rauschenberg's new work seemed to supply one kind of answer. A final condition is more prosaic. International air travel was by the early 1960s taking more and more people to the United States, especially New York. The excitement likely to be generated by a young American able to first register and then creatively shuffle the perceptual conditions of this new culture would be a rich prize indeed.

Robertson understood these factors in 1962, and he understood too that everything was in the timing. As he confesses to Leo Castelli in his September 27 letter, the planned Franz Kline show 'should really have been seen here four or five years ago: it's not really the right moment now'. [6] It finally took place in the later summer of 1964. Perhaps Robertson would also have admitted that Rothko had already been 'late' in 1961, just as Morris Louis and Lee Krasner might

seem a little late, when their time came, in 1965. But Rauschenberg in 1964: that seemed right, and Robertson was surely right about it seeming right. Even before the Jewish Museum show in 1962, Rauschenberg had had two combine paintings in the 1959 Paris *Biennale*, vying with the Groupe des Informels and the artists who the following year would become Les Nouveaux Réalistes; and he had had a prominent place in the *Art of Assemblage* show curated by William Seitz at New York's Museum of Modern Art in 1961. But he had yet to be seen in England. As Robertson wrote to the hapless young editor of London *Vogue* who dared to take the forthcoming Whitechapel show less than seriously, 'Rauschenberg is a kind of hero figure for a very widely distributed younger generation of artists all over America and Europe. He has revolutionized certain recent developments in art ... the exhibition will be his first of any consequence in Europe, and certainly his first show in London'. [7]

The press view of *Robert Rauschenberg: New Paintings and Drawings* was held on Monday 2nd February 1964. The evening before, a cold Sunday night on which affluent Britons would be gathered around their newly hire-purchased TV sets, a BBC *Monitor* programme under the stern hand of Huw Wheldon broadcast an interview between Robertson and Rauschen-

berg, who had been flown over the Atlantic for a few days and of whom photographs had already appeared in the London press. In his introduction Wheldon announced that 'serious people were taking Rauschenberg very seriously indeed' – itself an indication that the best 'Pop' art need be neither frivolous nor merely fun. Such pre-publicity could scarcely have been bettered. For the next two months the show was greeted enthusiastically by the majority of the press, who (with some exceptions) saw Rauschenberg as the *enfant terrible* of a new type of artistic consciousness that was both fascinating (and fascinated) and unsettling.

The show was hung with due sensitivity to the scale, size and in some cases the considerable physical weight of the works (fig 1). Starting from Rauschenberg's *White Painting With Numbers* (1949) but omitting the all-white and all-black canvases of 1950 to 1952, the emphasis was squarely upon the 'combine' works of 1954 onwards, up to and including the dramatic switch to silkscreen methods that took place in Rauschenberg's work in 1962. Not only had the artist introduced into his combines a cockerel, a bedspread, a bicycle wheel, a necktie, Coca-Cola bottles, a bag of cement, a drain-pipe, boxes, a pistol and a chair, but he had done so, according to most reviewers, by freshening the by now somewhat stale conventions of 'Pop' art celebra-

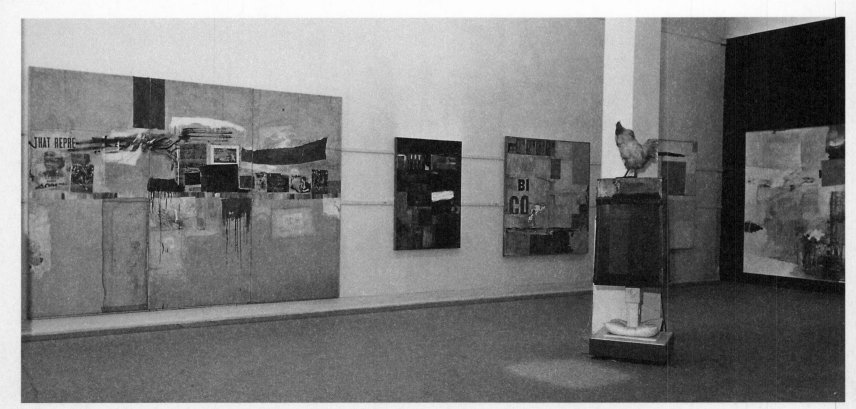

fig 2 (from left to right) *Rebus* (1955), *Curfew* (1958), *Gloria* (1956), *Odalisk* (1955–8), *K249765* (1957), *Flush* (1964)

tion. The presence of three radio sets built into the surface of *Kite* (1962), or the light bulb flashing on and off on the top of the small *Untitled with Light Bulb* (1954) – or again in the interior of *Odalisk* (1955–8) (fig 2) – was perceived as provocatively extending the sensory range of fine art, and (at least for some) as having transgressed or even broken its boundaries. Only for a minority were these transgressions disagreeable. *The Times* called the show 'the most exhilarating art exhibition to see in London', adding that 'even the most conservative spectator can scarcely fail to find it impressive, amusing, diverting, and as tonic as a novel holiday'. As so often, *The Times* managed to import a range of elite personal values into its review. It argued that Rauschenberg's works were 'sophisticated and modish, ... they triumph by their purely formal excellence and by their exquisite tact'. Reference was made to Rauschenberg's 'infectious mannerisms', the 'general integrity, the subtleties, the niceties of balance' of the work [8] – in effect a classic patrician vocabulary that identified for an upper-class readership values that they could recognise as applying not only to Rauschenberg's work, but to themselves, as complex self-descriptions in the mirror of art. Edwin Mullins of the *Sunday Telegraph* recognised Rauschenberg as 'the most important artist America has produced since Jackson Pollock',

positioning him at the synthesis of two traditions: an American tradition of 'free' painting, and a European one of objects from everyday life after the manner of Schwitters and Marcel Duchamp: 'This ability to link two quite different traditions is the key', wrote Mullins, 'to what Rauschenberg is trying to do'.[9] Nigel Gosling in *The Observer* spotted acutely that Rauschenberg was playing around with the codes and languages of representation: 'Take a table: remove it and remember it; draw the memory; reflect the drawing in a mirror; photograph the reflection; reproduce the photograph – you can go on for ever, receding from the image until the mind goes dizzy, and Rauschenberg does: he plays with the intellectual facets of an object as the Cubists played with its material facets'.

In fact Gosling got the latter point wrong, by today's lights. I suspect that we would now say that Rauschenberg has the material facets, the Cubists the intellectual. As Gosling himself went on to say, 'Rauschenberg is the most sensual of observers, with a touch as seductive as the stroke of a sable brush. Old iron becomes velvet in his hand'. Gosling had some other good phrases too: 'An intensely private world in which the elements are drowned in an overall awareness'. 'This is how it feels to live in New York now'. 'You are reminded of the magic-lantern images moving "invin-

cibly" over Marcel (Proust)'s bedroom door'; and so on. Rauschenberg's 24 drawings in chalk, watercolour, pencil and transferred photographs illustrating the Cantos of Dante's *Inferno,* Gosling described as 'elusive, allusive, exquisitely handled ... graphic masterpieces. Intelligence and sensibility have married and raised a family'. Picasso and Rauschenberg, says Gosling, are 'two jackdaws of genius, two wizards transmuting ashes and diamonds impartially into gold'.[10]

The competent critics of the day roundly agreed. John Russell in the *Sunday Times* suggested that the combines of the Rauschenberg exhibition presuppose 'first, pressures of a kind which exist only in a city which knows itself to be on top, and secondly, the presence of an alert and prehensile intellectual minority' (features he found lacking in most London art). But above all he referred to Rauschenberg's 'jumping nervous energy, the ability to dominate and organise a great variety of material, a command of new visual techniques, and ... a constructive sense of history.'[11] Guy Brett too, enthusiastically observed that 'the longed-for transformation of the ordinary objects of the mid-twentieth-century into the interrelated parts of a much grander object, the picture, has taken place.'[12] It may be significant that no critic referred to the exhibition's catalogue texts, and perhaps

for good reason. They have every appearance of having been thrown together at the last moment: an old Henry Geldzahler reprinted from *Art International*; an extract from John Cage's *Silence,* already published in 1961; and an old piece by Max Kozloff from *The Nation*. Evidently Robertson's plans to get a fresh text from Robert Rosenblum, or a new piece from Cage, all came to grief. Here too there is a contrast with the present day. Relatively little time was spent on 'interpreting' the works collectively or singly from a contemporary point of view.

One might say in summary that the Rauschenberg show impressed itself upon the major London critics as something like the great synthesis of art and life for which the ground had already been prepared by the succession of abstract and then Pop art. Many writers repeated Rauschenberg's often-quoted remark that 'Painting relates to both art and life. Neither can be made. I try to act in the gap between the two'. Yet they surely missed the significance of that middle part: 'neither can be made'. Nor did they much speculate what things were like in 'the gap between the two'. But the journalists were nearing the mark. An *Observer* column a month later spotted that Rauschenberg's work 'marks the end of the Hundred Years' War between photography and unrepresentational

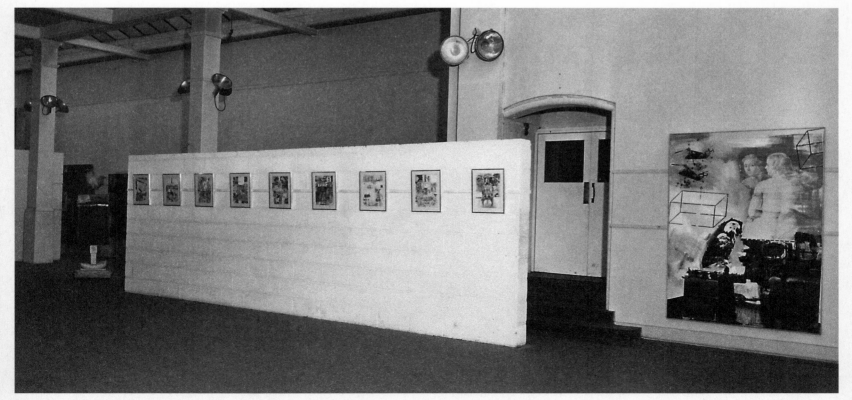

fig 3 (from left to right) *Dante drawings* (1959–60), *Tracer* (1964)

painting – it marks the end of the divorce between everyday life and high art: they've been growing together in recent years. Now they touch. The crowd and the exhibits at the Whitechapel looked as culturally linked as a medieval tapestry: this hasn't been true of intelligent art and popular taste in Europe since the 18th century'.[13]

Taken as a whole, then, one can perhaps say that the level of newspaper discussion on Rauschenberg's combines reflected creditably upon a London art world already in the midst of headlong social and economic change – change both in the commercial oppressiveness of everyday life and in the make-up of British institutions themselves. Only the *Daily Telegraph* was seriously offended. 'What cannot be justified', Terence Mullaly griped, 'is the uncritical, or even worse, the cynical praise that has been bestowed upon the 24 illustrations to Dante (fig 3). It is difficult to know whether they, or the esoteric nonsense written about Rauschenberg, are a greater affront to the senses … The gallery is strewn with hazards … pompous or gullible writers lie in wait to convince the unwary that Rauschenberg's work has something lasting to say of this, or any other age. They should be ignored.'[14] It was a level of paranoia matched only by the correspondent from *Apollo*, who could see only 'an

untidy and somewhat tedious neo-Dada hotch-potch that has gone as cold as the skiffle of a few years ago … a confusion that deteriorates into nihilism and virtual impotence. This is barren land'.[15] It was left to Andrew Forge, in a reflective piece in the *New Statesman*, to address a 'problem' that certainly preoccupied American critics at the time, and is still active in the critical reappraisals of Rauschenberg's career, namely his withdrawal from assertion; his ambiguity, his distracted, apparently non-committal posture. Yet he was 'engaged' with and by something. Forge knew enough about modern art to phrase it in terms of what Rauschenberg did *not* do: he did not aim to shock, like the Surrealists, nor to emote, like the action painters. His work was 'cool, reflective, unrhetorical, the opposite of weird' (weirdness had often been alleged). It wasn't overly personal, or even *made*. Forge noted its modesty, its shying away from anything that could be called discords or harmonies, 'its indifference to the swollen self-projection that sustains the run of modern art'. Rauschenberg's characteristic rhythms and tonalities, Forge suggested, were 'more like those of the Whitechapel High Street than like any kind of picture, abstract or naturalistic.'[16] One might say that a sense of welcome puzzlement was a leitmotif of the critical response – puzzlement combined with the reassurance that

Rauschenberg was a master draughtsman in the European tradition, and a master philosopher (of some kind) with the resources of urban detritus and paint.

One feature stands out, finally, in the London responses to Rauschenberg in 1964, and this is a dawning awareness, one that is still on the agenda today (or deserves to be), of the relation between the combine paintings after 1952 and the more or less sudden turn to silk-screen methods which took place in New York in 1962. For it marks a fundamental 'moment' of post-war art that in or around September of that year both Rauschenberg and Warhol had 'discovered' silk-screen methods of transferring photographic pictures to canvas (even though Rauschenberg had included a silk-screened head-scarf from the Metropolitan Museum's shop in an earlier combine and in that sense must have known what the technique involved). The fact is that few London observers, and perhaps not even Bryan Robertson, would have known that in 1960 Rauschenberg had moved from his studio at 128 Front Street in the South Street waterfront neighbourhood of lower Manhattan, to a new loft at 809 Broadway, and that this change of physical location was gradually contributing to a substantial and irreversible set of changes in his work. For immediately after the move to

Broadway, both the methods and the subjects of his combines shift decisively, and apparently for the worse. Suddenly removed from immediate contact with the street culture of garment traders, small shops, and the river front commercial life of lower east side New York, he begins around 1960 and 1961 to incorporate into his work images of wider American and national significance, such as JFK, military trucks, helicopters, space capsules, even baseball. And we find that those national themes and images deal relatively uncritically with contemporary American political and cultural life. The US space programme is a patriotic event. JFK is a saviour. Technology in all its forms is king.

Rauschenberg's 'shift' into silkscreen that takes place in September 1962 is part and parcel of a quite widespread technicisation of the image among artists of the early 1960s; in which it is aligned with mass-production techniques more typical of an earlier phase of commercial capitalism, in short, a much earlier phase of modernity in which one-by-one construction techniques are replaced by fordist methods of multiplication and uniformity. Some of the first, black-and-white images from Rauschenberg's new process were present in the London show. The very first, *Payload* (1962), and four others from the following year, includ-

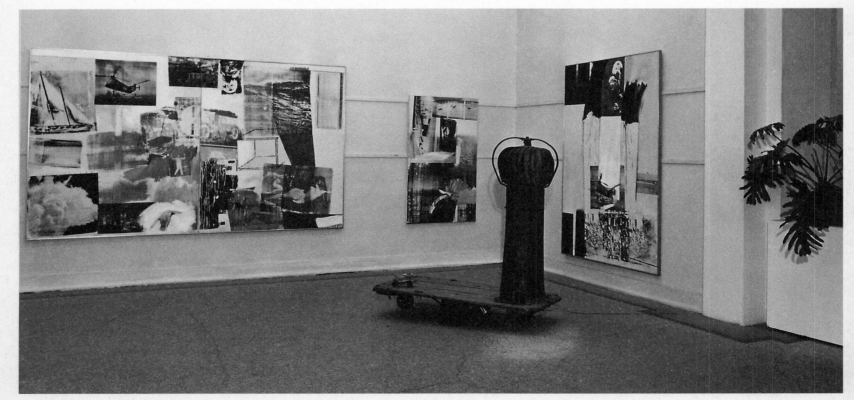

fig 4 (from left to right) *Bicycle* (1962), *Payload* (1962), *Empire II* (1961), *Kite* (1962)

ing *Kite* and *Bicycle* (fig 4), and the 27-foot long *Barge* (all of 1962), as well as some coloured silk-screen works such as *Tracer* and *Flush* (both of 1964) all dominated the later stages of the Whitechapel show. Yet only two commentators were astute enough to register the change. The traditionally-minded *Burlington Magazine* found the earlier combine paintings ingenious, but deficient in what it called 'formal connexions'. 'In the silk-screen paintings, however', the *Burlington* suggested, 'the very process allows repetition and a merging of images and it can impose great areas of a single, controlled, tone. The finest work of all is the largest: *Barge*, an enormous painting in black, grey and white. Here, the images cooperate, the sense of flux is preserved, a unifying style has been found'.[17] Such a formalist defence of silk-screen was not however favoured by the young art historian Stephen Bann, more concerned with the philosophical implications of Rauschenberg's two techniques. For Bann, Rauschenberg's play with issues of representation in the combine paintings had landed him in an inescapable paradox: that the inclusion of real objects which, while remaining ordinary, had ostensibly led to 'an increased immediacy and vitality', had rendered the work 'ultimately self-defeating'. On the other hand the new silk-screen method had not only imposed a much-needed technical unity on the picture surface, but had allowed Rauschenberg to comment on the illusory nature of illusion itself, by overpainting photographic reproductions, cancelling illusionistic cubes, and subjecting the codes of representation to a degree of radical self-reflexivity. For Bann, Rauschenberg had used silk-screen to vindicate a basic truth about representation, that it is concerned not with imitating or reproducing an external form, but with establishing a substitution 'at a distance' from the viewer's space.[18]

There is insufficient space here to comment on the multifarious European and American implications of the Whitechapel show. Suffice it to say that the show helped establish Rauschenberg as the main American exponent of a new sensibility of ironic, amused, sometimes bewildered detachment — a detachment both personal, political and ethical

– in the face of the burgeoning new commercial and cultural order of the fast-developing West. What we might now define as Rauschenberg's posture of radical non-commitment — a posture Brian O'Doherty would later characterise as awareness structured by a 'vernacular glance' directed at a sensorium newly colonised by commerce, rapid communications and the bland absurdities of American TV[19] – this posture was itself the value, the mode of existential commitment, that European intellectual elites were now being challenged to adopt and understand.

The success of the Whitechapel show in these terms played its own part in the award to Rauschenberg of the International Grand Prize at the *Venice Biennale* some two and a half months later. The award was surrounded by controversy as to whether Rauschenberg was strictly eligible, given that his pictures were only on show at the US annexe, and not in the official *Biennale* grounds (the Giardini) where large paintings by Morris Louis and Kenneth Noland were on show.[20] But here too, chance,

and some clever timing, would play a part. Merce Cunningham's Dance Company was at that time passing through Venice on a world tour; and on the night before the Prize announcement, Rauschenberg's set designs could be seen on stage at La Fenice. By happenstance, the president of the *Biennale* jury, Arnold Hamacher, who that same morning had threatened to resign if Rauschenberg won the Prize with his off-site works, was in the audience — and fortunately he loved the spectacle. Next morning, Rauschenberg's works were hurriedly transported by barge to the Giardini, where the artist duly received the Grand Prize. Noland and Louis, both of Clement Greenberg's critical stable, were eclipsed, along with a widespread indigenous European pop art movement and several varieties of abstract art. At the end of a narrative that had begun in the east end of London at the Whitechapel, Rauschenberg's international reputation, and with it a seismic shift in at least one dominant way of understanding American culture and values, was assured.

Brandon Taylor is Professor of History of Art, University of Southampton. His most recent book is *Art for the Nation: Exhibitions and the London Public 1747–2001*, Manchester University Press, Manchester 1999. He is currently working on a book on *collage*.

Notes

1 For this and other information I am indebted to the MA dissertation by Janeen Haythornthwaite, *American Art and the Whitechapel Art Gallery in the 1950s*, University of Southampton 1998.

2 Minutes of the Trustees meeting of 10 December 1952, WAG archives.

3 'The Director said that...the citizens of Texas had pointed out that some of the painters to be represented in the (*Fifty Years of American Painting*) exhibition were Communists...', Minutes of the Trustees meeting of 19 September 1956, WAG archives.

4 Bryan Robertson to Leo Castelli, letter of 27 September 1962, WAG archives.

5 Bryan Robertson to William Lieberman, letter of 21 October 1962, WAG archives.

6 Bryan Robertson to Leo Castelli, letter of 27 September 1962.

7 Bryan Robertson to Anne Garland, letter of 29 September 1962, WAG archives.

8 *The Times* (unsigned), 8 February 1964.

9 E. Mullins, *Sunday Telegraph*, 9 February 1964.

10 N. Gosling, *The Observer*, 9 February 1964.

11 J. Russell, *Sunday Times*, 9 February 1964.

12 G. Brett, *The Guardian*, 11 February 1964.

13 *The Observer* (unsigned), 8 March 1964.

14 T. Mullaly, *Daily Telegraph*, 24 February 1964.

15 *Apollo* (unsigned), February 1964.

16 A. Forge, *New Statesman*, 21 February 1964.

17 *Burlington Magazine*, March 1964.

18 S. Bann, *Cambridge Review*, 7 March 1964.

19 B. O'Doherty, 'The Vernacular Glance', *Art In America*, November 1972.

20 For the story of US involvement in Venice in 1964, see L J Monahan, 'Cultural Cartography: American Designs at the 1964 Venice Biennale', in S. Guilbaut (ed.), *Reconstructing Modernism; Art in New York, Paris and Montreal 1945–1964*, MIT, Cambridge, Mass. 1990 pp 269–416. Further detail is provided in L. Alloway, *The Venice Biennale, 1895-1968*, Faber & Faber, London 1969 pp 149–152.

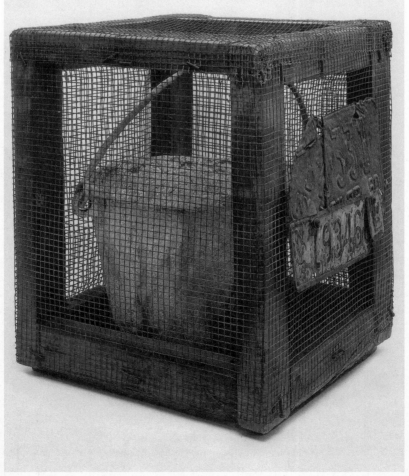

fig 5 *193466* (1961), construction, 48.8 x 38.1 x 38.1 cm Collection Kate Gantz New York.

Hélio Oiticica's 'Whitechapel Experiment'

by Guy Brett

'Shalom of Safed; Hélio Oiticica; Helen Frankenthaler; Robert Downing; Yves Gaucher; Three Israeli Artists: Agam, Lifshitz, Zaritsky.' So reads the entry for 1969 in the list of Whitechapel Gallery exhibitions between 1901 and 2001. How many different circumstances, contexts, histories, styles, memories, are reflected in this brief list! How many more if the focus draws back to consider 100 years of activity of one prominent London venue. For years the Oiticica exhibition was all but forgotten in the British art world. The show deeply inspired a number of artists and other visitors and the experience

remained lodged in their minds as a liberating influence, but it was not until the mid-eighties, several years after Oiticica's death, that the importance of his work began to be recognised internationally and outside his native Brazil. It is now commonplace for his name to be invoked in writings, conferences and debates, especially those that discuss the future of art in the era of 'globalisation'.

Oiticica's 'Whitechapel Experiment' or 'Whitechapel Experience' (he never used the word exhibition) was one of the most audacious visual arts events of the sixties in London. He conceived of the space as a complete integrated 'environment', rather than

a show of discrete objects – only the second time, I believe, that such an undertaking had been attempted at the Whitechapel.[1] Oiticica's experiment was also audacious for its proposal of 'spectator participation', an aspect which was received with considerable scepticism and sometimes scorn, by a number of critics. In this aspect Oiticica's Whitechapel show anticipated by two years Robert Morris's experiment in spectator participation at the Tate Gallery in 1972, a show that was famously closed a few days after the opening because the structures had been physically destroyed by the public (an aggressive energy and conflictive dynamic that never emerged at Oiticica's Whitechapel show).[2]

Outside the art institution, participatory experiments were already in full swing in the late sixties among a number of artistic groups, notably David Medalla's Exploding Galaxy, with whom Oiticica planned to collaborate when he arrived in London (Exploding Galaxy members were regular visitors and helpers at the Whitechapel show and Hélio devised an event for the group – 'Galaxyen' – which, however, never took place since a large contingent of the Galaxy, including Medalla, had set off on a journey to India). The French writer Jean-Christophe Royoux has recently described the 'participation of the spectator' as the key legacy of the avant-garde of the 1960s and 70s.

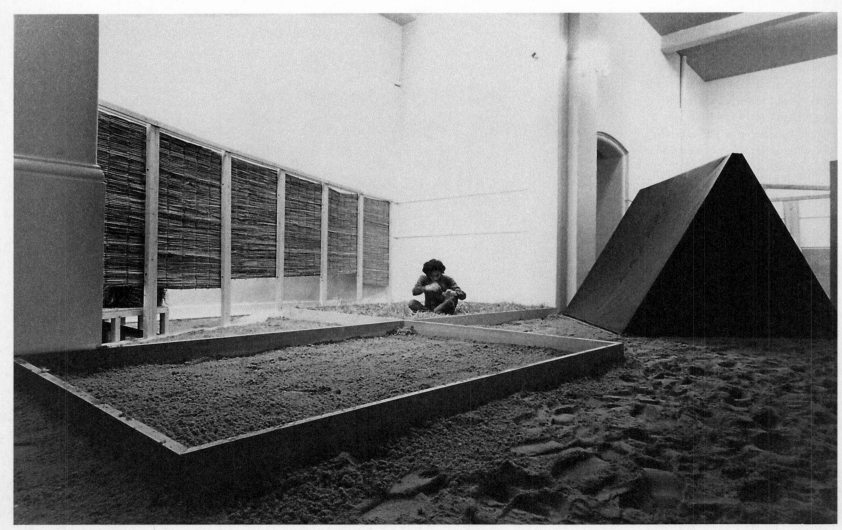

*Area Bolide 1,*1967, *Area Bolide 2,* 1967 and *Caetano-Gill Tent,* 1968 in *Eden* installation
Archives Projeto Hélio Oiticica, photo: John Goldblatt

In an article reviewing *documenta X* 1997, he expressed strongly the opinion that the forms of interaction provided by the new information technology were sadly impoverished compared with ideas artists had proposed in the 1960s. 'Redefined as practice' he wrote, 'art was conceived as a critical model able to explore various forms of the individual's social, psychic, or linguistic integration to a reality informed and deformed by the all-pervasive power of mass-culture. The aim of art, broadly aligned with the other manifestations of sixties counter-culture, was therefore clear: To expose the spectator, within the frame of a precisely defined spatial environment, to a theatricalised experience offering the means of access to alternative modes of self-fashioning.'[3]

The causal chain that led to Oiticica's London exhibition probably began with visits by David Medalla, Paul Keeler and myself to the studio of Sergio Camargo, the Brazilian sculptor living in Paris, in 1964 (we had been introduced to Camargo by Christian Ledoux, who later became a Galaxy member). Camargo's white reliefs were shown in 1965 at Signals London, the space in Wigmore Street run by Keeler and Medalla, as one of a series of exhibitions which introduced London to the work of a number of Latin American innovators: Lygia Clark, J. R. Soto and Mira Schendel among others. It was Camargo who made us realise that an extraordinary group of artists had emerged during the 1950s in Brazil. By 1965 Oiticica's work had featured in *Signals Newsbulletin* (a newspaper-format gallery journal edited and designed by Medalla)[4] and a show of his work was planned for 1966. A first consignment of work had already arrived from Brazil when the Signals enterprise foundered economically and was forced to close. To send Oiticica's work back to Brazil unseen was unthinkable so I set about looking for a venue for it during 1967. I invited Bryan Robertson, then the Whitechapel Director, to see a collection of Hélio's *Bolides* (wood boxes and glass flasks containing pigment, gauze, earth, glass, and interior compartments) assembled at my flat in Soho. He was so taken with these radiant objects that he proposed a show on the spot and wrote an invitation to Hélio a few days later.

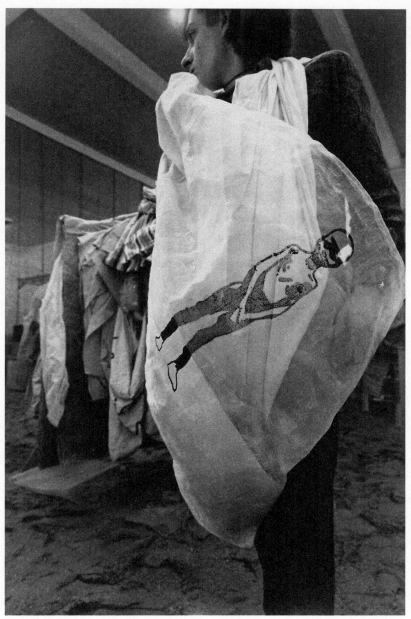

Torquato Neto with *Parangolé P22 Cape 18*, Nirvana realised with Antonio Manuel, 1968. Archives Projeto Hélio Oiticica, photo: John Goldblatt

However it took almost another two years for the show to come to fruition.

Though almost unknown in London, and having no dealer behind him (Oiticica avoided the gallery system throughout his life, and indeed saw himself as a creator of 'situations to be lived' rather than as a producer of objects), he stuck to his principles regarding the realisation of the radical concept he had for the Whitechapel exhibition. In particular he defended the need for individual works to be seen as part of an environmental whole that would be specially constructed for the show. There were, certainly, distinct objects of individual origin, but he wanted them to be known and felt 'in the sense of orders for the whole'; in other words, not to appear isolated but as 'cells of an environmental idea that has for a long time been the aim of all my creative process and theoretic thinking'.[5] At

one point, the distinguished Brazilian art critic Mário Pedrosa, friend and long-time champion of the artist, came to London to meet Bryan Robertson and explain Oiticica's concept in more detail. The show finally opened in the form in which Hélio wanted it in February 1969, a few months after Bryan Robertson's retirement as Director and his replacement by Mark Glazebrook.

Oiticica was actually present in the gallery for much of his event and could often be found resting or writing in one of the cabins, or *Penetrables*. The whole ensemble constituted a kind of village, campus, or 'mind-settlement' as he called it. It was the proposal of what he termed *Creleisure* (a neologism combining creation, growth, leisure, pleasure, and perhaps Creole). You took off your shoes before stepping onto the sand of *Eden*, as the central environment was called;

otherwise you could not enter. Rather than a simple and mechanical form of behaviourism, Oiticica's *Eden* was an invitation to play and reverie, whose ends were open and unconditioned. There were *Bolides* to be explored by hand, and sometimes by smell, cabins for solitary reverie and other, more communal, spaces. There were *Parangolé* capes to be worn and danced in, and there were the *Nest-Cells*, a cluster of boxes each about 2 metres by one, divided by veils, which the visitor was invited to make habitable with found materials of their own choosing and in their own way. Hélio drew a map of *Eden*, which was printed in the catalogue with a Joycean subtitle: 'an exercise in the creleisure and circulations'. All in all, Oiticica took a daring inspiration from the simplified forms of twentieth century abstraction. Instead of the confrontational, irreducible 'objecthood' of the minimalists, he proposed open voids to be entered and inhabited. His environment, though minimal, had a rhythmic feel, strongly marked by the popular in Brazilian culture, but not in a folkloric or illustrative way. It allowed a subtle exploration of the relationship between the subjective and the social, the poetic and the material.

These were the general features, but if one came down to the fine detail there were many subtle differentiations. For example, the *Parangolé* capes ranged in their effects from provoking a feeling of sensuous exaltation to the chafing burden of hunger, from exuberant wraps of pure colour to a wearable 'banner', in which the silk-screened image of Che Guevara could be shown or hidden by turning the materials inside out. Beside the genie-bottle filled with coloured liquid and vaporous gauzes, which was rather suprisingly called *Homage to Mondrian*, was a tribute of a different kind: a dark hinged box containing a small bag of red pigment and a repeated photograph on all four sides of the bullet-torn body of a young man. This youth was Cara de Cavalho ('horse-face'), a *favela* (shanty town) outlaw and friend of the artist, eventually gunned-down by the Rio police. This work, Oiticica said, was a memorial to 'the individual social revolt'.

The exhibition divided the critics. Paul Overy in *The Listener* wrote a sympathetic review, as did Elizabeth

Whitechapel Experiment installation, 1969. Archives Projeto Hélio Oiticica

Glazebrook in *Queen*. Jasia Reichardt took the work seriously but not to the point of removing her shoes to enter *Eden*. *The Observer* dismissed the show as 'infantile', and for the *Sunday Telegraph* it had less interest than a 'dry ski slope'.[6] Both the latter critics took the work merely literally and felt disappointed that it failed to match up to the 'real world'. What was lacking then was any sense of the artistic history of 20th century Brazil, in which Oiticica's work had developed, and, furthermore, of how an innovatory artistic practice could emerge from a 'third world' context and address itself to some of the deepest dilemmas of contemporary culture.

A highly sophisticated artistic evolution was secreted in the playful spaces of the 'total environment'. One of its 'tracks' was a gradual progression that Oiticica made, from the predominance of the eye in the experience of colour to its apprehension by the whole body. This could be traced in the first part of the exhibition, after one had entered through the main door, as Oiticica

moved from monochrome paintings of the 1950s, inspired by Mondrian and Malevich, through the free-hanging *Bilaterals* and *Spatial Reliefs* of 1959, to *Nuclei* and *Penetrables* (1960), labyrinths and cabins of close-keyed colour panels to be walked into, and finally to the *Parangolé* capes, complex sewn structures to be worn, delved into or danced in. Here the formal influence of European constructivism ceded to that of

Carnival and Samba, without, however, sacrificing the lucid legibility of early abstract art. Another track was Oiticica's digestion and supercession of Pop art, represented by the Penetrable *Tropicalia* (1967) and by the environment *Eden*, which was realised for the first time at the Whitechapel exhibition.

To put it briefly, *Tropicalia* (a spiral labyrinth in the guise of a Rio 'back-yard') wrested the Pop image away from its North American association with consumer culture and located it amidst the aspirations and adversities of the Brazilian metropolis. The work was hugely influential in Brazil for that reason, but Oiticica almost immediately became critical of its reception. His view was that a fixation on visual imagery had prevented people from noticing the bodily experience of penetrating the environment, which to him was more important. Consequently, in *Eden*, he emptied the *Penetrables* of imagery, relying only on a few sensory stimuli in a spatial void. The 'supra-sensorial' he called it; where the artist would give the barest minimum, a sort of template or 'behaviour-cell'[7], to be developed by the participants according to their own imaginations and cultural particularities.

'It is not the object which is important but the way it is lived by the spectator'. The completely new attitude taken by a number of Brazilian artists in the 1960s towards the role of the object has now become more widely known and understood internationally. In Oiticica's own way of referring to his works, a precise placement of the object within a set of conceptual orders (according to its

location within the environmental whole), was accompanied by a kind of ambulatory description of encountering it, full of sensory clues. Writing from the depths of a London winter, assessing the meaning his Whitechapel experiment had had for him, he described how:

'Structures become general, given, open to collective-casual-momentary behaviour; in Whitechapel, behaviour opens itself up for whoever arrives and bends forward into the created environment, from the cold of London streets, repetitive, closed and monumental, and recreates himself as if back to nature, to the childhood warmth of allowing oneself to become absorbed: self-absorption, in the uterus of the constructed open space, which, more than 'gallery' or 'shelter', this space was....'.[8]

Guy Brett is an art critic and curator, whose recent exhibitions include *Force Fields: Phases of the Kinetic* at the Museum of Contemporary Art, Barcelona and the Hayward Gallery, London.

Notes

1 *This is Tomorrow* in 1956, which brought together artists like Richard Hamilton and architects like Alison and Peter Smithson, was the product of a different epoch, whose vision of a 'future' would make an interesting comparison with Oiticica's.

2 A few years ago Sandy Nairne gave an interesting conference paper comparing the two shows in detail. It was originally written as a contribution to the Ideas in Progress programme at Middlesex University on the theme *Values and Display: Questions in the Making of Exhibitions of Contemporary Art*, 1993

3 Jean-Christophe Royoux, *Omnibus*, special number on *documenta X*, Paris, October 1997.

4 A facsimile edition of the eight issues of *Signals Newsbulletin* (1964–66) is published by the Institute of International Visual Arts, London.

5 Hélio Oiticica, letter to Bryan Robertson, October 28th 1968. Preserved in the archives of the Whitechapel Gallery.

6 Paul Overy, 'Cabins', *The Listener*, 6 March 1969; Elizabeth Glazebrook, 'Art', *Queen*, February 1969; Jasia Reichardt, 'Eden', *Architectural Design*, May 1969; Nigel Gosling, 'Lotus-land, East London', *The Observer*, 9 March 1969; Edwin Mullins, *The Sunday Telegraph*, 1969

7 Hélio Oiticica, 'Creleisure', in *Hélio Oiticica*, Witte de With, Rotterdam; Jeu de Paume, Paris 1992, p. 128.

8 Hélio Oiticica, 'Apocalipópotese', in *Aspiro ao Grande Labirinto*, Ed. Rocco, Rio de Janeiro 1986, p.120.

Part of **Tropicalia**, 1966–67. Archives Projeto Hélio Oiticica, photo: John Goldblatt

Frida Kahlo and Tina Modotti

by Mark Francis

In 1982, the exhibition of Frida Kahlo and Tina Modotti seemed to be an eccentric addition to the periodic series of historical shows which we presented during the early 80's, which included Max Beckmann's triptychs and Joseph Cornell. In retrospect, however, it seems to have had an influence that was out of all proportion to its scale.

The idea was first proposed to me in 1979 by Laura Mulvey and Peter Wollen, both of whom I had got to know after presenting their film *Riddles of the Sphinx* in Oxford. They had seen a small show of Kahlo's work in Chicago, while teaching in the US (neither had been offered at that time the academic positions in England appropriate to the authors of such seminal texts as *Signs and Meaning in the Cinema* and *Visual Pleasure and Narrative Cinema*), and conceived of an exhibition which would bring together painting and photography in the revolutionary context of Mexico in the 1920s and later. Issues of self-portraiture and representation in the iconography of women, the relationship of Kahlo and Modotti with their companions Diego Rivera and Edward Weston, and the contested boundaries of art and politics were fundamental to the debates around avant-garde art and film studies during the 1980s.

For me, as a young curator, the project was intensely exciting not just as a means of connecting with a contemporary intellectual and creative world, which included other projects around that time with Mary Kelly, Sally Potter and Yvonne Rainer, also it immersed me in the treacherous currents of the century's unresolved cultural conflicts. In Mexico, we had to secure the confidence and support of Fernando Gamboa, the great director of the Museo de Arte

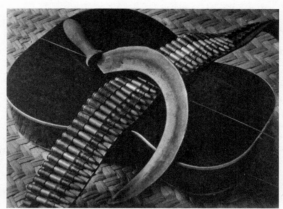

Tina Modotti
Bandolier, Guitar and Sickle,
Comitato Tina Modotti, Trieste

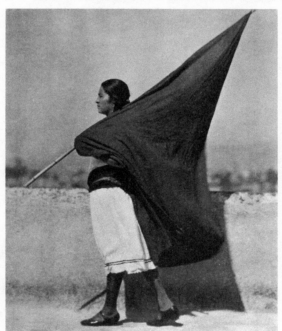

Tina Modotti
Woman with the Anarcho-Syndicalist Black Flag,
Comitato Tina Modotti, Trieste

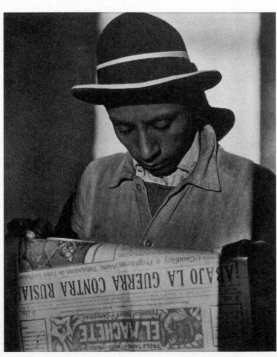

Tina Modotti
Reading 'El Machete',
Comitato Tina Modotti, Trieste

Moderno, in which Frida Kahlo's masterpiece *The Two Fridas,* 1929 occupied a central place. Even more important, the key lender of Frida's paintings would be Dolores Olmedo, Diego Rivera's last lover, who was responsible for the Blue House in Coyoacan, Frida Kahlo's refuge and studio, with its extraordinary collection of her own work and of ex-votos, her bed and other relics. At that time the house was not well maintained, was almost deserted and had not yet become the pilgrimage destination it is today. I remember going to see the ageless Sra. Olmedo in her enormous villa, the surreal atmosphere enhanced by the hairless dogs wandering around the gardens. We also managed to find a cache of Tina Modotti's documentary photos of Rivera's mural which had been preserved by the widow of B. Traven, originally known as the anarchist Communist Ret Marut, the mysterious author of *The Treasure of the Sierra Madre,* who fled to Mexico from Germany and assumed a new identity.

Most nerve-wracking of all our negotiations were those with Vittorio Vidali, then elderly and long retired as a Communist senator in Trieste. Vidali had an ambiguous reputation, with a dangerous glamour attached to his relationship with Tina Modotti during the Spanish Civil War. He was deeply menacing later after the defeat of the Republican side, when he retreated to Stalin's Moscow, and it has always been unclear what role he played in Tina's death in Mexico in 1942. Vidali had the greatest collection of Modotti's original photographs, and so I went to Trieste, travelling by train from Venice, to borrow them for our exhibition. I felt like a character from Peter Wollen's story, which was filmed as *The Passenger* by Antonioni, as I was driven by a Party functionary into the back streets of Trieste, and taken into Vidali's dark and shuttered

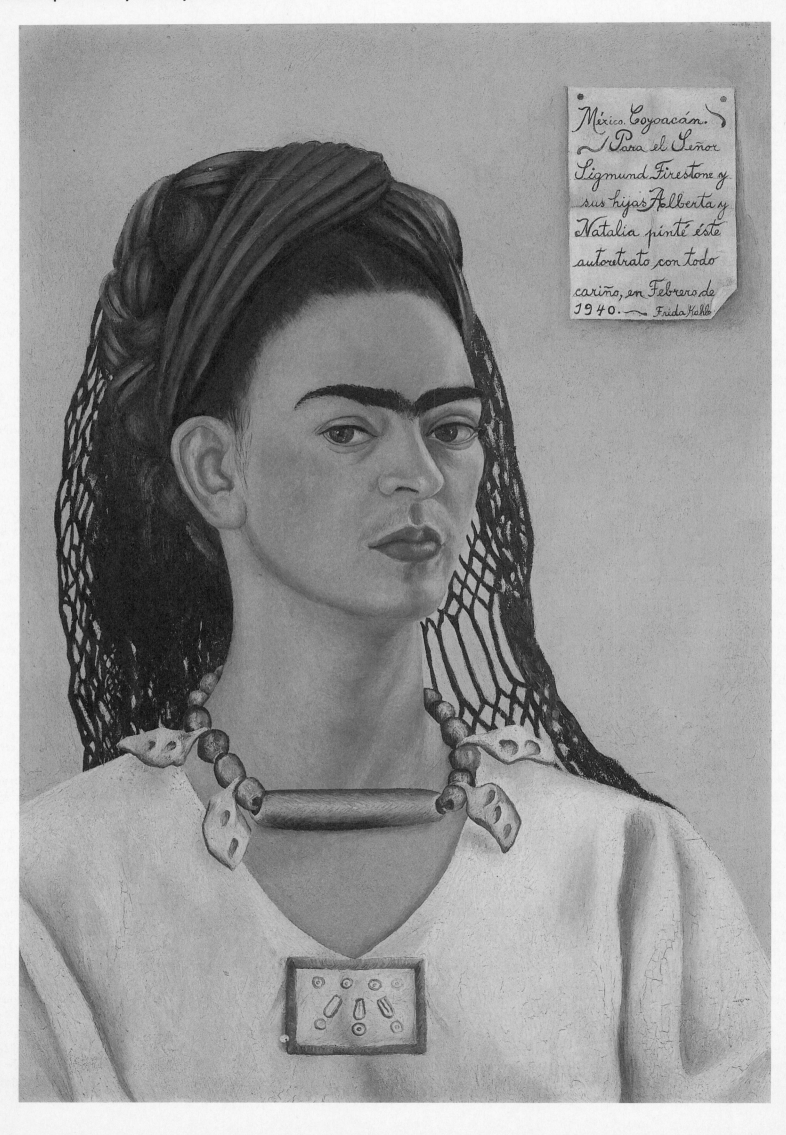

apartment to shake the hand of the villainous revolutionary. He generously lent all Tina's photographs, which I carried back to London uncatalogued, though Vidali later refused to lend them to the one US venue, on political principle, remembering how he had been refused entry himself many years earlier.

Our essential collaborator in the organisation of the exhibition in Mexico, Sylvia Pandolfi, finally succeeded in getting *The Two Fridas* released for the exhibition in London, and it arrived only a day before the exhibition opened. The great painting occupied the place of honour on the walls we had painted the blue of Frida's house, and we bought two calla lilies to honour the artists, who had received their dues at last.

By the time the exhibition opened in London we had arranged a further tour to Berlin and other venues in Germany, helped by a sympathetic feminist publisher which took on the German edition of the catalogue. Harald Szeeman was interested in showing the exhibition in Zurich but it turned out not to be possible. Bob Littman, however, then director of a small university gallery, the Grey Art Gallery at NYU, bravely took the exhibition, where it became an extraordinary cult success among downtown artists and a wider public. We had to keep shipping hundreds of catalogues to New York day after day, as supplies constantly sold out. The final approbation came as INBA took the exhibition back to Mexico City as the final venue. Frida Kahlo was already acknowledged there as a vital figure in the history of art in Mexico, and Hayden Herrera's biography – published the same year as our exhibition – played a major part in creating the new cult of the artist, but Tina Modotti's multiple contributions, as a muse and icon,

Frida Kahlo *Basket of Flowers*, 1941, oil on metal, diameter 64.5 cm. Private collection. Courtesy Mary-Anne Martin/Fine Art, New York
© Banco de Mexico Diego Rivera & Frida Kahlo Museums Trust. Av. Cinco de Mayo No. 2, Col. Centro, Del. Cuauhtemoc 06059, Mexico D.F

as an artist, and as a political revolutionary, had been largely forgotten, or deliberately obscured.

In retrospect, the exhibition enlarged our understanding of modernism outside the mainstream, as the crosscurrents between Kahlo and Modotti, André Breton, Marcel Duchamp, Leon Trotsky and Edward Weston, were clarified. It established the two women among the great artists of the century, as role models certainly, but also as participants in the critical movements of our time. It also served to reinforce the Whitechapel's ability to generate projects independently of received wisdom. And like a ribbon round a bomb, the potential of their lives and work continues to live today.

Mark Francis was Curator at the Whitechapel Art Gallery during the 1980s and then Curator at the Andy Warhol Museum in Pittsburgh. He is currently a free-lance curator.

left:
Frida Kahlo *Self-portrait*, 1940, oil on masonite 61 x 42.2 cm. Private collection, courtesy Mary-Anne Martin/Fine Art, New York
© Banco de Mexico Diego Rivera & Frida Kahlo Museums Trust. Av. Cinco de Mayo No. 2, Col. Centro, Del. Cuauhtemoc 06059, Mexico D.Fa

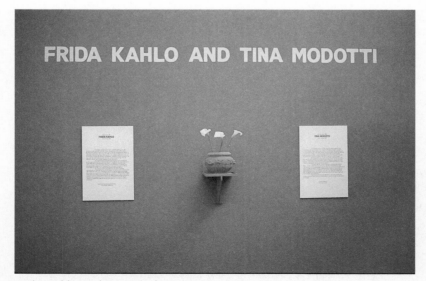

Frida Kahlo and Tina Modotti
Calla Lilies at the entrance to the Whitechapel exhibition, 1982

Supping with the Devil

by Bryan Robertson

...Four years on, I was about to present a Nicholas de Staël retrospective at the Whitechapel following the artist's early death. As a gesture to the French, whose Musée d'Art Moderne de la Ville de Paris had just staged the show perfectly under the ever-helpful Director, Jean Cassou — a true man of letters of the old school — I set up, with a press statement, a committee of Honour: some senior artists, Moore, Sutherland, Smith, Hitchens, as well as Herbert Read for the ICA, and the directors of our National Gallery and the Tate Gallery, Phillip Hendy and John Rothenstein. All hell broke loose.

A statement from Cooper appeared on the front page, no less, of the *Evening Standard,* saying that his friend de Staël, whose work he had collected with such admiration, had been ignored by the Tate under Rothenstein's benighted directorship, that Rothenstein's presence on the committee of honour for this great painter was a disgrace, and that he would personally ask all de Staël collectors world-wide to boycott the Whitechapel exhibition and to withdraw their loans. This he proceeded to do, according to de Staël's shocked art dealer, Jacques Dubourg.

...I was shaken but also rather saddened by this eruption, because a year or two earlier in my first months at Whitechapel, Cooper had been generously open-handed and radically helpful in some supportive letters and phone calls in my attempt to stage a Picasso exhibition.

...In the de Staël war, another missive in violet ink was launched, denouncing me as a traitor to de Staël's memory and achievement, and worse — 'you shit....' screamed the first words of the letter. A day or two later, Sutherland publicly resigned from the Whitechapel committee with a statement, again in the *Evening Standard* (Sutherland had painted the *Standard*'s owner, Beaverbrook, whose then girlfriend, Lady Dunn, thought that the only two living geniuses were Sutherland and Dalí), repeating Cooper's allegations against Rothenstein and siding with his new patron, Cooper, who was now, it transpired, preparing a monograph on his work: the most unexpected new protégé after so many years of derision. A letter followed from Sutherland, rather creepily apologising for rocking the boat.

...All through this, telephones rang incessantly. The daily and hefty press exposure bewildered my trustees — we had only a small staff and very little money. To compound my troubles, Denys Sutton, the critic and collector, had promised a large and magnificent de Staël painting to the show, and had agreed, as a friend of the artist, to write a catalogue essay, but now withdrew both essay and painting — as a loyal old friend, and sometime lieutenant, of Cooper's. We were left with an incomplete catalogue hanging fire at the printers with only a few weeks to go before the sched-uled opening, and no news from the lenders to the exhibition, by now subpoenaed by Cooper to boycott the show. Happily, on this last point the redoubtable Françoise de Staël, the artist's widow, telephoned from Menerbes to assure us that the whole art world knew Cooper's tantrums and mischief of old and would ignore him: she had already received reassurances from everyone. But we still had no big centrepiece for the show with the withdrawal of a key work, and no text for the catalogue.

During this crazy little drama, Rothenstein rang, of course, in distress, offering to remove his name instantly from the committee, which I refused. He asked me to meet him urgently. We had a gloomy drink at the Atheneum, where a tired Rothenstein, after entreaties for confidentiality, showed me a photostat of an excerpt from the minutes of a trustees' meeting at the Tate, where it was plainly recorded that at this meeting, a few years before this hysteria, the director had put forward for a possible purchase a group of canvases of various dimensions by de Staël. These had all been turned down by a majority of trustees, including Graham Sutherland, still a trustee before he resigned amid much self-contrived publicity over Rothenstein's pallid taste and poor administration of the gallery.

...Back at the office, the Cooper drama suddenly took the most unexpected final twist. Denys Sutton had just presented a new and 're-defining' Gauguin exhibition at the Tate. The show had opened — but accompanied by a long and utterly blistering commentary on the exhibition simultaneously published in *The Burlington* magazine: 'wrong attributions, fakes, confused dating, general slovenliness' from Douglas Cooper, Sutton's supposed old friend, on whose behalf he had withdrawn so dramatically from any participation in the de Staël show a week or so earlier. The magazine was read in the office with much amusement. It was too rich: the entire staff, all three of us in those days, went round to the pub and stayed there. Webster had become Feydeau.

The next morning a subdued Denys Sutton telephoned, not referring to Cooper, or the *Burlington* extravaganza, in which he was clearly portrayed as a poltroon of the first order. 'Perhaps I was a little hasty in withdrawing my paintings', he said, ' you may have my essay — we must work together and get the show on the road...'

On my way to work the next day, my mind full of Sutherland's self-serving treachery and Cooper's idiotic skulduggery, and catalogue anxieties, I suddenly saw new and beautiful posters advertising cheap evening travel on the tube, executed in the unmistakable coloured lozenge-like style of Nicholas de Staël. They were, rather amazingly, all over the tube station next door to the gallery. For once, commerce had caught up with art in almost unnervingly good time, and I thought how amused de Staël would have been to see his work thus popularised next door to the show, part of the living visual currency. And I thought how cheap and despicable were the antics sometimes of those who profess to serve art and artists but plainly feel superior to them and behave accordingly. The show opened on time and was a great success — de Staël was much loved by fellow artists at the time.

Nicolas de Staël
Composition, 1949–50,
oil on canvas,
119.3 x398.7 cm.
Formerly collection of
Denys Sutton

Extract from a review of the book by John Richardson on Douglas Cooper, *The Sorcerer's Apprentice,* 1999. *Supping with the Devil* was part of a longer piece in *Modern Painters,* Spring 2000. The de Staël exhibition took place in 1956.

The Women's International Art Club

by Joanna Drew

Often during its life the Whitechapel has operated as a receiving rather than a producing house. As in the theatre, the roles are different; the first requires at least a competent house manager, the latter ideas, knowledge, a team and much more money.

So, in practice, the Whitechapel's programmes have been a mixture, the balance depending on many factors, the two most important being the abilities of the director and the availability of funding. At some low points in the Whitechapel's history it was little more than a handsome hire-hall, perhaps serving its local audience but not attracting one from further afield.

Of the many types of exhibitions that have been held at the Whitechapel, mixed shows of the work of living artists were the major element until the 1980s. Some have been loan exhibitions with a selector or selection committee, some open submission shows, notably the East End Academy /Whitechapel Open, some exhibiting societies.

Among the exhibiting societies early in the 20th century was the Women's International Art Club, founded in 1900 and which held its first exhibition in Paris. Like the London Group, with which the membership overlapped from time to time, the WIAC had no permanent place of exhibition but held six of its annual exhibitions at the Whitechapel, the first in 1921, the last in 1966.

Whereas it is noticeable that artists tended to drop out of membership of the London Group if they became successful and acquired a good gallery, the membership of the WIAC was more constant. The best known professional women artists were not members – Mary Fedden was chairman in the mid-fifties – but they might sometimes show as invited artists; in 1966 these included Elinor Bellingham-Smith, Sonia Delaunay, Elizabeth Frink, Françoise Gilot, Helen Frankenthaler, Willie Barnes-Graham, Mary Kessell and Penalba.

Now the very idea of a society of serious women artists seems quaint.

Alan Davie *Two Upright Characters*, 1956, oil on hardboard, 101.6 x 121.9 cm. Lent by the artist

Whitechapel Art Gallery. An Early Memory

by Clive Phillpot

Alan Davie Photo: Ida Kar

For me it all began with the miners. In April 1956 my aunt or my cousin had heard about the retrospective exhibition of Josef Herman at the Whitechapel Art Gallery in the popular press or on the radio, and it was suggested that we two schoolboys, my cousin and I, go and see for ourselves; so we found our way to the new world of Aldgate East. The lasting memory that I have of the exhibition, apart from the dark earth tones of Herman's palette and his brooding mining scenes, is of what seemed to me then to be a gigantic painting of miners hung on the back wall of the ground floor gallery. The row of large looming miners were all hunkered down underground, each of their helmeted heads looking out at us over their knees; they reminded me of an Egyptian sculptural frieze. (I seem to recall that this big painting might have been painted for the Festival of Britain.)

The Whitechapel Art Gallery was the second public gallery that I discovered after the Tate Gallery. The latter had a peculiar smell of what seemed like a combination of cooking and floor polish. The Whitechapel did not smell, and 'Aldgate East' became a magical phrase to me as I went back to the Gallery time and again. It came to stand for all the intellectual and aesthetic pleasures and provocations that I obtained at the Whitechapel Gallery as well as the ambience of the street life in Whitechapel High Street.

I began to visit the gallery quite regularly, but the next exhibition that really left a mark on me was the Alan Davie retrospective which I saw two years later in July 1958. I was knocked over by the un-British exuberance and joyfulness of the paintings. I went twice to the exhibition, and immediately became not just a fan but also a follower. Then four months later came a posthumous retrospective of one of the catalyst's for Davie's lyrical paintings – Jackson Pollock.

Ethel Walker *Invocation*, oil, 104 x 165 cm.
Lent by the executors of the Late Dame Ethel Walker to the Whitechapel Art Gallery, 1952.

Ethel Walker, a prominent British artist of the early 20th Century, showed in a number of mixed shows at the Whitechapel, including with the WIAC and *Mural Decorative Paintings*, 1935.

Rosemarie Trockel.
The artist as collector

by Dorothée Brill

In 1990 Rosemarie Trockel made a machine for the production of art, a machine to paint paintings. It consisted of 56 brushes, hanging on threads from a metal structure. The brushes were not made with animal hair but with that of humans, more precisely of artists. She had taken it from 56 colleagues, including A.R. Penk, George Condo, Martin Kippenberger, Walter Dahn, Philip Taaffe, Arnulf Rainer, Cindy Sherman and Curtis Anderson in addition to her own. All of these names appear again either amongst the artworks in her own possession or within the list of works selected for the Whitechapel Centenary.

The *Painting Machine* was shown for the first time at the Galerie Michael Werner in Cologne, in 1990. For this exhibition Trockel had switched spaces with A.R. Penck, whose work was in the meantime exhibited in her traditional Cologne address, the gallery of Monika Sprüth. Both had left their traditional surroundings to experience a new spatial situation with its own particular artistic history. This exchange, expressed as a kiss on the exhibition poster, is part of a chain of artistic encounters that links the two. In 1984, on the occasion of an exhibition of Trockel's work at the Galerie Ascan Crone in Hamburg, Penck contributed a text to the accompanying publication. He did not write about his colleague though. Instead, he dedicated a text to her that he had written some 10 years earlier without yet knowing her work, but in which he now discovered an inner affinity.[1] His text is not the only artistic work that made its way from Penck to Trockel. The art collection that Rosemarie Trockel and Curtis Anderson have commonly built up includes three works by Penck, all given to either Trockel or Anderson

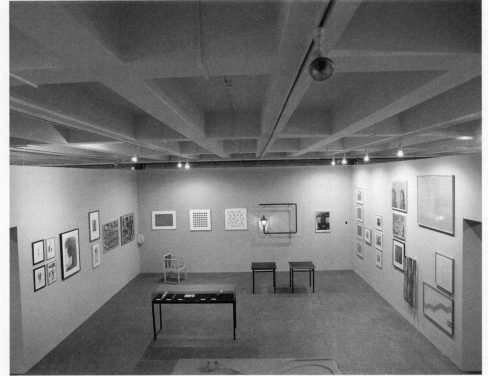

Collection Anderson-Trockel, Josef-Haubrich-Kunsthalle, Cologne. Front wall with, from left to right: Bridget Riley, *Untitled*, 1965; Bridget Riley, *Untitled*, 1965; Bridget Riley, *Untitled*, 1965; Martin Kippenberger, *Lantern*, 1989–90; Valie Export, *Untitled*, c.1976; Richard Artschwager, Rubber BLP, 1989. © Wolfgang Burat, Cologne 2001

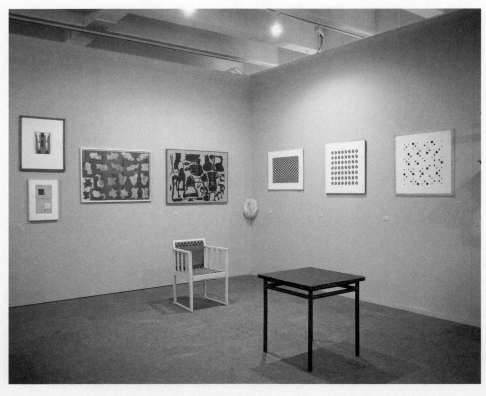

Collection Anderson-Trockel, Josef-Haubrich-Kunsthalle, Cologne. Left hand corner with, from left to right: Jean-Paul Philipe, *Untitled*, 1991; Eileen Gray, Carpet Design, c.1925; Philip Taaffe, *Untitled (Piece Unique – Paris)*, 1990; Philip Guston, *Untitled*, 1965; Günter Weseler, *Untitled (Kinetic Sculpture)*, 1997; Bridget Riley, *Untitled*, 1965; Bridget Riley, *Untitled*, 1965; Bridget Riley, *Untitled*, 1965; Leopold Bauer, *Chair*, c.1900; Le Corbusier, *Table*, Cité de Refuge at Paris, 1932. © Wolfgang Burat, Cologne 2001

as gifts. One of these is the *Nudelholz (Rolling Pin)*, made and given to Trockel in the year of the space switch. It might have in turn inspired her drawings of a *Drunken* and *Very Drunken Rolling Pin*, two years later.

The multi-layered exchange between Trockel and Penck is just one example of the subtle relationships Rose-marie Trockel and Curtis Anderson maintain with other artists. These encounters and their impact on both artists' work are rooted within the same foundation as their motives for collecting and the characteristics of their collection. Interestingly, the collection itself is the product of constant collaboration.

Curtis Anderson, born in Minne-apolis, raised in Seattle and educated at The Cooper Union in New York City, came to Cologne in 1985. The city and its ancient history have become fertile ground for his work[2]. His immaculately conceived mixed-media works are rich in allusions to history, art history and philosophy, and transform obvious references into an individual and enigmatic language of symbols.

The works Rosemarie Trockel and Curtis Anderson assembled over the last two and a half decades, at first independently of each other, have found their way into their possession in varying ways. Some have taken the traditional path via an art dealer or a private gallery. Some have been gifts or have been achieved in exchange for one of their own works. Some have been given by one to the other and some might have been created at the very moment they entered the col-lection. This happened with Sigmar Polke's 1990 work *Untitled (Brush Sculpture)*, a handmade brush with a roughly cut wooden handle and some golden bristles, made by Polke instead of the strand of hair Trockel had asked him to supply for her *Painting Machine*.

The collection of the two artists was thus neither conceptually planned nor systematically compiled, but grew over the years according to personal interest, artistic affinities and unexpected discoveries[3]. In its spontaneity, however, it reveals an internal coherency and is the outcome of the owners' approach towards art.

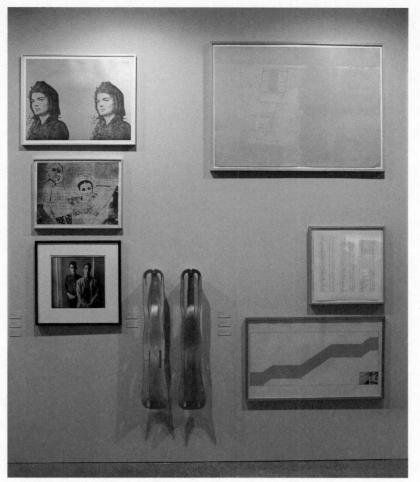

Collection Anderson-Trockel, Josef-Haubrich-Kunsthalle, Cologne. Wall segment with, from top to bottom and left to right: Andy Warhol, *Jacqueline Kennedy no. 2*, 1964; Sigmar Polke, *Female Friends*, 1967; David Armstrong, *John and Evan Lurie*, 1980; Charles Eames, *Leg-Splints*, 1943; Andy Warhol, *Electric Chair*, 1965; Gerhard Richter, *Index of Works*, 1969; Blinky Palermo, *Konrad Fischer Staircase*, 1970. © Wolfgang Burat, Cologne 2001

One of the earliest objects in the collection is a chair, designed by Leopold Bauer around 1900. This piece of furniture – perhaps surpris-ingly found within the context of a fine art collection – is accompanied by two minimalist square tables from 1932, designed by Le Corbusier to function in the standardised flats of his *Cité de Refuge* in Paris. The gouache design for a carpet by Eileen Gray from 1925 completes this section of applied arts.

The elongated wooden casts by Charles Eames, the *Leg-Splints* of 1943, cross the border between a 'functional object' and one that lacks any such definition in common understanding. Irritating, however, is the remaining impact on the design. A similar ambiguity appears in a metal tube bent into the shape of a square and ending in an old-fashioned streetlamp with a glowing light bulb. It is one of the much more recent works, *Laterne (Lantern)* by Martin Kippenberger, dating from 1989–90.

These works point to the common factor in the collection: an investiga-tion of the border between art and non-art, interpreted as one between functionality and non-functionality rather than in terms of fine art and design. As if proof against such separation, the *Rubber BLP*, 1989 by Richard Artschwager, a black oval piece of rubber a few centimetres long and flatly glued to the wall, is as much a work of design as it is lacking any applicability. In turn Bridget Riley's painted patterns have had an important influence on Op-art fashion, as Trockel under-lines[4] Three of her 1965 screen prints of black and white patterns on acrylic glass and several works on paper are part of the collection.

The investigation of a possible sepa-ration between fine art and design as a metaphor for the border between art and life reflects an aspect of Trockel's understanding of art itself. In a rare statement about her work she underlines that her idea of art and that of the world are inseparable one

from another[5] 'Art works are focuses of time. They provide information about the relation between art, culture and politics. And the question of the meaning of art is bound up with this', she says.[6] It is the context that provides the meaning of its content but it is always just one of many pos-sible systems and thus only relative.

Within the framework of such a context-dependent understanding of art, the fact of appropriation appears not merely as a choice but as the inevitable basis for any artistic cre-ation. Collecting, appropriating and exceeding former positions are part of the creative process that happens within the given system. The act of collecting and the numerous allusions, quotations and ironic commentaries to important artistic steps within recent art history that can be found within Trockel's work can thus be understood as part of her perception of art.

The collection of Rosemarie Trockel and Curtis Anderson was recently presented within the exhibition *Wahre Wunder: Sammlungen und Sammler im Rheinland* (5 November 2000 – 11 February 2001). During the installa-tion the two artists spent hours and days in the exhibition space arranging and rearranging about forty selected works they had brought with them. In a very careful and thoughtful process the single works were brought into a dialogue with each other. 'The true collector is an artist himself,' Duchamp had once said. 'He selects images and hangs them up on his wall; in other words, he is painting his very own collection.'[7] No sentence could better describe Trockel and Anderson's approach. In addition to the deeper affinities between the activities of collecting and creating art, participating in the public display of other artists' work, the two artists disguise another act of creativity.

Lucio Fontana, Bridget Riley and Andy Warhol have, amongst others, each been compared with different elements of Rosemarie Trockel's work and indeed she has chosen a work by each of the three artists for inclusion in the Centenary exhibition. The parallels and similarities between them and Trockel operate on a variety of different levels.

A striking visual parallel connects the famous *Concetti Spaziali* by Lucio Fontana with a series of untitled screen prints Trockel made in the early 90s. In fact, it is more than just a parallel. In about 1950 Fontana had started to destroy the two-dimensionality of his monochrome paintings by cutting or puncturing the canvas, thus letting space intrude the plane. Trockel's works are screen prints of photographs of a plain knitted fabric that is also sliced open. In each of these works Trockel had performed the cuts following exactly one of Fontana's *Concetti Spaziali* that she had projected onto the knitted surface. Unlike her colleague's well-balanced incisions, the outcome of a meditative concentration of consciousness, Trockel's cuts are the result of mere imitation. Interestingly, there is another series of works from the same time that is almost similar in its outlook, but different in its formation. Here the injury to the fabric is not the result of imitation but is made to look like the arbitrary feat of hungry moths. The tiny insects are visible on the screen-printed photographs. Thus Trockel confronts the knowing, artificial act of her male colleague with the mechanical act of imitation on the one hand, or with the unconscious natural intuition of animals on the other. Both series appear as the visual equivalent to her often quoted saying 'every animal is a female artist,'[8] counterpart to Joseph Beuys' statement 'every person is an artist.' As a comment on Fontana and the fruit of a conceptual approach, Trockel delivers the frame for a 'typical female' artwork.

For both of these series of screen prints, which are applied onto the back of a sheet of acrylic glass, Trockel adopted a certain technique of hidden framing developed by Bridget Riley. Beside the technical adaptation there is a second and more substantial parallel between the two artists. They share a great interest in investigating the functioning of patterns. Both examine the change that occurs done to a single formal element through endless repetition. Whereas Riley's investigation produces optical 'irritation' in the spectator, Trockel looks into the alteration of meaning caused by repetition. Restating the same historical, political, cultural or commercial symbol over and over again, mutated into the design of a

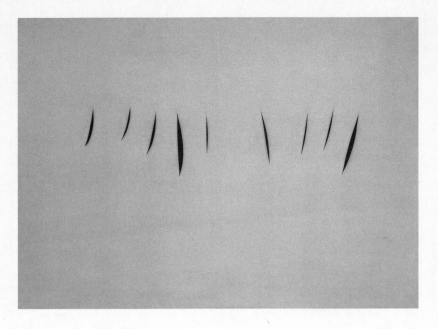

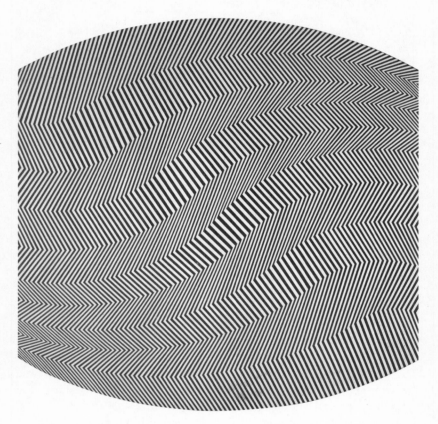

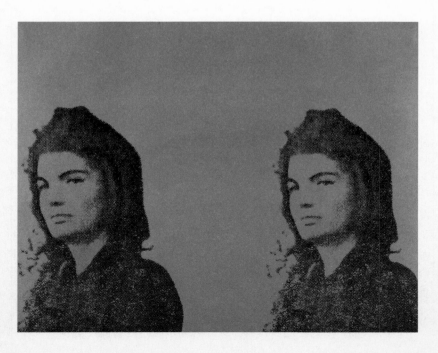

mechanically knitted fabric, Trockel suggests that the multiplication of a symbol leads to an undermining of its meaning.

The only work from Trockel's collection on show in the Whitechapel Centenary is a 1965 Andy Warhol screen print, *Jacqueline Kennedy no. 2*. Warhol multiplied the portrait of Jacqueline Kennedy, an image given symbolic status by the nation, as potent as a political icon. Similar likenesses do not only appear in two other artists' works within the collection – Nam June Paik's homage to the *20th of July*, 1989 and Raymond Pettibon's *Jackie and Patty Hearst*, *c*.1994 – but also in Trockel's own work (as in an untitled ink drawing from 1994 for example). By simply adorning the portrait with a lengthened nose Trockel disrupts an existing iconic power.

There are two exhibitions within the Gallery's history which Rosemarie Trockel returned to, while curating part of the Centenary exhibition: *Drawing the Line*, 1995 and *Inside the Visible*, 1996. *Drawing the Line*, selected by Michael Craig-Martin, was dedicated to drawing throughout the centuries. However, there was one formal aspect all chosen works had in common: they were pure line drawings. It is this very same characteristic that unifies the majority of the proportionately rich number of Trockel's choices. Drawing was key to the beginning of her artistic identity and continues to be so today. Still a student at the Werkkunstschule at Cologne she discovered the immediacy of the video camera as a new way of sketching.[9]

from top to bottom:

Lucio Fontana *Concetto Spaziale 'Attese'*, 1959, painting on canvas, nine times incised, 91 x 212 cm. Stedelijk Museum, Amsterdam

Bridget Riley *Shuttle*, 1964, emulsion on board, 112.5 x 112.5 cm. Fundação Calouste Gulbenkian/CAMJAP, Lisbon

Andy Warhol *Jacqueline Kennedy no. 2*, 1965, silkscreen on paper, 68 x 82 cm. Rosemarie Trockel

The works she has chosen from *Drawing the Line* include one by Jean-Antoine Watteau (1684-1721), showing *A Woman in a Striped Dress, Seen from Behind, Reclining on the Ground*. It is a strongly graphic drawing carried out in a warm red coloured charcoal over fading black lines. The woman's vertically striped coat dominates the picture. She appears as if sitting in the void and without seeing anything but her back and the soft flow of the fabric, the spectator's entire attention is drawn to the abstract pattern of the broken stripes. The predominance of the fabric replaces the woman's body and becomes a kind of substitute for her. Thus the woman is shown in her traditional artistic role as model just to disappear behind a mass of fabric, which can be read equally as a symbol for her realm in life and for the image of femininity.

On an aesthetic level it is the reduction of the formal elements that might appear attuned to Trockel's general formal principle. In terms of content, however, it is the impact on the fabric and its pattern and the connected connotation of a set idea of the female, that build a connection to a main concern of Trockel's work.

It is this very same occupation with the artistic role of women and the examination of the weakness or potential of typical female art and traditional female materials that explains the attention Rosemarie Trockel dedicated to *Inside the Visible*. The exhibition's aim was to draw attention to often overlooked women artists, whose works were a catalyst to change within the language of art, as a response to changes in the cultural or political system they were part of. The exhibition's investigation started out from art 'as a manifestation of culture', which thus 'reflects changing socio-political and economic circumstances'.[10]

One of the works selected is a *Self-Portrait, 1932* by Claude Cahun. Dressed as a young girl with nicely arranged blond and curly hair, the artist appears crouched into the shelf of a wardrobe. Cahun characterises herself through her physiognomy rather than through a certain positioning of herself within the surrounding world, converting the traditional impact of the self-portrait. Creating

from top to bottom:

Rosemarie Trockel *Untitled (Fontana)*, 1993, screen print behind Plexiglas, 80 x 100 cm. Galerie Tanit, Munich

Rosemarie Trockel *Untitled*, 1986, wool on canvas, 140 x 140 cm. Edition of 3. Private collection

Jean-Antoine Watteau
Seated Woman in Long Dress, red chalk and graphite, 15.5 x 9.4 cm.
The British Museum, London

the most varying representations of herself she exemplifies that there is no need to search for the one true Ego amongst the different masks, but to accept instead the multiple forms of a person's appearance as their authenticity.[11]

Notes:

I would like to thank Curtis Anderson for being a patient and extremely helpful source of information in compiling this article.

1 Penck's text, together with one by Reiner Speck, himself a collector of Trockel's work, is reprinted in: *Rosemarie Trockel. Skulpturen und Bilder*, Galerie Ascan Crone, Hamburg 1984, pp.5-8, 14-18. There are other artists who have written about Trockel's work in a similar manner, for example George Condo (in: *Rosemarie Trockel. Bilder, Skulpturen, Zeichnungen*, Rheinisches Landesmuseum, Bonn 1985, p.52) and Walter Dahn (in: Sidra Stich (ed.), *Rosemarie Trockel*, Prestel, Munich 1991, p.52).

2 See Janis Hendrickson, 'Curtis Anderson', *Alive/Survive. Amerikanische Kunst in K3* (exh. cat.), Halle K3 Kampnagelgelände, Bücherdruckkunst Herres-Costarel GmbH, Hamburg 1988, pp.7-9, p.7.

3 See Ilka Becker, 'Sammlung Anderson-Trockel', *Wahre Wunder. Sammler & Sammlungen im Rheinland* (exh. cat.), Josef-Haubrich-Kunsthalle Cologne, Oktagon, Cologne 2000, p.315.

4 See Jutta Koether, 'Interview with Rosemarie Trockel', *Flash Art*, No. 134, May 1987, pp.40-42, p.42. This influence sometimes went against the artist's will, as in 1965, when a US dress firm used one of her paintings as fabric design without her consent.

5 See Doris von Drahteln, 'Endlich ahnen, nicht nur wissen', *Kunstforum International*, No. 93, Feb./March 1988, pp.210-217, p.216.

6 See Jutta Koether, 'Interview with Rosemarie Trockel', *Flash Art*, No. 134, May 1987, pp.40-42, pp.41.

7 See Peter Weibel, 'Der Sammler und die Logik des Marktes', *KunstSammeln* (exh. cat.), MNK | ZKM Karlsruhe, Cantz/Hatje, Ostfildern 1999, pp.199-207, pp.199.

8 It is the title of an artists' book by Rosemarie Trockel: Wilfried Dickhoff (ed.), *Jedes Tier ist eine Künstlerin*, Propexus, Lund 1993.

9 Heinz-Norbert Jocks, 'Als das Fragen noch geholfen hat', Kunstforum international, 1999, pp.271-287, 271.

10 Catherine M. de Zegher, 'Introduction: Inside the Visible', *Inside the Visible* (exh. cat.), The Kanaal Art Foundation, Kortrijk, Flanders, Cambridge/Mass., The MIT Press, London 1996, pp.19-41, p.20.

11 Claude Cahun, *Aveux non avenues*, Editions du Carrefour, Paris 1930, p.16.

Dorothée Brill is a curator, working at the Hausder Kunst, Munich.

Dear Catherine

Thanks for inviting us to contribute to the Whitechapel Centenary Review.

While browsing the exhibitions catalogues in the archive, we found *Setting Up Home*, 1952 and thought of reprinting the open letter written by Alan Jarvis, addressed to Bill and Betty. In celebrating the Whitechapel's involvement with the cultural life of London, we thought it was worth remembering how varied and ambitious the exhibition programme has been. By mixing displays of art with those of design, as well exhibiting artifacts from other cultures, the Gallery has been able to fulfil its founding remit of engaging with, and exciting its ever-changing audience.

Although sometimes amusing in tone and particular range of references, Alan's letter does indeed 'hand on experiences to us' that remain pertinent today. Two of those seem most relevant; the responsibility to produce and consume art and artifacts ethically, and the necessity of limiting the excesses of retail culture.

Good luck with the celebrations,

Best wishes

Neil & Marysia

Oxford House
Bethnal Green
London E2
4 June 1952

My Dear Bill and Betty,

You little realised how much you were starting when you asked, on the day you announced your engagement, how you could get good, reliable advice about setting up your home. You started, in fact, a real chain-reaction, and here are the results – this booklet, the exhibition which it accompanies, and a host of manufacturers and retailers anxious to help you.

You will remember, when we first talked, how worried you were about doing the right thing and how frightened you were about this business of taste. I urged you to forget about what was correct, to decide what kind of home you wanted, make up a budget of how much you could afford to spend during the first year or two, and then settle down to seeing that you got the best possible value for your money. Your were worried about how to shop. You didn't believe me, because you didn't know, that you could go to shops like Liberty's and Story's – shops you thought must be expensive – and find furnishings of the finest quality at incredibly reasonable prices: that you really got value for money, just as you got wonderful value for money at Aquascutum when you bought the going-away outfits you are wearing now.

So, when you go shopping now, you look for the same sort of reputable and conscientious retailer, the man who genuinely wants to see a satisfied customer; who will go out of his way to try to supply the goods you want and not talk you into accepting some second-rate piece he has in the back room. In fact you have slain the dragon which menaces young couples who lack shopping confidence, the salesman who goes to any extreme,

including twisting your arm, in order to make a sale.

I earnestly hope this exhibition of yours will help many other young couples to avoid the tragedy of the bad first-buy. Tragedy is not too strong a word for I am convinced that an ill-chosen piece or suite of furniture has broken up as many homes as a bad mother-in-law. Think of being haunted for years by some horror, which represents Betty's first mistaken idea of what was the right thing to do and the mis-spending of Bill's first bit of savings. Knowing what you really want for yourselves is the vital thing. For example, Bill, you wouldn't dream of buying a motor car which had bad workmanship disguised by window boxes, and half-timbered chassis and chromium knobs all over it, but you jolly nearly bought a bedroom suite which was just as dishonest in exactly that way. Betty's clothes-sense is so good that she would no more dream of wearing a mixture of too many patterns than of going about nude, yet you nearly covered the sitting room walls with parrots in a jungle and the floor with cabbage roses.

And why? I think the answer is really very simple. In the field of engineering or clothes most of us rely on common sense and we have few pre-conceived ideas of what is the correct thing. We dress nowadays to be comfortable and move about efficiently, the same things we look for in our motor cars. But in furnishings we go on imitating a past age and put ribbons and bows on everything as if we were refined Victorian ladies and gentlemen. You hear the word 'contemporary' applied to some present day styles in home

nishing and shopping can not only save up to hundreds of pounds but create a home of enduring pleasure. We do not give any set of ten easy rules for smart furnishing, nor hot tips on bargain hunting, nor any blue prints for an ideal home. All we can do is emphasise a few simple principles. Know what you want. Know how to shop wisely. Plan the sequence of your purchases, make the best use of space. And, finally, use colour.

BETTY: *Coat*—Aquascutum Ltd. *Hat*—Otto Lucas Ltd. *Dress*—Horrockses & Crowdson Ltd.
BILL: *Suit and Coat*—Aquascutum Ltd. *Hat*—Hilhouse & Co. *Wategby Luggage*—S. Clarke & Co. Ltd. *Models*—Winston Clarke Studios. *Drawings*—David Judd.

It may seem undignified to crawl on all fours in a furniture shop, but wise shoppers will go to any extreme in buying furniture to see that they are getting a well-made piece and value for their money. The

material on the north wall shows how to recognise good workmanship and finish. The material was supplied by the L.C.C. Technical College for the Furnishing Trade in Shoreditch and the Council of Industrial Design.

ROSTRUM: *Plastic tiles*—De la Rue.

FIRST SET
OF ROOMS

ROOM A—SITTING-DINING ROOM
Warmth with lightness is the keynote for this pleasant lived-in room. Bright curtains, with a bold window check, set the colour scheme—a

8 9

furnishing and it sums up in one word just what I have been saying about motor cars and clothes. In an age of science and mass production, of air travel and radio, we should be producing furniture which is well engineered, soundly constructed, efficient and – thanks to mass production – cheap. And, in an age devoted to out-door exercise, healthy diet, fresh air and light, we should expect furniture design to discard the ribbons and bows, the corsets and the petticoats of our ancestors. Designers and manufacturers of good contemporary furnishing are trying to do just that – supply household goods which really meet the needs of twentieth century young people. When you apply the standards you apply to almost every other part of your lives, you will see how well they are doing their job.

If good contemporary products seem rare in the shops, again the answer is quite simple. The retailers are supplying what they believe *you* want. If you buy only from what they stock, that is what they will go on selling. If you express a demand for what you really want, the retailer will want to sell it and he will see that the manufacturers make it for him to sell. I hope you won't get the idea, however, that I think only modern furniture is good or suitable for your home. Human needs haven't changed all that drastically over the years and you will find that a well-designed and well-made piece of furniture from any period will fit into your home and make a happy marriage with good contemporary. That is why we are showing one or two old pieces in the exhibition, and an illustration of how some old pieces can be adapted to present day needs.

In another age, the grand ladies and gentlemen not only dressed in ruffs and brocade or top hats and bustles, but decorated their houses for show. This is no longer so. Showy taste was once confused with good taste, but now the standard is based on good materials well made up, and a true revolution has been achieved whereby now – again thanks to mass production – clothes of the highest standards of style and making up are available at utility prices within weeks of their appearance in Paris or the West End. Price is no longer the criterion. So, also, in a wide range of domestic equipment, particularly for the kitchen, mass production methods have made very well designed products available at extremely low prices. To choose only one example, the admirably designed cruet set which is included in the exhibition can be purchased at any Woolworth's. Equally, most of the once expensive stores are now proud to handle well designed furnishings and fabrics at modest prices, just as the best clothing houses produce utility goods.

Once you gained confidence the job of setting up home was comparatively easy. You are – and this is a compliment – a good average couple. You have clear ideas of the kind of life you want to lead together as a partnership and you are setting up home as a partners' job. Bill, you are lucky to have a wife who finds homemaking fun, but even luckier in that Betty will never be one of those house-proud-horrors who keeps the place so like a museum that it is unbearable to live in. Your home will not therefore be like so many others in which the wife talks so much about 'her' furniture that the husband goes out and buys one of those smoking companions in order to have something around he can call his own. All the same, you have realised that you are not twins and each has different needs. So Bill, you got a good big easy chair to relax in after work, and Betty, you got an easy chair without arms so you could sew in comfort. That meant buying separate pieces rather than a suite, but you got what you each really wanted. You are thinking ahead about your future family, so you remember that the children will have to live with the furniture too, and their needs are quite special ones. You will not find yourselves in the awful position of being torn between wanting to let the children play freely and keeping the knobs and the carving on the front of the sideboard intact. Again, like so many other young couples, you know you will move house once or twice in the future; so you haven't bought enormous pieces which won't fit the council flat you hope you will live in one day.

Thank you both for asking us to help. We, too, have learned a lot from you, and in dedicating our show and our book to all the other young couples who are setting up home, we are handing on your experiences to them.

Yours,

Alan Jarvis

PS. You were kind enough to send me a list of the inexpensive books you found most helpful, so I am handing it on herewith:

Council of Industrial Design: Ideas for your Home. 1950. Her Majesty's Stationery Office, 6d.
Margaret Llewellyn: Design and Our Homes. 1951. Prepared and published by the Education Department, Co-operative Union Ltd, 1/-.
Roger Smithells: Make Your Self at Home. 1948. Reprinting.
Gordon Russell: How to Buy Furniture. 1951. Her Majesty's Stationery Office, I/6.

'The things we see' series. *Published by Penguin*

1. Indoors and Out *by Alan Jarvis*. 1946. 3/6.
2. Houses *by Lionel Brett*. 1947. 2/6.
3. Furniture *by Gordon Russell*. 1947. 2/6.
4. Pottery and Glass *by Bernard Hollowood*. 1947. 2/6.

I am lured by faraway d
I project upon the worl
grows in me; it infiltrate
impalpable fluid. In its pr
infinity, I perceive the m
most contradictory feelin
soul. I am simultaneously
and depressed, overcor
despair in the most contra
cheerful and yet so sad th
both heaven and earth. If o
I wish there were no death on

ALFREDO JAAR IN MEMORIAM, 1995

tances, the immense void

. A feeling of emptiness

my body like a light and

gress, like a dilation into

sterious presence of the

s ever to inhabit a human

appy and unhappy, exalted

e by both pleasure and

ictory harmonies. I am so

t my tears reflect at once

for the joy of my sadness,

his earth. Cioran 1911-1995.

from The Rwanda Project 1994-2000

Sovereign

Sovereign (detail), 1999, 63 x 406 x 14 cm

I have a compulsion to dredge deep and without shame into my inner angst, laying bare that which at the same time I am desperate to hide. Like a murderer who ineffectively tries to hide a body – always already knowing that it will be found, as the blood and guts seep from its hiding place – I make a piece like 'Sovereign' and blithely assume that my angst has been contained within the formal structure I have devised for it, neatly hidden and tidily formalised, I take the angst out in order to try and hide it again.

It is as if my inner subconscious thoughts will not stay safely contained within my mind. They force themselves forward, demanding to be expressed or expurged in this strange medium of visual art. I find it to be a genuine compulsion. That I choose to use a visual means of expression, lays it bare to a multitude of misreadings. On the surface, words as tools are far more wieldy and powerful, giving evidence and tangibility to that which I would rather not name, even to myself. I prefer the ambiguity of the object. Without using the betraying knife of language to peel back the layers, to reveal the muddy thoughts within.

You know when you wake up from a strange dream, where you break and transgress the taboos and structures of your waking being? The unsettling thoughts linger in your head, not really ripe enough to exchange with anybody, but savourable as an option nevertheless. Haunting your day with sleep dredged memories of fantastical possibilities. Is it only you who sees this nightly movie? Where do the images come from? I often feel that about the things I make. How could they be? How do I arrive at them? How could I explain their presence as tangible objects to the other human beings?

My objects are never dictated by one thing or another, more an amalgam of lingering doubts and happenings. At the time of making 'Sovereign' I was pregnant with my first child, I was gripped with fear fuelled by the alien occupation of my body and the unremitting anxiety about the birth and the subsequent responsibility involved. The potential castration of my actions by so flagrant a dismissal of the rules of cause and effect.

But you know us women always yearn secretly for a child. Our sex dictates it. The soft flesh and loving smile of an infant all of one's own. The final requited love. The imaginary child that haunts our dreams is always too small, too loved, too easily broken. Fear was diffused by my joyful excitement at the prospect of this gift to myself caused by that momentary abandon. Cozily contained within my womb, manufacturing its fingers and toes, a strange waterbound mermaid creature brushing its downy hair as it waited to be ripe for my inspection.

But on the other hand, it had time to be sharpening its spear ready to gouge its way out of my body. Nightly I dreamt of the tunnel of pain that my body would become, razor blades from within tearing the flesh, the surgeon outside waiting with his knife to cut my tender hide if necessary, as the child burst forth, castrating my sex. The forceps mashing their way into my inner being to drag my child into the world. I had a fear of my vagina turning inside out, my womb hanging limp and exposed outside my body for all to see. The desexing and removal of my balls and functioning as a singular being. Rendered instead to an animal state. Howling.

And as I worked on this piece, I grew tired from the invasion of my body. Daily as I worked the child dragged me into the deepest of sleeps, indifferent to my need to create, drawing a veil over my mind. Fervently I wished to be like a man, immune from the tortures of procreation. The only imperative being to drop his seed.

I needed to make order of this chaos in my mind, to make a sovereign remedy by neatly lining up all those penetrations that could have been lusts, desires, children or diseases. Serried ranks laid out for bare inspection. Turning it into formal pattern, a painting neat within its frame. A frieze to diffuse the power of my doubts and fears. To take a shamanistic control of the spirit growing within me as a consequence of that random seed.

And always already knowing that once delivered, the child would stop me in my tracks. The neat order of my selfish blinkered existence disrupted and diverted to unknown territories. Fear of loving someone that much, a lifetime's indifference rerouted and unsprung. The sovereignty of my actions castrated.

In the sculpture I wanted the restraint of the formality of the picture plane to be holding back the horror. The action unclear as to being within or without the body of the world of the viewer. An un-gested within, an expurged without. A guarded expression. The fretwork of metal gavelling the angst into control. The fear bursting uncontrollably through the dam of its fingers. The speed of the final forming of the object, the very half-fitting unordered last minute lashing of the metals like the chaos of birth.

And all the vaginas are the same yet different, the peculiarities of their singularness torn by the randomness of delivery. The knife held ready for slashing, the fingers prising apart yet thrust and containing the shit. The implements rudely applied to the delicate female surface. No method, no politeness. A vague procedure gnashed in the anyhow of medieval midwifery. Re-sewn together with rough stitches, the vagina reformed, unrecognizable, its form given no credence. Trying to tame the knowledge of the pain in neat formal rows. To castrate the pain by making an object.

And I knew all of this before I saw and felt it. Like a primeval dream that I had then forgotten. Second sight gave me the knowledge of how it would be. Hindsight justified my fears. As with a dream, the true meaning of this sculpture is evasive to me. Whispered subconscious clues drove me forward. The making was imperative, the reasoning unclear. Truth, if there is one, lies somewhere lodged between the object and the viewer's subconscious. For me it was about forsaking all for the gift of my sovereign son.

Cathy de Monchaux

William Hogarth *The Happy Marriage*, c.1745, oil on canvas, 69 x 89 cm.
Royal Cornwall Museum, Truro

The opening exhibition at the Whitechapel in the spring of 1901 was
a great gathering of art, past and present, under a banner of moral and
social improvement. It ran for six weeks and was open from 10am to 10pm.
Attendances were very high indeed with 16,000 visitors on a single day and
a total of 206,000. Work by the Pre-Raphaelites (Millais' *Joan of Arc*, Ford
Madox Brown's *Cromwell, Milton and Marvel*, Arthur Hughes' *April Love*)
predominated in numbers, sentiment and high ideal. There was a host of his-
tory pictures (Dyce's *John Knox administering the Communion before Mary,
Queen of Scots*) and subjects drawn from the bible and the classical world.
There were portraits of Rudyard Kipling, Alfred Lord Tennyson, Mr. Gladstone
and Queen Victoria as well as Canon Barnett, the Whitechapel's founder
and the moving spirit behind this exhibition. Older masters were mostly
English though Rubens, van Dyck and Canaletto were well represented. There
were paintings by Lely, Wilson, Gainsborough, Reynolds, Morland, Cotman,
a great late Venetian Turner, Bellini's *Pictures Carried in State to the
Redentore*, and Constable's masterpiece, *The White Horse*, at that time in the
collection of J Pierpont Morgan (who also lent the Turner).

The exhibition included three paintings by Hogarth, born in the City of London
and traditionally regarded as 'the father of English art': *The Happy Marriage*;
A Portrait of Peg Woffington; and *The Lady's Last Stake*. The last is now in the
Albright Knox Art Gallery, Buffalo, and the portrait of the actress Peg Woffington
has not been traced. *The Happy Marriage* was painted for Garrick but left
unfinished. According to the catalogue note the great actor felt the lady's
face was 'not pretty enough', though the entry concludes that '… the happy
bride is finished, the husband seems a ghost'. Andrew Dempsey

Howard Hodgkin *After Corot*, 1979-82, oil on wood, 36.8 x 38.1.
Private collection, courtesy L.A. Louver Gallery, Venice, California

The Whitechapel re-opened in 1985, Charles Harrison Townsend's building
extended and modernised by Colquhoun and Miller. It boasted a splendid new
staircase, lecture theatre, café and other facilities. The opening exhibitions were
Jacqueline Poncelet (the first artist to show in the New Gallery) and recent paint-
ings by Howard Hodgkin.

As Richard Cork wrote: 'Ever since its doors opened, the Whitechapel Art
Gallery has effortlessly established itself as the most beautiful exhibition space in
London. But now … the remodelled and extended building seems more beguil-
ing than ever. The airiness and exhilarating sense of space in the ground floor
gallery has been intensified, so that it heightens the perceptions of anyone look-
ing at the art on display…the Whitchapel devotes the major part of its exhibi-
tion space to artists of international standing and the main event at the moment
is a distinguished selection of paintings by Howard Hodgkin…Rather than sim-
ply confirming my previous admiration the new show proves that Hodgkin has
developed and enriched his art considerably…and is now at the height of his
powers' *The Listener*, 10 October 1985.

Brian Sewell wrote, '…against the bright whiteness of its walls the painting of
Howard Hodgkin are startling patches of colour, drawing the spectator like the
songs of sirens', *The Standard*, 3 October 1985.

Rembrandt van Rijn *The Angel Appearing to Joseph in a Dream, c.1652,*
reed-pen and bistre, 17.9 x 18.1cm. Rijksmuseum, Amsterdam

The catalogue of the Dutch Art exhibition of 1904, which presented no fewer
than 415 objects including 'a fairly representative collection of the paintings of
Dutch artists of all periods', begins by explaining that: 'The study of no other
national art can be more valuable and instructive to Englishmen than that of
the art of Holland. … The Dutch people are, like us, descended from a mixed
Saxon and Celtic stock, with a similar infusion of Norse blood. Like us they
have been moulded by close familiarity with the sea, – like us they have stood
for liberty and felt the call to distant adventure. Like us they have reaped a rich
reward in colonial empire and profitable trade.'

Amongst the old masters was a fine Ruysdael landscape now in Glasgow
and a Wouvermans in the National Gallery. Several Rembrandt paintings,
then at Althorp, have since been declassified and twenty Rembrandt draw-
ings then lent by Hofstede are now in Groningen.

'Although in reality his [Rembrandt] style became consumately learned and
calculated, his drawings appear so spontaneous and unaffected that we seem
to be looking at the scrawls of the first man who ever drew. He never allowed
his pencil to carry him further than a rendering (necessarily as swift as possible)
of the image his eyes had conveyed to his brain – when he saw *that* on his
paper he was satisfied. He never 'explained' – did not add details of the nature
of the object as so many draughtsmen do, with fatal consequences to the
'life-like' look of their sketches. This fidelity of Rembrandt's hand to the image
in his brain has never been equalled by any other artist. Here was his secret:
he saw that life is imparted by having the courage of one's impressions,
believing nothing but the testimony of one's own two eyes. Add to this that
he had a great and subtle perception of beauty, and an imagination so
glowing, that often you cannot tell whether the thing drawn has been a
thing seen or only thought about.'

Franz Hals *Portrait of a Woman, c.1611,* panel, 94.2 x 71.1 cm

Devonshire Collection, Chatsworth. By permission of the Duke of Devonshire
and the Chatsworth Settlement Trust. This is one of two splendid portraits by
Hals included in the Dutch Art exhibition and is thought to be the companion
to *Portrait of a Man Holding a Skull, c. 1611,* Barber Institute of Fine Arts,
Birmingham.

Japanese Exhibition 1902
Ishikawa Jozan, *Letter to Hayashi Razan*, early 1640s, Japanese yokomono
hanging scroll, 31.5 x 86.5 cm. Sydney L. Moss Ltd

The text is a letter from Ishikawa Jozan (1583–1672), former general turned
literati recluse who wrote poetry in the Chinese style and introduced *reisho*
(clerical script) calligraphy to Japan. Jozan named his unique retreat in Kyoto
after his own list of thirty-six Chinese-inspired poetry immortals, in reflection
of the classic Japanese grouping. This letter, to his friend Hayashi Razan,
a prominent Confucian and physician to the Shogun, discusses the Shisendo
and several of the Chinese poets and calligraphers involved.

'What is marvellous about it is that it's an absolutely exquisite bit of calligraphy,
and one doesn't have to understand the writing, to get its extraordinary fluency
and simple directness, that one could write a letter with such simple bravado
gives importance to what one has to say.' Anish Kapoor

Chinese Art and Life 1901 Chen Juzhong, *Falcon and Horse*, 13th century,
ink and colour on silk, 24.8 x 26.3 cm. Private collection, London

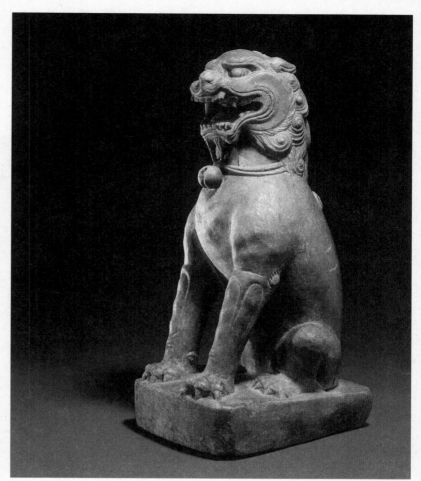

Chinese Art and Life, 1901, **Chinese Art,** 1913
Unknown, *Buddhist Lion*, Tang Dynasty, stone 34 cm high. Private collection

In selecting works for the centenary exhibition, we chose, with specialist advice, works which represent the many objects previously exhibited at the gallery in order to indicate the Whitechapel's active involvement in art from all over the world. As Anish Kapoor observed, the early shows were much more exotic in their feel than their equivalents are today, but they were always informed by the local community, whether Jewish or Bangladeshi, and pertinent to their culture. The archives of these shows do not allow exact identification of most objects but our selection matches the taste of collectors, and what was available to purchase, in the period. For example, in the 1913 *Chinese Art* exhibition there were cases of pottery, porcelain and other works from the George Eumorfopoulos Collection, including Tang animals like the carved Buddhist Lion, once belonging to this collection and included in the centenary exhibition.

Each of these early exhibitions ambitiously aimed to interpret and represent an entire national tradition in an attempt to educate the people of the East End. The Chinese exhibition, for example, included such diverse objects as the Chinese national flag ('taken in 1900 at the Shan-Hai-Kuan Forts, which surrendered to Sir Walter Hillier with 18 men, while the Chinese garrison numbered 5,000'), sculptures of such figures as Kwanyin, the Goddess of Mercy (a Buddhist deity who 'takes somewhat the same place that the Virgin Mary does in the Roman Catholic Church') and ancient bronze vessels (one in the form of a goose which was used 'for holding wine at Imperial banquets as a warning to the guests not to get drunk').

Other objects listed in the catalogue include wheelbarrows, 'A Very Ancient Picture of Buddha', examples of Chinese money, a pair of babies' shoes, exact plaster models of cramped women's feet (from a hospital in China), an 'ancient Japanese bronze vase (because 'Japan derived its art from China)', musical instruments, ivory chessmen, numbers of the *Peking Gazette* as well as ancient soapstone, ivory, lacquer, porcelain and jade vases, plates, sculptures and models, jewellery, chopsticks, furniture, lanterns.

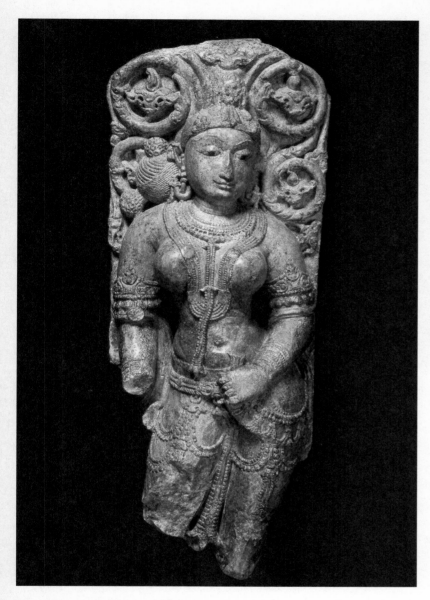

Indian Empire Exhibition 1904
Unknown, *The Female Deity Salabhanjika*, mid-10th Century, India, Rajastan, polished white marble, 98 cm high. Private collection

When a salabhanjika resides in a mango tree, she touches the branches with her fingers to make them bring forth fruit. The mango tree bears its fruits in early summer, when the temperatures become unbearably hot prior to the onset of the monsoon. The image of the salabhanjika is therefore associated with the continuing seasonal cycle. Mangoes are popularly believed to have aphrodisiac qualities too, which may be another reason for assuming a voluptuous goddess is hiding in the tree. The heavy *basubands* on her arms are set with enormous gemstones, perhaps the fashion amongst the aristocracy of the period and the multiple bangles around her wrists are still worn by Rajput women after marriage. Placed on the gateways and railing of a temple, looking outwards, the suggestion was a renunciation of worldly pleasures on the route to enlightenment.

'The stone has the most incredible patina, seeming truly flesh-like, beautiful. The goddess of fecundity and plenty, this image is almost as old as Indian art itself, first occurring in the yakshis at Sanchi. This example comes from that side of Indian art, which is relatively medieval and which is all about full-ness and plenty and the kind of horror-vacui.' Anish Kapoor

David Bomberg *Vision of Ezekiel*, 1912, oil on canvas, 114.3 x 137.2 cm, Tate. Purchased with assistance from the Morton Bequest through the Contemporary Art Society 1970.

Born in 1890, the son of Polish immigrants, Bomberg at the time of this painting was living with his family in the Tenter Buildings, St Mark Street in Whitechapel. Richard Cork in his vivid monograph on the artist suggests the tragedy of his mother's unexpected death, while Bomberg was at work on the painting, perhaps contributed to the result. The final drawings progressively interpret the 'miraculous nature of Ezekiel's vision by relieving each body of the solidity it possessed in earlier studies', suggesting an existence beyond the grave. Bomberg's art came to be associated with English painters like Wyndham Lewis (with whom he quarrelled) and other Vorticists. In May 1913 he went to Paris (his first visit abroad) in the company of Charles Aitken (who had gone to the Tate in 1911) and Jacob Epstein to select work for the forthcoming exhibition at the Whitechapel – *Twentieth Century Art. A Review of Modern Movements*. This painting was hung in the part he chose himself, 'The Jewish Section', which included works by Pascin and Modigliani as well as artists with local roots like Bernard Meninsky and Mark Gertler. Both the national press and the Jewish community rejected the brutal abstraction of works in the show and the controversy reinforced Bomberg's already belligerent nature.

In 1979 the Whitechapel organised a show of Bomberg's late works, largely landscapes contemporary with his teaching at Borough Polytechnic where he had a major influence on post-war drawing and painting.

Albert Marquet *The open-air theatre, Algiers* (*Le théâtre en plein air, Alger*), 1942, oil on canvas, 44.5 x 53.5 cm. Fondation Bemberg, Toulouse

In 1944, during the war and the occupation of France, the Whitechapel Art Gallery and the Royal Watercolour Society joined forces to show an exhibition of *Modern French Pictures from Algiers*. The exhibition was arranged between the British Council and the French Committee of National Liberation. The catalogue preface expressed the hope that: 'Despite the fact that many famous French artists are now in metropolitan France ... this collection will constitute an interesting approach to the actual trend of feeling in French painting.' Matisse was represented with two lithographs from the National Museum of Fine Arts in Algiers and Dufy by a watercolour from the same collection. There were paintings by Marquet, Friesz, Camoin and Puy, and two canvases by Henri Valensi, leader of the 'Musicalist' school.

It has not been possible to identify the paintings by Marquet (whose wife came from Algiers and who spent the war years there); there were three paintings, a beach scene at Les Sables d'Olonne (a resort on the west coast of France) and two views of the port of Algiers, all lent by a M. Martinet who was probably the artist's nephew. This 1942 painting of the port of Algiers with its open-air theatre was exhibited in London at the Crane Kalman Gallery in 1958 (together with a Sables d'Olonne painting) and is now in the collection of the Fondation Bemberg in Toulouse. Marquet was close to Matisse, with whom he studied in Paris and whose studio and apartment on the Quai Saint-Michel he took over in 1908. Marquet was recently described by the writer Tim Hilton as a 'painter's painter'. His moment in the great surge of art in the early 20th century was as one of *les fauves* ('the wild beasts'). He later developed a kind of painterly realism which owed much to Manet and with which, for almost four decades, he depicted the cities and above all the ports of Europe and north Africa. Andrew Dempsey

Jack B Yeats *Roundstone Quay*, 1911, oil on canvas, 23 x 36 cm.
Pyms Gallery London

Jack B. Yeats (1871–1957) is recognised as Ireland's most important 20th
Century artist and is now acclaimed as an important European painter in the
northern European romantic and expressionist genre. He was the youngest son
of the portrait painter John Butler Yeats and the brother of the poet W.B.Yeats.

Jack B. Yeats, when he returned to Ireland from England in 1910, turned to oil
painting and started to move away from his watercolours, pen and ink drawings
and illustrations for *Punch* of his early career. *Roundstone Quay*, 1911 is
a typical work of this period where the linear style of the black and white
drawings was breaking down and the paint quality was more immediate and
fluid. In symbolic and metaphorical terms the lamp-post at the end of the quay
can be read as a figure, this single figurative element is something that Yeats
was often to use in his late paintings. The Irish Art exhibition at the Whitechapel
Art Gallery in 1913 (his father also exhibited in it) was one of the first survey
exhibitions of Irish art in England; it followed the seminal 'Armory' exhibition
of modern art in New York, in which Yeats exhibited five works alongside
Picasso et al.

Jack B Yeats *Death for Only One*, 1937, oil on canvas, 61 x 91.5 cm.
Private collection, New York

The solo exhibition of *Jack B. Yeats: The Late Paintings* in 1991 was the first
in England since the York festival in 1960 despite the retrospective at the Tate
Gallery in 1948. Yeats describes *Death For Only One*, 1937 as 'a dead
tramp lying on a headland with another tramp standing by – and a dark sea
and a dark sky.' The subject touches on the existence of man, it predates
'*Waiting for Godot*' yet the starkness of Samuel Beckett is tame by Yeats's
sense of tragedy, which is formed by an act of remembrance rather than the
unseen future. Yeats plumbs the mystery and loneliness of departures, whether
they are from death or from a quayside.

The 1991 exhibition was to project Yeats's work to new audiences, to artists,
critics and historians and to establish a revised context, thinking and appreciation
of his work. Frank Auerbach said: 'There is a lot of *Punch* in the early paintings,
and a lot of the early paintings in the late paintings.'

Jack B. Yeats used paint to catch moments of great emotion, which renew us
and lift up our hearts to face an ever-changing world. When we look at his
work let us hope for a moment of radiance and in Yeats's own words, 'Never
have a narrow heart.' Stephen Snoddy

Giotto *The Last Supper*, tempera on panel, 22 x 106 cm.
Upton House, The Bearsted Collection, (The National Trust)

The inscription on this *predella* reads 'The lady Giovanna, widow of Gianni di Bardi, caused this work to be done for the relief of the soul of the said Gianni; Master Jocti [Giotto] of Florence'. As the Upton House catalogue states: '… it is perhaps safest to say that the painting is in the late style of Giotto and must be by a member of his workshop'.

Exhibited during *5 Centuries of European Painting* in 1948, an impressive collection of works borrowed from the National Gallery as well as from the Bearsted and Cook collections, it was shown alongside works by Antonello da Messina, Fra Bartolomeo, Annibale Carracci, Albert Cuyp, van Dyck, El Greco, Francesco Guardi, Hogarth, Fra Filippo Lippi, Hans Memling, Murillo, Parmigianino, Raphael, Rembrandt, Reynolds, Rubens, Stubbs, Tiepolo, Titian and Veronese among others. This was the first show to open during the directorship of Hugh Scrutton, and one among many that addressed historical periods in European art.

John Martin *The Last Judgement*, 1853, oil on canvas, 198 x 325 cm.
Private collection

This painting was shown in *John Martin, 1789–1854*, 1953, 'the first comprehensive assembly of John Martin's work to be seen in London since his death in 1854' and part of a general rehabilitation of the artist's significance which had been gaining momentum since the 1940s.

'…at the 1816 Academy, his *Joshua Commanding the Sun to Stand Still* made him famous. The picture has disappeared, but it is still well-known from his large engraving of it, with its stupendous architecture and innumerable host set in a vast storm-ridden landscape. It broke all current rules of 'history painting', and the public was thrilled, though the pundits were dismayed. Five years later, in 1821, his *Belshazzar's Feast* caused such a stir that for the next thirty years he became, with the possible exception of JMW Turner, the most famous English artist both here and in Europe and America.'

The Last Judgement is the third in Martin's *Last Judgement* series, perceived as his masterpieces at the time, and was preceded by *The Great Day of His Wrath*, 1852 and *The Plains of Heaven*, 1853. 'Whereas *The Great Day of His Wrath* was to represent supernatural violence, and *The Plains of Heaven* supernatural calm, in *The Last Judgement* Martin attempted the impossible task of combining a maximum of turbulence with a maximum of serenity in one picture. The many *pentimenti* visible in *The Last Judgement* show with what difficulty, if at all, he finished it to his satisfaction.'

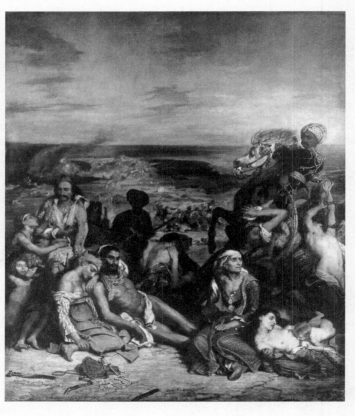

Eugène Delacroix *The Massacre at Scio*, 1824. Louvre, Paris.

Also known as *The Massacre at Chios*, Delacroix executed the painting for the Salon of 1824 and, as legend has it, took it down off the Salon walls to complete the sky and landscape while still in the gallery. The subject was chosen from an event in the Greek War of Independence, rather than from a literary source, and the painting was heavily influenced by Velázquez. According to Delacroix's diaries, Constable was also very much on his mind while working on *The Massacre*: '…saw Cogniet, and the picture by Géricault, also the Constables. It was too much for one day. That Constable did me a world of good. Came home about five o'clock. Spent two hours in the studio.' The painting featured alongside works by Corot, Degas, Gaudier-Brzeska, Géricault, Millet, Rodin, Tissot and Toulouse-Lautrec, amongst others, in *French Art*, held at the Whitechapel in 1932. It was one of many national surveys mounted at the gallery from its opening until the late 30s. The paucity of information in the exhibition catalogue prevents absolute confirmation of the inclusion of such a famous figure but the lists are impressive.

J.M.W. Turner *Reclining Venus*, 1828, 175.3 x 248.9 cm.
Tate. Bequeathed by the artist 1856

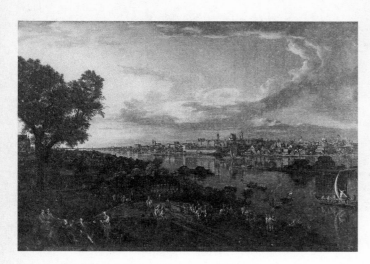

Bernardo Bellotto 1720–80, *View of Warsaw from Praga*, oil on canvas,
172.7 x 259 cm. Collection The National Museum, Warsaw

Under the exemplary patronage of Stanislaw Augustus Poniatowski, last king
of Poland and a hero of the Polish Enlightenment, Bellotto immortalised the
increasingly beautiful city of Warsaw between 1767 and 1780, with a series
of twenty-six townscapes. All but two have survived the machinations of dictatorial
regimes, including the bombing and subsequent dynamiting of the Zamek
Krolewski (Royal Castle) by the Nazis. 80 per cent of art objects were rescued
by Warsaw architects and art historians. A castle curator lost his life when
the first bombs fell on 17 September 1939.

In this painting from the eastern bank of the Vistula, Bellotto painted himself in
the act of painting and talking to the king, with whom he seems on easy terms.
(Bellotto's son Lorenzo and his father-in-law, Karol de Perthees, who was the
royal geologist, are among the group). In the centre of the picture and below
the baroque tower is the rococo façade of the Royal Palace, which fronts up
the vast complex of the Zamek Krolewski. Because they are so informative – in
detail – about Warsaw's town plan and its historic architecture, Bellotto's paintings
played an honourable role in the long-drawn-out but brilliantly successful
programme of rebuilding the city after the second world war.

Bellotto's paintings are very much more than topographical records, of course.
They combine the art of landscape painting with the art of genre painting in
such an original and distinctive way that many connoisseurs prefer Bellotto to
his uncle and teacher, Canaletto. (Confusingly, Bellotto adopted his uncle's
nickname). Certainly, Bellotto's work is much rarer, and more consistently
excellent: it might even be thought that there is almost a glut of Canalettos in
England, due to the Grand Tour habits of 18th century English gentlemen.

Bellotto had planned to move from Dresden where he lived for six years, to
seek work in St Petersburg, at the court of Catherine the Great – a lover and
friend of Stanislaw Poniatowski. The Polish king snapped Bellotto up however,
offering him 1,000 ducats per annum and a carriage. Bellotto showed the
world what Dresden and Warsaw looked like at the end of the 18th century.
Tragically both towns were destroyed by opposite sides in the second world
war. That Bellotto's paintings survived to help recreate the heart of Warsaw
is a sort of victory of art over evil; or at the very least, a triumphant vindication
of the ancient dictum, *Ars longa, vita brevis*. The 1957 Whitechapel exhibition
followed a successful Bellotto show at the Palazzo Grassi in Venice. The
decision to reconstitute it for London and Liverpool was also intended to mark
a renewal of cultural relations between Britain and Poland. Mark Glazebrook

The 1953 exhibition was my first direct exposure to Turner, whose more
Claudian works I had already admired in reproduction as a country schoolboy.
It was the painter's riddles in some of his complex subjects, especially the two
Deluge paintings of 1843, which I saw at the Council of Europe *Romantic
Movement* exhibition, six years later, which set me on course for my first book
on the artist, *Colour in Turner*, in 1969.

This large, unfinished, figure painting, executed in Rome in 1828, is characteristic
of the Turners which the open-minded organisers presented at the Whitechapel
in 1953. With the 71 *Liber Studiorum* engravings, thirty oils and over a hundred
watercolours, this was the largest one-man show of works outside the Turner
Bequest at the Tate Gallery until that date, and it included an unusual range
of figure subjects, as well as unfinished works, many from private collections.
The compilers of the catalogue reminded visitors that Turner had literary interests,
not simply in the context of his subject pictures, but also in the form of a 'MS
poem', *The Fallacies of Hope*, which they thought existed as 'a long and
incomplete poem' (whereas it seems almost certainly to have been devised
in *ad hoc* passages, to caption certain exhibition pictures). This reference,
together with the emphasis on the paintings of the human figure, which had
been so derided during Turner's lifetime, was prophetic of the interest in aspects
of Turner which was to emerge a decade later, especially in Jack Lindsay's
publication of an edition of Turner's poems, *The Sunset Ship*, and in Jerrold
Ziff's edition of the lecture on the history of landscape painting, given by
Turner in the context of his Professorship of Perspective at the Royal Academy.

The large Roman *Nude*, so dependent on Titian, was a clear indication that
Turner hoped to find his place in the tradition of the Old Masters, and not
simply in landscape, either; and in that sense the Whitechapel exhibition gave
an unprecedented stimulus to the interpretation of Turner which has prevailed
ever since, at least among historians of art. Painters, on the other hand, were
encouraged by Turner's mastery of his medium, and his interest in process,
evidenced chiefly in the many unfinished works, both in oil and in watercolour,
which were presented at the Whitechapel. John Gage

George Stubbs *Lady reading in a park*, c.1768–70, oil on canvas, 62.2 x 76.2 cm. Private collection

Denigrated for much of the twentieth century as a mere painter of horseflesh, George Stubbs conceived images which cultivated idiosyncrasy in place of homogeneity, conferring on his subjects a very particular kind of prestige. One such subject is the woman represented in *Lady Reading in a Park* of c.1768–70.

The approximate dimensions of the canvas are familiar to us from many of Stubbs's pictures of people and animals. However, to the best of my knowledge, Stubbs painted no other full-length portrait of a person alone in a landscape. Individual portraits of men and women recur throughout the artist's career, but the sitter is always accompanied by other people, or by horses or dogs or birds. In his portrait of Isabella Saltonstall in the character of Una from Spenser's *Faerie Queene* of 1782, the artist depicts his subject with a lion and an ass. None of these companions make their appearance in this painting.

Also unusual is the anonymity of the subject. Stubbs may have provided a clue to the woman's identity in the flowers which bloom prominently at her feet, or over the back of the bench on which she is enthroned. Stubbs expert Judy Egerton proposes that the painting might possibly be a pre-marriage portrait of Charlotte Nelthorpe, the daughter of one of the three Lincolnshire families for whom Stubbs regularly worked. In any event, the portrait is clearly specific.

The female reader is positioned on the right side of the canvas, engrossed in the pages of a small book which she holds in her right hand. The bench is located against the base of two large oaks whose boughs sweep down from the upper edge of the painting, generating something of a proscenium arch. The centre of the canvas gives onto a wooded scene in the middle distance which falls away to our left to reveal open countryside.

Using a device he employed on an habitual basis, Stubbs creates a strongly contrasting background against which the subject of his picture is delineated. The arboreal setting in this painting engenders an almost narrative theatricality. By contrast, the positioning of the woman off-centre anticipates a compositional arrangement whose creative impact was only widely recognised with the invention of photography. Born into a different century, Stubbs may have given us some very fine photographs. As it is, he has bequeathed to posterity some of the most impressive paintings ever realised. Paul Bonaventura

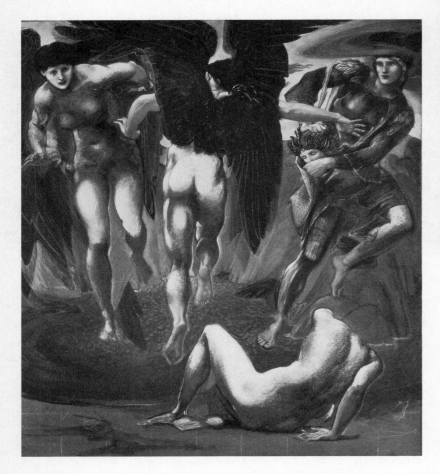

Edward Burne-Jones *Perseus Series: Death of Medusa II*, 1890s, body colour on paper, 152.5 x 136.5 cm. Southampton City Art Gallery Hampshire, UK/Bridgeman Art Libary

An exhibition of *The Pre-Raphaelites* took place at the Whitechapel Art Gallery in 1948. It was selected and catalogued by John Gere, at that time Assistant Keeper in the Print Room of the British Museum and later to become a distinguished Keeper. It followed a larger exhibition in Birmingham the previous year and Gere wrote that the Whitechapel exhibition should be considered 'an anthology of Pre-Raphaelitism in which the exhibits are chosen primarily on their merits as works of art'. The catalogue suggests that it was concise and exemplary as an exhibition with 118 works including the major figures associated with both periods of the movement: Millais, Rossetti, Ford Madox Brown, Holman Hunt, Burne-Jones, William Morris, Elizabeth Siddall and others; as well as many of their most famous paintings such as Hunt's *Scapegoat* and Millais' *Blind Girl*. Understandably there was less attention paid to the 'Pre-Raphaelite Sisterhood' than there would have been nowadays.

Burne-Jones set the tone for the second phase of the movement which evidently was not highly regarded by the selector, who wrote that 'the pictures in the lower gallery are by Burne-Jones, and serve to emphasise the contrast between the passionate realism of the true Pre-Raphaelitism and the 'aesthetic' languor of the movement which succeeded it, and which is often confused with it'.

The Perseus series was commissioned by the future Prime Minister Arthur Balfour for the drawing-room of his house at 4 Carlton Gardens, though the whole scheme was never completed. There are ten full-scale cartoons now in the collection of Southampton City Art Gallery, of which this is one of the most dramatic (and least languorous). The whole series, together with two large later oil paintings, was included in the Whitechapel exhibition. Andrew Dempsey

George Stubbs *Mares and Foals Under an Oak Tree*, 1773, oil on canvas, 78.7 x 99 cm. Her Grace Anne, Duchess of Westminster and the Trustees of the Grosvenor Estate

In a recent article, the *Guardian* newspaper reported a growing public fascination with the work of George Stubbs, commenting on the fact that the first-ever major exhibition of the artist's work had taken place at what is now Tate Britain in 1984. That show, brilliantly organised by Judy Egerton, Assistant Keeper of the British Collection, was compendious, but the article was inaccurate by more than a quarter of a century for the first-ever major exhibition of Stubbs took place at the Whitechapel Art Gallery in 1957 under Bryan Robertson's directorship. Arguably, it is Robertson rather than Egerton, or Stubbs's 1971 biographer Basil Taylor, who should be credited with unearthing the painter from relative obscurity.

Stubbs' rise to fame isn't so very recent. Nonetheless, current appreciation of his talent can be closely linked to the 1996 loan to and subsequent purchase by the National Gallery of *Whistlejacket*, one of the painter's finest works. *Whistlejacket* and the even more astonishing *Hambletonian, Rubbing Down* testify to the artist's matchless abilities. Rather than Constable or Turner, Gainsborough or van Dyck, it is George Stubbs who should be considered Britain's supreme painter.

Traditionally, the 2nd Marquess of Rockingham is believed to have commissioned the life-size 1762 portrait of *Whistlejacket* to carry an equestrian portrait of George III, later deciding against the monarch's addition for political reasons. The similarly life-size 1800 portrait of *Hambletonian*, one of the greatest racehorses of the 1790s, was commissioned by Sir Henry Vane Tempest after his seven year-old had won a match at Newmarket against Joseph Cookson's Diamond. Yet the majority of Stubbs' paintings of the horse were on a much smaller scale.

In most instances, the artist's equine subjects are depicted with their riders, jockeys and handlers. Sometimes, as is the case with *Whistlejacket*, they are painted alone, without backgrounds, isolated from the world outside the frame. And very occasionally, they are arranged together as collections of mares and foals.

Pre-eminent amongst the latter group is *Mares and Foals Under an Oak Tree* of 1773. Three brood-mares and two foals occupy the landscape beneath a mature oak tree. Behind them we glimpse the gently undulating countryside around Newmarket, where the 1st Earl of Grosvenor had the stud-farms in which he bred, in the late eighteenth century, the victors of three Derbys and five Oaks. The vegetation provides a screen against which the animals are posed. The horses themselves are anonymous.

Unlike his fantastic scenes which feature horses being frightened or attacked by lions, the artist is not engaged in this picture with the recording of a psychological state. Neither is he attempting an allegorical representation or the depiction of an abstract idea. As with the bulk of his paintings, Stubbs is aiming to evoke a vivid illusion of the actual presence of something simply for its own sake.

The plausibility of Stubbs' portraiture, equine and non-equine alike, was based on his lifelong interest in the full range of anatomical types, encompassing everything from humans and cheetahs to chickens and zebras. His precise modelling of flesh, grass, bark and cloud in *Mares and Foals Under an Oak Tree* reproduces appearances with a fidelity matched only in his lifetime by Ingres. Compositionally, Stubbs eclipses the greatness of Ingres for his arrangements of form on the picture surface are invariably flawless.

Some of the formal relationships created in this canvas are traceable to other paintings. During the course of his career, Stubbs was constantly engaged in the act of testing arrangements, pulling images apart and reassembling their basic components in new configurations. Long before Cézanne struggled with the presence of a not particularly significant mountain in the south of France, and soon after Chardin had come to terms with the morphology of a dead hare, destined for the pot, Stubbs had alighted on the living thoroughbred as the catalyst for his enquiry into the nature of visual perception.
Paul Bonaventura For CJ

Ben Nicholson *June 1937*, 1937 159.4 x 201.3 cm, Tate. Purchased 1955
© Angela Verren - Taunt, 2001

20th Century Form: Painting, Sculpture and Architecture was designed to demonstrate to the ordinary man in the street 'who is not usually interested in modern art, that a great deal of the aesthetic endeavour of this century is less remote from life than is often realised'.

The show stemmed from the acknowledgement of a deep gulf between the production of art and its reception by the general public. This concern reached the newspapers in April 1953, when John Summerson's leading article in *The Observer* firmly stated that modern art was '*profoundly obscure*'. The controversy had arisen when Reg Butler's prize winning *Unknown Political Prisoner* was shown at the Tate.

20th Century Form had an ambitious and difficult educational goal, as abstraction was its main feature. The means used to achieve it was to present formal arrangements demonstrating the links between fine arts and architecture, the latter being accepted as part of daily life experience. This decision would bring interesting aesthetic consequences: Le Corbusier, Frank Lloyd Wright, Mies van der Rohe, Alvo Aalto or Walter Gropius were represented with large photographs of some of their most famous buildings, suggesting a bi-dimensional – and thus pictorial – experience of architecture. Trevor Dannatt was responsible for the selection of architectural models by Yorke, Rosenberg and Mardall, Max Lock and Associates, Denys Lasdun and others. Many models mounted vertically could be looked at as patterns. Picasso, Braque, Léger, Gris, Kandinsky, Miró, Feininger, de Staël, Nevinson, Paul Nash, Moore, Hepworth, Lowry, Colquhoun, Ozenfant, Heron were included alongside Ben Nicholson who exhibited the large painting *June 1937*. Nicholson's exhibition planned for the Venice Biennale in 1954, was to have begun at the Whitechapel. Monica Portillo

Anthony Caro *Lock*, 1962, blue painted steel, 88 x 536 x 305 cm.
Private collection, London

Caro's show at the Whitechapel in 1963 consisted entirely of steel sculptures, shocking in their direct use of girders, bolts and rods, painted bright colours. These works, like *Midday*, the *Month of May*, *Lock* and the others are now part of the history of sculpture and at the time were received with enormous excitement. The author of a recent book on Caro divided his work into four groups: *Lock* (photographed here by John Riddy) fell into the 'ground' section and Karen Wilkin spoke of its 'stately hovering'.

'Caro's *Lock* comes from the period when the great expansive space that painting had recently discovered came into a true play in this first sequence of big metal pieces, almost all of them are landscape related. What I like particularly is that somehow colour, horizontality and this curious linear quality are almost openly associated and allow readings from all directions. What one forgets is what an incredible adventure it was to make sculpture in that way, with pre-manufactured materials. That linking of the industrial with the rediscovery of the romantic spirit of landscape opened up the poetic space. Caro fulfilled that very British vision, and I think that colour as perhaps discovered by the Abstract Expressionists previously had never been fully brought into the space. Caro was doing something really radical – if we had Judd in the show that would have been interesting because Judd did this even more radically.' Anish Kapoor

Mark Rothko *No. 11/No. 20 (Untitled)*, 1949, oil on canvas, 238 x 134.6 cm.
Collection of Christopher Rothko

The claims which Rothko has made for his work seem on the surface decidedly perverse. He says he is 'no colourist', which might well be thought affected in view of the dully glowing splendour of his harmonies. He denies the view common among his admirers that his work is Apollonian, quietist, maintains that on the contrary it is nothing if not violent, Dionysian – the perverseness of this claim being that it seems pretty extravagant to attribute violent passion to paintings whose means of expression – the hushed colour, the design in terms of horizontals – are traditionally associated with serenity and stillness. But the claims are not perverse: it is not when he talks that Rothko is paradoxical but when he paints. The value of his painting lies precisely in the paradox that he uses seductive colour so that we disregard its seductiveness, that he uses the apparatus of serenity in achieving violence. For of course the stillness is there as well, and that is just the point: violence and serenity are reconciled and fused – this is what makes Rothko's a tragic art.

The strength of the great monomaniacs of modern art – who also include Giacometti, Rosso, Monet – in relation to their audience is that they are not distracted by success or by failure. Their vulnerability is that they are peculiarly subject to hazards of presentation, since their work pushes the medium to extreme limits where there is no margin between glory and absurdity, so that, shown in the wrong light or at the wrong height, it can so easily go the other way. At Whitechapel the exhibition is worthy of the exhibits.
Rothko, by David Sylvester, published in: *New Statesman*, 20th Oct. 1961 (extract)

Tim Scott *Dulcimer*, 1961,
glass, fibreglass and wood,
25.4 x 7.6 x 7.6 cm.
Private collection

Phillip King *Span*, 1967, metal, 20.3 x 39.3 x 44.4 cm. Private collection

John Hoyland *20.12.64*, 1963, green with red-violet, pink, yellow, red and
two greens, 20.3 x 279.4 cm. Private collection

The above artists all participated in *The New Generation* exhibitions, 1964–68,
alongside Patrick Caulfield, Bridget Riley, David Hockney, Allen Jones and
Paul Huxley. Their solo shows at Whitechapel came in a sequence that also
included Bryan Kneale, Richard Smith and Robert Medley and established a
standard of spacious mid-career exhibitions that now occurs nationally.

THE HYPNOTIST

David Hockney *The Hypnotist*, 1963, oil on canvas, 214 x 214 cm.
Private collection

The famous *New Generation* exhibition of 1964 marked a point where British art 'suddenly woke up out of a long provincial doze' into an atmosphere 'of self-confidence but also of competition' with work characterised by its 'toughness and ambiguity'. As sponsors of the exhibition, the Stuyvesant Foundation bought work from and provided travel grants for 6 of the 12 painters, all of whom were under thirty years old.

Hockney was one of the four painters in the exhibition who championed a 'new figuration' while at the Royal College of Art between 1960 and 1962. By 1964 he had already won the John Moores Junior prize in 1961, exhibited at the ICA and the Whitechapel and had work bought by the Tate and MoMA, NY. His inclusion in the *New Generation* show and his 'staying power' is vindicated by a 'wiry streak of resilience' and the sophistication of the 'humorous, almost self-mocking undercurrent to … an art that is concentrated autobiography.'

At the time Hockney explained that his pictures divided 'into two distinct groups. One group being the pictures that started from, and are about, some 'technical'

device (i.e. curtain pictures) and the other group being really dramas, usually with two figures. Occasionally these groups overlap in one picture.' He later recalled that he '… felt like painting another picture with the figures very separated. I'd realised by then that a reasonable way to unite figures that were painted on the edge of a very large canvas was to put them in a theatrical or stage-like setting.'

Sourced from a scene in a movie called *The Raven*, *The Hypnotist* was one of these multi-layered paintings. Entering a semiotic discourse through the tautological label and indulging in a theatrical trompe-l'oeil, Hockney performs as the dramatic illusionist and puppeteer outside of the canvas and the dazzled, disarmed subject within. This is his way, in the words of catalogue contributor David Thompson, of 'practising elusiveness'.

Hockney's first major solo exhibition was held in 1970 at the Whitechapel and contributed to his subsequent widespread acclaim and international recognition.

Kenneth Martin *Chance and Order (Green)* 1970, oil on canvas, 122 x 122 cm. Private Collection

An exhibition of both Kenneth and Mary Martin was shown at the Whitechapel in 1971 at the conclusion of a twelve-stop tour organised by what was then the Arts Council of Great Britain. A number of people looked after the arrangements for this show on its lengthy itinerary from Exeter to Edinburgh, including Nick Serota, at that time working for the Arts Council and subsequently Director of the Whitechapel. For the London showing a number of new paintings by Kenneth Martin were added including this work, which is one of the early *Chance and Order* paintings, a series which was to preoccupy Martin throughout the 1970s.

Kenneth and Mary Martin belonged to the stream of art beginning early in the 20th century with Russian Constructivism and the Dutch De Stijl movement and whose heroes included Tatlin and Mondrian. Mary Martin is particularly associated with relief sculptures in perpsex and Kenneth Martin with screw mobiles and transformable constructions in brass, though the *Chance and Order* series marked a return to painting. The series involved the conscious use of chance to find and vary forms and a long period at the easel during which the plane of the canvas was built up, producing a surface full of incident and receptive to light. Andrew Dempsey

Leon Kossoff *Children's Swimming Pool, Autumn,* 1972, oil on board, Arts Council Collection, Hayward Gallery, London, UK Bridgeman Art Library

Born in 1926, Kossoff's family lived in Bethnal Green and Hackney and from the age of twelve he drew and painted London. His paintings of Christ Church, Spitalfields have immortalised this splendid Hawksmoor building as much as any painters' or writers' fixation on a similar landmark.

The swimming pool in Willesden was the newest subject at the time of the Whitechapel exhibition in 1972 arranged by Jenny Stein. Unusually two of the four large canvases are dated to a particular day even though they were worked over time. 'I started drawing in the pool almost as soon as it was built. This was some years before I finished the first painting... I was very interested in how the pool changed during the summer months and how at different times of the day the changing of the light and rise and fall of the changing volume of sound seemed to correspond with changes in myself.'

Piet Mondrian *Composition with Colour Planes No.3*, 1917, oil on canvas, 48 x 61 cm. Lent by the Gemeentemuseum, Den Haag, 2000 ℅ Beelderescht Amstelveer

The Mondrian exhibition in 1955 included early portraits and landscapes, through to the late grid compositions that Mondrian was painting before his death in 1944.

Bryan Robertson hoped the exhibition would give visitors a 'fair idea of Mondrian's heroically logical development as an artist'.

Mondrian's oval composition presented in **Dutch Art 1921,** (when he was nearly fifty) and his presence in Britain in the 30s, had established precedents for links to Whitechapel.

Hendrik Nicolas Werkman *The next call nr.9* 1926, paper, 35 x 42.8 cm. Private Collection

Hendrik Nicolas Werkman was the fifth nineteen-century born Dutch artist who reached international standing (the others being Jongkind, Van Gogh, Kees Van Dongen and Mondrian). Werkman was an artist who worked as a printer in the provincial town of Groningen in the north of Holland. He questioned the use of printing as a commercial business and activity without humour and poetry.

Werkman started experimenting with letters, figures lines, punctuations and the reverse of printing blocks to create the most playful typographical designs. For him Dada was a self-evident mentality. As Werkman used to say, art is everywhere and is thrown on the coats of people by the birds. Herman Lelie

John Lifton *Green Music installation*, 1975. Photo: Dan Flowerden

Trained as architect and mime, John Lifton became seduced by the possibilities of art that could encompass the senses. He abandoned his job in the Architects' Department of Hackney Borough Council and became involved with mixed media, happenings and electronics. He made a cybernetic music machine which played music in response to the movements of people in its environment, and a second one that responded to ambient sounds. Other experiments followed, with electronics and performances. He moved fast, not following trends but anticipating them. Soon after the creation of *Green Music*, he was working on a parrot opera, by which time he had already left England for Colorado.

In *Green Music*, Lifton developed a system for analysing and translating electrical signals of plants' cells into a range of sounds and rhythms. The plants responded to light, heat and their own electrical activity, all fed back in the form of sounds. It was a paradoxical work of art insofar that for much of the time the six plants (aphelandra, ficus, palm, or another sturdy species) produced no music to speak of. However, at about 4 o'clock in the afternoon, when the gallery became very warm and the light subtly changed, the plants became enormously active for about two hours. They performed with such loud and melodious abandon, that visitors to the gallery could scarcely believe they were hearing music generated by the six potted plants on the floor in front of them. Jasia Reichardt

Andrew Logan installing *Goldfield* 1976 for the exhibition of the same name, 1976

Logan was an architect before he became an artist. After he had painted skies on a ceiling, lit a room with a daffodil, and furnished a sitting room with Covent Garden grass, he realized that nature may be found in any environment. Later, after an accident with a mirror, he found that the shattered pieces were suitable material for making sculpture. And so, as well as gods and goddesses, fauna and flora became his subjects and the subversion of appearances became his signature. Things were not as they seemed and Andrew Logan decided to take us through the looking glass to the other side.

Goldfield 1976, had the subtitle: 'giant wheat, butterflies & mice'. The stalks, surmounted with giant sheaths of wheat embedded in rocks on a straw-covered floor, stood 16 feet high. Among them, glittering in the yellow light in which the field was bathed, were giant butterflies and giant mice, made from mirror fragments. The atmosphere was that of a ballroom more than a gallery. There was music too, the *Goldfield Fantasia* by Richard Hartley. For those who wanted a different view of the field, there was a castle tower that visitors could climb in order to look at the field from above. Only on view for a month, the *Goldfield* was one of many of Andrew Logan's inspired alternatives to a real world of grey pavements, sad faces and low ceilings. Jasia Reichardt

Mario Merz *Che fare*, 1968, wax and neon tube in metal tub,
14.4 x 45 x 17.8 cm. Galleria Civica d'Arte Moderna e Contemporanea,
Torino – Fondazione Guido ed Ettore de Fornaris

'This is a real fluxus object with this wonderful tongue in check – 'what are you doing?' and this fabulous neon light. Only an Italian artist can show this complete 'f... you' all over, and this wonderful sense of collective design. It's astounding. This is not programmatic and ungraspable. There were a few moments in the best of arte povera that escaped real, obvious ways to meaning. And of course the most cogent way to mean is design, but it's as if the fat and tube have nothing to do with each other, they are sort of incidentally together.' Anish Kapoor

Eva Hesse *Tomorrow's Apples (5 in white)*, 1965, painted concretion, enamel, gouache, varnish, cord on wire and papier-mâché on hard board, 65.4 x 55.6 x 15.9 cm. Tate. Purchased 1979.

Nearly ten years after her death, Nicholas Serota was able to express that 'Eva Hesse helped to change the way artists, critics and viewers look at art and particularly sculpture. Her own doubts about the work gave way only slowly to a belief that the art she was making had strength and importance. She began with what she called the 'integrity of the piece', 'in finding out through working on the piece some of the potential and not the preconceived' using materials 'in the least pretentious and most direct way'.

As Rosalind Krauss points out in the same exhibition catalogue of 1979, 'The most powerful and continuous element of Eva Hesse's work comes from the way it concentrates on this condition of edge, the way it makes the edge more affective and imperious by materialising it. In this way, the edge that is displayed by Hesse is not focussed on the boundaries within a painting or a sculpture, but rather on the boundary that lies between the institutions of painting and sculpture. In Hesse's work the gravitational field of either painting or sculpture is always experienced as shifting. Things begin on the wall and end on the floor, or on the wall adjacent to the one where they started. Things lean from floor to wall; or they begin stretched out on the horizontal plane only to turn the corner and snake up onto the vertical one. From the position at the edge, the boundary between those two formalised conventions, there emerges an experience of matter that is both bewildering and beautiful.'

Joseph Cornell *Untitled (Compartmented Box)*, c. 1958, box construction, 43 x 26 x 6 cm. The Joseph and Robert Cornell Memorial Foundation, courtesy C&M Arts, New York © The Joseph and Robert Cornell Memorial Foundation/VAGA, New York and DACS, London 2001.

Likened at different times to 'a souvenir and culture scavenger', an 'American constructivist' or simply a maker of adult toys or objects, Cornell produced his first works in 1931, in the context of Surrealism. The hundreds of 'box-constructions' made over the next four decades include Shadow Boxes, Homages to Romantic Ballet, Soap Bubble Sets, Constellation Boxes, Carousels, Averies and Hotels.

His own definitions of a box included a kind of 'forgotten game' and for Dawn Ades, he was a maker of 'jouets surréalistes' with 'nostalgia for the golden age of the Victorian toy, in which scientific invention was blended with pure imagination.'

Other boxes are full of fragments; torn tickets, a single feather, etc, which all hint at a presence too elusive to be enclosed in a box. Many of Cornell's works refer enigmatically to birds, with a perch, a ring, or the broken wire netting of a cage. In the 1950s he started a number of new series including the emptiest of his boxes (of which this work is an example). In his own words, they are like a 'philosophical toy', a vertical pinball machine without the satisfaction of flashing lights or ringing bells, a deserted dovecote, or an imaginary world where geometric order is balanced against nature.

As John Ashbery remarked, Cornell's products have had a far-reaching impact. The more cluttered, Surrealist works clearly impressed younger artists like Rauschenberg, and the sparer, white, gridded boxes preceded the geometric sculpture of Sol LeWitt, Donald Judd and Robert Morris.

This work was included in the Joseph Cornell retrospective exhibition, which toured from the Museum of Modern Art, New York to the Whitechapel in 1981.

Philip Guston *Painting, Smoking, Eating*, 1973, oil on canvas, 197 x 263 cm. Stedelijk Museum Amsterdam, acquired with support of the Vereniging Rembrandt and Mrs Musa Guston

Guston's late paintings were introduced to Britain in an exhibition in 1979 at the Hayward (curated by Catherine Lampert). Twenty-three canvases were gathered for the Whitechapel's show, planned shortly before his death in 1980, and which travelled to the Stedelijk. In the wonderful narrative text *Philip Guston Talking* he wrote: 'Then I did a whole series of paintings of smokers smoking; it's me. When I show these, people laugh, and I always wonder what laughter is. I suppose Baudelaire's definition is still valid 'it's the collision of two contrary feelings'. Many of the following paintings are paintings about the painter. This is called *Painting, Smoking, Eating*. There is a guy lying in bed eating a bunch of french fries, imagining this big pile of stuff above him'. This work was amongst Trockel's selection for the current exhibition, that would also have included the similarly unclassical Kippenberger self-portrait in his underwear shown in *Examining Pictures*, had it been readily available.

Sonia Boyce *She Ain't Holding Them Up, She's Holding On (Some English Rose)*, 1986, oil and pastel, 218 x 99 cm. Middlesbrough Museums and Galleries

In 1986 three artists, Sonia Boyce, Gavin Jantjes and Veronica Ryan joined a Whitechapel team to select a show entitled *From Two Worlds*, which was one of the first to acknowledge the post-war Diaspora and the Whitechapel's responsibility for continuing a tradition that was begun with the first generation Jewish artists living in the East End in 1906. Boyce was only twenty-four when she made this self-portrait with her arms supporting an image of the artist, her sister and parents. The idea for the painting came from thinking about conversations her mother had, 'I'm talking about the stories and tales that our parents brought with them when they came from the Caribbean'. With David Bailey, Boyce helped found AAVAA (African Asian Visual Arts Archive) at the University of East London.

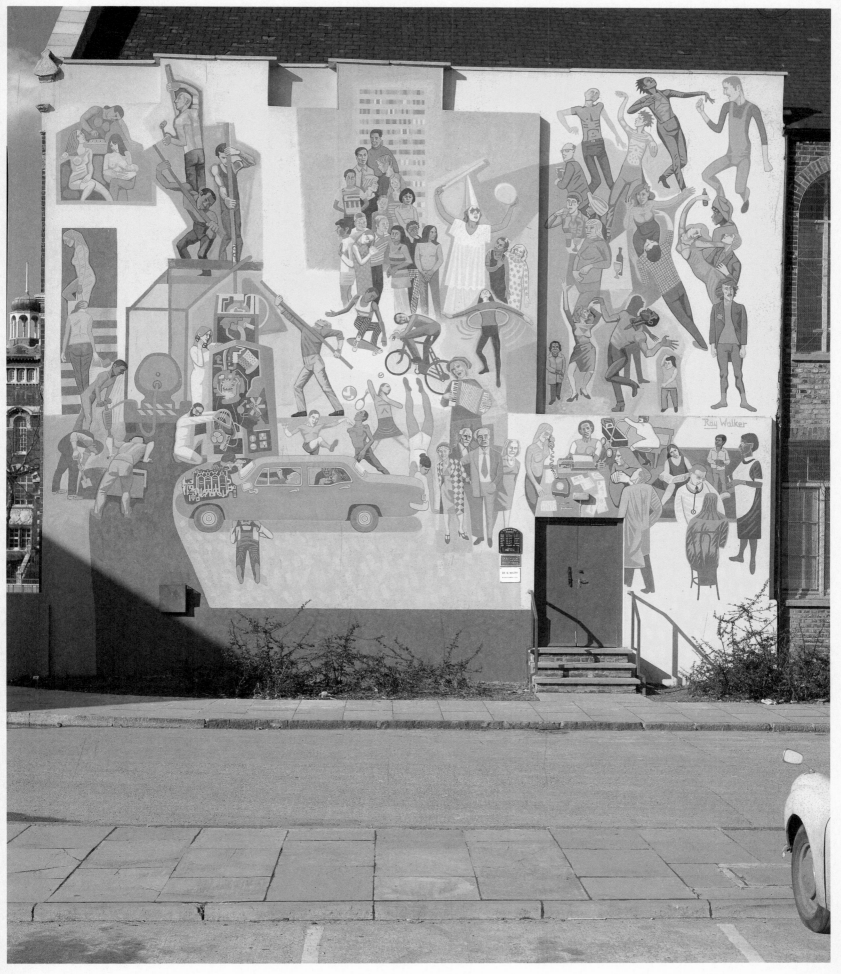

Ray Walker exhibited the working drawings for his Bow Mission Mural at the Whitechapel in 1979. The mural, in Merchant Street E3, was completed in 1978. It was the first of Walker's East End Murals, others being in Chicksand Street, Bow Common Lane, Cable Street and Dalston Lane. Walker spoke of the Bow Mission mural as 'reflecting images of fate without remorse within a working-class community'. The Mission's annual report described it as follows; 'The original aim was simply to brighten a very drab wall, which faces a new estate. But now the mural is with us it means much more. In a simple way the mural brings out some of the ideas and attitudes that are basic to our work. The mural is first and foremost about people. People doing all sorts of things, working, playing, shopping, feeding, visiting the doctor, attending lessons. Primarily it is about people at work and at play.' A later exhibition was held in 1986 at the Whitechapel, *Ray Walker: Studies and Working Drawings*, again including the Bow Mission drawings. Andrew Dempsey

Barry Flanagan *Lack of Civility*, 1982, bronze, cast 5 from an edition of 7, 66.6 x 80 x 30.5 cm. Collection Waddington Galleries

Flanagan represented Britain at the Venice Biennale in 1982, and afterwards his exhibition came to the Whitechapel. In a show remembered for the beautiful gilded unicorn and the first sculptures of hares, he added this piece (also cast in Bow) which refers to the Falklands War. Another 1982 sculpture *Toy*, made from a washtub by Richard Wentworth had as its subject the sinking of the Belgrano. A constant theme in Flanagan's work is professional manners and external events. The Whitechapel included his drawing *When attitude offend form*, 1971 and *ring n*, 1966 in *Live in Your Head*, an exhibition whose core was the generation at St Martins identified with Bruce McLean, Gilbert & George, Richard Long and Flanagan. All were shown at the Whitechapel in the 70s just as their teachers, Anthony Caro, Phillip King and Tim Scott had been in the 60s.

Cy Twombly *Untitled*, 1983, painted bronze, 142 x 23 x 41 cm. Private collection, Rome

Cy Twombly's work was first shown during *In Tandem. The Painter-Sculptor in the Twentieth Century*, 1986, an exhibition that 'traced the engagement of painters with the third dimension' at a time when 'a new wave of sculptural activity has appeared on the part of a large number of painters'. It's curator, Lynne Cooke, argued that 'It compares the efflorescence of the present with two other crucial moments... the first occurred in the early twentieth century when painters contributed greatly to the establishing of what has proved the prevailing conception of sculpture for much of this century... a free-standing self-sufficient, discrete object. The second occurred in the sixties, when painters again took up sculpture in considerable numbers, but on this occasion placing themselves mostly at a tangent to the prevailing debates.' Including 21 artists, from Degas to Clemente, Twombly was represented with a crayon and pencil canvas from 1956 as well as 4 sculptures.

A year later Twombly returned with a solo exhibition, *Cy Twombly: Paintings, Works on Paper, Sculpture*, organised by Harald Szeeman. In the catalogue Szeeman wrote: 'All the beauty and elegance of the balancing act performed by this prince of painters is present in his sculpture of recent years... They are made from recognisable, used-looking, everyday objects... The latest ones consist of sand mixed with plaster, or are directly worked in plasticine and plaster, before being cast in bronze or synthetic resin by a process that destroys the original. All these sculptures are painted with *Cementino*; the resulting nuances of white, and the intensity of light, rob them of their concrete quality as objects. They transmit an unreal, elusive radiance. They are transmitters of light, transmitters of silence, transmimtters of poetry.'

Bruce Nauman *Untitled*, 1965, fibreglass, polyester resin, 61 x 335 x 12.7 cm.
Collezione Prada

'This is a great period in Nauman's work, 1965, when the human content of the work comes together with the fabrication and the mould played a real role as a finished object. This work had the curious Giacometti reference to the walking figure. It seems to have no obvious logic but the way it kind of moves in and out of the formal sculpture, from body to long and loopy form. It is a kind of investigation into the extended human space.' Anish Kapoor

Jeff Wall *Diagonal Composition*, 1993, transparency in lightbox, edition of 10, 40 x 46 cm. Collection the artist

As Briony Fer points out in her contribution to the exhibition catalogue 'The Space of Anxiety', '*Diagonal Composition*, is, by Jeff Wall's standards, a small picture which, unlike his 'trademark' works, appears not to be staged but found. The scale of the objects in *Diagonal Composition* is life-size, but the cropping of the frame seems to magnify them and give them undue significance. It is the composition that dominates the image with diagonals cutting across and dissecting the pictorial field, recalling that moment in the history of modernism when familiar ways of seeing were radically 'made strange'. However unfamiliar that process may have been at the time, it has now become familiar, a commonplace in modernist photographic vocabulary. The diagonal, the angle which once registered as 'dynamic' and as an index of the new, appears now as a left-over from the past – its vividness remembered rather than actual. *Diagonal Composition* shows clearly, then, Wall's self-reflexive engagement with different pictorial registers and different orders of representation.'

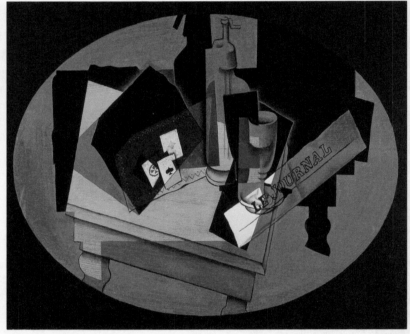

Juan Gris *Still Life with Playing Cards and Siphon*, 1916, triplex wood with oak upper layer, 73 x 117 cm. Kröller-Müller Museum, Otterlo, The Netherlands

Juan Gris finished this picture in July 1916, with France caught in what increasingly appeared a bloody stalemate with the German armies that had occupied her North Western territories. The Battle of Verdun had months still to run. Food in Paris was increasingly scarce and expensive; sugar and diary products were luxuries.

One level on which this austere treatment of a siphon, glass and playing cards can be approached is as an image of deprivation. The glass may perhaps contain wine, but there is nothing here to eat, and the partially modelled volumes of siphon and glass rise from their own empty black shadows, which are etched with that of the table into the coldest of grey grounds. Yet, Gris' engagement with these objects is intense and vital. He explores them as unfolding presence, projected forward from their flat black silhouettes through intermediary flat shapes into the round; and he locks their threefold intricacies into a complex harmony contained within an interior oval frame. By 1918, Gris' work would routinely be described as idealist in the purest Platonic sense: the reduction of objects to some abstract essence. It is a moot point, however, whether here he invites us to see things as emerging from their shadows or as dematerialising into them.

For those who admired his work in his time, Gris's austerity was never as cold as his greys could be. 'This was a Spaniard', his friend and dealer D-H. Kahnweiler wrote, 'with a fanatical and passionate temperament'. Chris Green

Tony Bevan *Self-Portrait*, 1992, pigment and acrylic on canvas, 88 x 76 cm. Courtesy of the artist

The core of Bevan's show in 1993 was the series called *The Meeting* that included a large polyptych of six canvases. 'Tony Bevan has always been fascinated by extreme psychological states, and by their bodily correlatives in lines of tension. The obtrusive, bright red, scar-like lines which mark the body-surfaces of his figures are concentrated at certain key areas, especially the neck and the throat.' Peter Wollen

Lucian Freud *Parts of Leigh Bowery*, 1992, oil on canvas, 50 x 104 cm. Mr and Mrs Kennaway

The striking sequence of Leigh Bowery paintings left an indelible impression on visitors to the Whitechapel in autumn 1993. When the show travelled to the Metropolitan Museum in New York it declined to show *Parts of Leigh Bowery*. A canvas with an extraordinary pillow appeared on the catalogue cover, *Still Life with Book*, underscoring Freud's reply in the *Lovely Jobly* interview to Bowery's question on the sexual possibilities in pictures, 'The paintings that really excite me have an erotic element or side to them irrespective of subject matter – Constable for example'.

The following year Freud worked on Leigh standing under the new skylight, a masterpiece completed shortly before his death. Bowery lived near the gallery, came frequently to our café and shows and was inspiring to a whole generation that is now settled in the area.

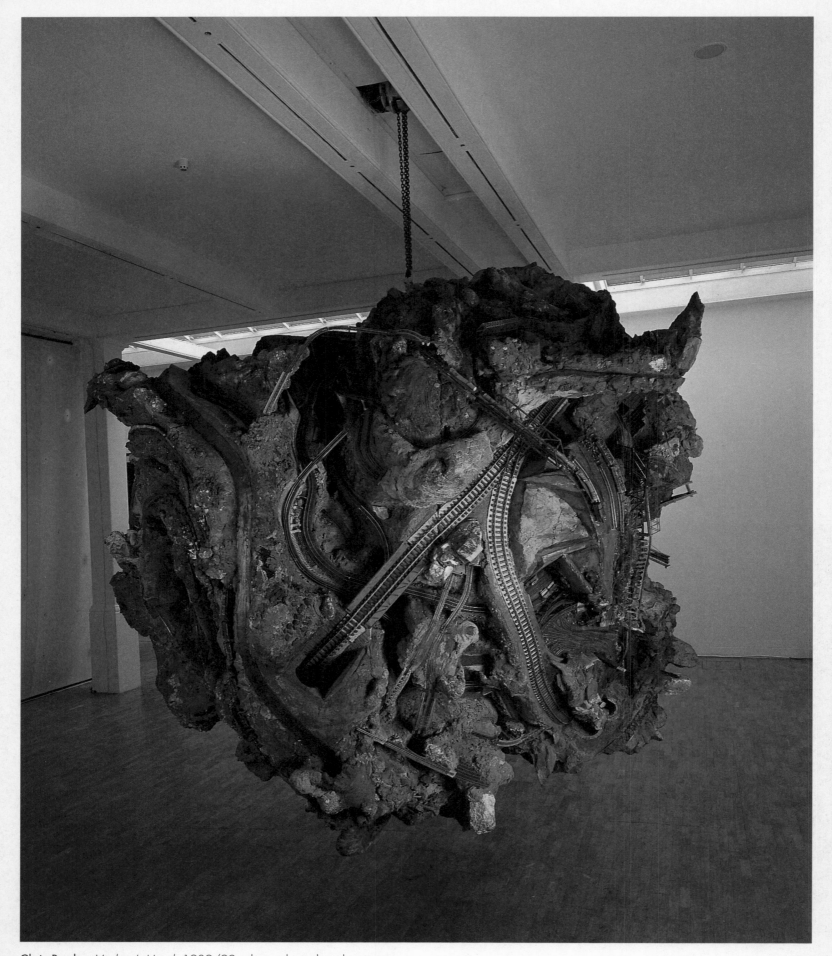

Chris Burden *Medusa's Head*, 1989/92, plywood, steel work, cement.
Private collection

Medusa's Head, 3.5 metres across, weighing seven tons, was finished shortly before *Seven Obsessions* opened and, suspended in the Lower Gallery, left an indelible impression on visitors. The gorgon's head is wreathed in toy trains loaded with rocks and earth. Like many of his works it is a metaphor for the world engulfed in its own technology, heading towards self-destruction. Whereas railroads were once smoking monsters, new dangers emerge, as Burden says:

'We worried about the atom bomb and now we have AIDS.' Immediately before this show opened Saddam Hussein's invasion of Kuwait triggered a new conflict. Another Californian artist Mark Thompson built a sealed room of wax blocks in the New Gallery and introduced a beehive. The exhibition included two winners of the Artists Award, Melanie Counsell and Angela Bulloch as well as new work by Darrell Viner, Tim Head and Sophie Calle.

Peter Doig *Young Bean Farmer*, 1991, oil on canvas, 186 x 99 cm.
Collection Warren and Victoria Miro

In 1990 Peter Doig was one of the recipients of the Whitechapel Artists Awards which had been established in 1987 to assist young British artists at a crucial stage in their careers. As part of the award, Doig was given an exhibition at the Whitechapel in 1991 in a section of the Upper Gallery, where he showed a small selection of paintings made in that year; they are now considered as some of the cornerstones of his practice. His subsequent solo exhibition at the Whitechapel in 1998 confirmed his position as one of Britain's most prominent and exciting young artists.

Exhibited in both these exhibitions, *Young Bean Farmer* combines a sentimental affiliation with post-impressionist colour, technique and subject matter with an awareness of memory-provoking photography or film stills.

'Jumping the gun, better than dead: what's next in Peter Doig's paintings' is Terry R. Myers' contribution to the publication accompanying the 1998 show: 'What is going to happen?' is so clearly and critically the pressing question in the subject and substance of Doig's pictures (even or particularly – when the answer lies in the 'past') that when we find the artist suggesting that 'I'm not trying to make nostalgic pictures, or to make things that are new. I suppose I reflect. The now is given, the now is now, you don't have to make paintings of the now,' we should take it at face value and – at least on some truly unreal level – watch our backs.'

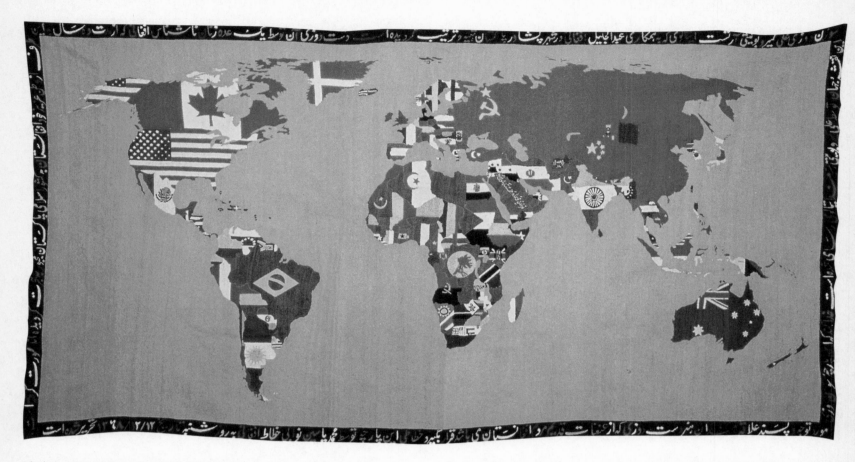

Alighiero Boetti *Mappa*, 1988, embroidery on canvas, 115 x 213 cm.
Collection Caterina Boetti, Rome

This is one of many maps produced by Boetti from 1971–2 onwards, in which the landmass of each country is marked by its national flag. It is likely that Boetti's recurring use of embroideries owed much to his encounter with its widespread use in Afghanistan, a country he first visited in 1971 and which was to remain profoundly influential to his way of thinking. All maps were made by local craftswomen, and often took a number of years to complete. Writing about the maps, Boetti stated: '...the embroidered map is for me the ultimate in beauty. I did nothing for that work. I chose nothing, in that the world is made the way it is, I did not draw it; flags are the way they are, I did not draw them; in other words I did absolutely nothing: once the basic idea has emerged, the concept, the rest is not a matter of choice...'. Some bear the marks of individual improvisation; Boetti had not requested, for example, that the oceans in the illustrated map be embroidered pink. Versions with red and black oceans also contrast with the more usual blues. *Mappa*, 1988, was one of three included in the first comprehensive overview of his work in the UK, held at Whitechapel in the autumn of 1999, curated by Judith Nesbitt, Andrea Tarsia and Antonella Soldaini.

Tariq Alvi *Fucked Up with Flyers and Aesthetics* (detail), 1996, torn up club flyers, table, cut outs from jewellery magazines on sheets of paper, peacock feathers. Collection the artist.

Using materials already in circulation – club flyers, mail order catalogues, photographs and magazines – Tariq Alvi creates a new visual language by appropriating the images and general detritus we accumulate in our day to day lives. Frequently sculptural, his works contain a web of references that explore and record the artists own methods and thought processes, as much as they do the distinction between domestic, public and gallery spaces and between art and reality.

Alvi's first major presentation in the UK took place during *Temporary Accommodation*, which also included Simon Faithfull, Ella Gibbs and Szuper Gallery. Laurence Sillars.

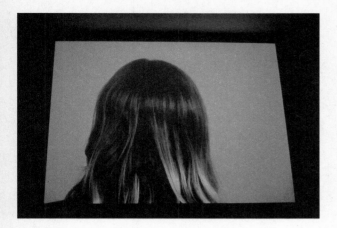

Runa Islam *Turn (Gaze of Orpheus)*, 1998, video projection (DVD), dimensions variable. Courtesy of the artist and Jay Jopling/White Cube, London

000zerozerozero, a three-week exhibition held at the Whitechapel during the summer of 1999, presented an intense programme of art, contemporary music, fashion, film, photography, and performance all from second generation Asian artists living in London. Challenging and dispersing preconceptions of ethnicity, the show renegotiated what it meant to be 'British and Asian' at the turn of the century.

'Of the three works I presented, *Exile*, a small green light box which literally plays with the semiotics of standard Exit signs, succinctly applied itself to the show. Its connotations, derived from the politics of representation, work through the memory after the event and prompt the recognition of the implicit ideological meanings in every day objects.

The short sequence of video in *Turn (Gaze Of Orpheus)* promises the returned gaze as a fulfillment, a recognition, but is engulfed at the moment of engagement into a blackness. As the title indicates, the moment of contact is one of mythic resonance, repositioning the work as poetic metaphor for the persistant loss of every moment perceived. Installed in the Whitechapel foyer during *000zerozerozero*, the piece maintained a public but solitary presence. Its twin work *Stare Out (Blink)*, a 16mm film projection the size of A4 paper, occupied a darkened area in the Upper Galley. The image, again of a girl looking, presents itself on the original negative upon which it was captured. The black and white inverse portrait is a registration of reality cast onto celluloid, a materialisation of spatio-temporal immateriality. The spectator, forced to blink at the flashes of light projected through the intervals of clear film experiences a somatic response, an after-image onto their retina. The ghostly image, a positive of the face, lingers as a phenomenon against the vicissitudes of time' Runa Islam

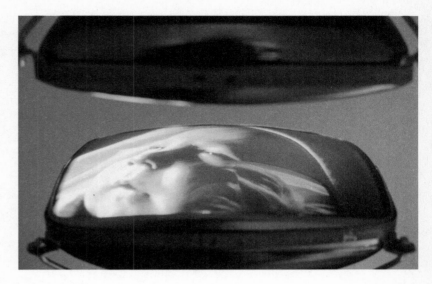

Bill Viola *Heaven and Earth*, 1992, two-channel video installation, edition 1 of 2, lower column: 144.78 x 36.83 x 27.94 cm, upper column: height variable, 36.83 x 27.94 cm. Collection Museum of Contemporary Art, San Diego; Museum Purchase, Contemporary Collectors Fund © Bill Viola

Viola produced 9 new installations in 1992, 7 of which toured through Europe in an exhibition which originated at the Städtische Kunsthalle, Düsseldorf and alighted at the Whitechapel in the same year. In January, Viola completed *Heaven and Earth*, which consists of a tall column connecting ceiling and floor. The column is interrupted at eye-level by two video monitors, face to face. On the upper screen, the face of a dying woman is visible; on the lower, that of a newborn child. Since the surface of each monitor is glass, an image of the opposite screen is visible through the surface of each image, reflecting life onto death (and vice versa) both literally and metaphorically.

Birth and death occur simultaneously and constitute the link (the column) between Heaven and Earth, or, between this life and beyond. These co-ordinates of human existence are crucial to Viola, who sees them in the context of cosmic principles and articulates insights into the world and the state of being. Again and again the theme of beginning and end, transience and rebirth, consciousness and dreaming, reality and transcendence occur in his works.

Heaven and Earth is dedicated to the artist's mother who passed away in 1991 and his second son who was born nine months later, the silent images incorporating his son's first days and his mother's final hours.

Francis Alÿs *Le temps du sommeil*, 1995 – ongoing, oil on wood, 50 paintings, each 11.5 x 15.5 x 1.5 cm. Collection the artist

Le temps du sommeil has grown in number since the first ones were displayed at the Whitechapel in *Antechamber* in 1997. At the moment the series is split, the other half on display at the Walker Art Gallery in Minneapolis. All of Alÿs' paintings are of this scale and they develop alongside notebook drawings, tracings and collages of similar subjects although painted directly. His friend, the writer Cuauhtémoc Medina has called the images 'miniature installations'. Alÿs' practice includes walks (several are reconfigured in these paintings), performances, videos, collective works with sign-painters and postcards, many related to his adopted country, Mexico. The works reflect the position of the international artist living in a zone of poverty, like the international traveller, always a tourist and outsider.

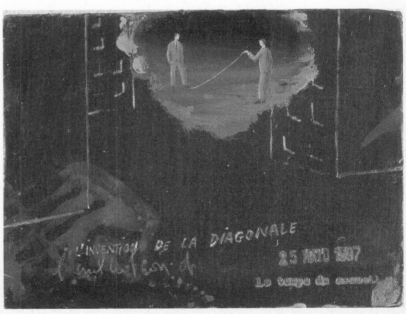

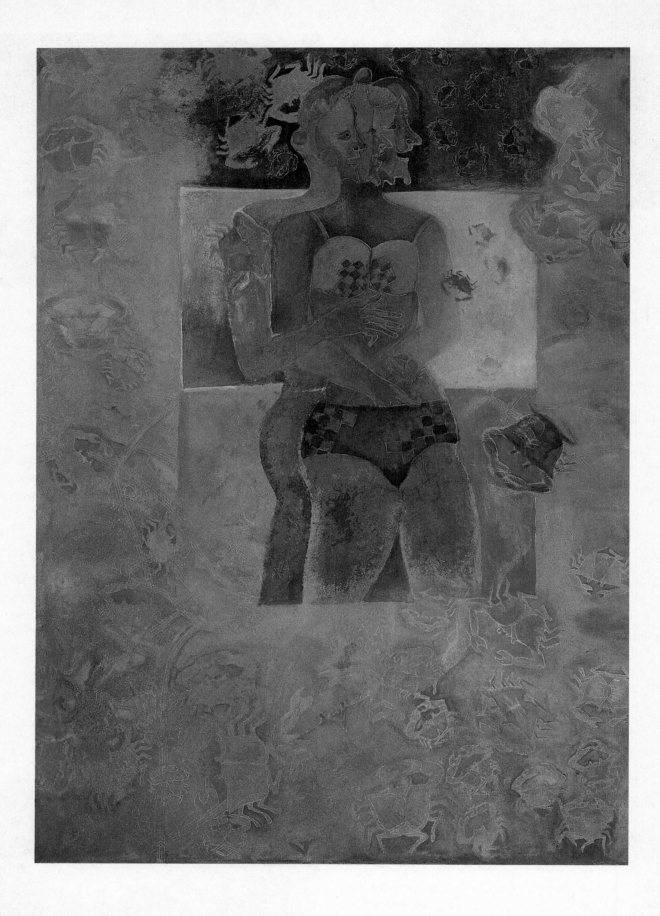

Francisco Toledo *Rua Nisado / A la orilla del mar /At the seashore* 1974, oil on canvas, 200 x 140cm. Private collection, courtesy Interart S. A. de C. V.

Rua Nisado is filled by a field of restless crabs surrounding the couple, the texture at once sandy and aquatic, conveying a swampy milieu. The Zapotec title translates to Spanish – 'A la orilla del mar', the poetic thought of the lips of land meeting the sea extends to the hands exploring the body; many of Toledo's terrifically evocative works play with lust and other appetites. Toledo is known for his attachment to the Isthmus of Tehuantepec and the valley of Oaxaca. His strong material sense and knowledge of traditional architectural forms is as apparent in the transformation of historic buildings in the region as it is his insistence that their ambience and contents should benefit local people. The best known project is the open-door library at the Institute of Graphic Arts and one of the newest the garden of native plants outside the cinema at El Pochote. The Prince Claus Foundation recently awarded Toledo one of their city prizes, naming him 'an urban hero'.

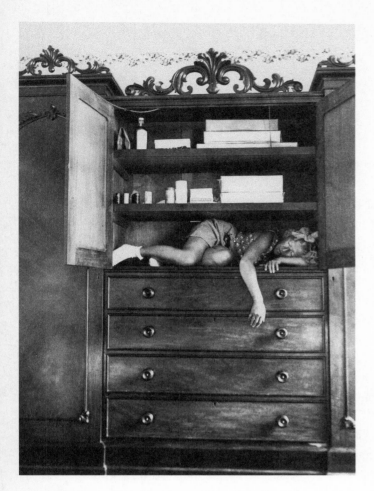

Claude Cahun *Self-Portrait*, 1932, gelatine silver print, 11 x 9 cm.
Jersey Heritage Trust

One of more than 100 works brought together for *Inside the Visible: an invisible traverse of 20th century art. In, of and from the feminine*, curated by Catherine de Zegher. The show grew out of 12 process-based exhibitions organised by de Zegher at the Béguinage of Kortrijk (a medieval convent in Flanders) for the Kanaal Art Foundation. It was elaborated and organised further with the Institute of Contemporary Art Boston and shown in slightly altered form at the Whitechapel in 1996. Three historical periods articulated the work of over 30 women artists: the 1930s–40s, 1960s–70s and the 1990s, cutting through racial, class, ethnic, sexual and regional modalities of identity to retheorize the feminine and the role of women in 20th century art.

In her essay on Cahun in the exhibition catalogue (a 500-page publication that covers the themes and artists in some considerable depth), Laurie J. Monohan defines Cahun's practice as disruptive of both gendered identity and the notion of any fixed identity at all. '…indeed, her identity became so uncertain that for a time it was unclear whether she was male or female', and so disquieting that she is reputed to have driven André Breton away from his favourite café by force of her presence alone. Cahun contributed to numerous publications, including *Mercure de France*, *Disque Vert* and *L'Amitié*, and wrote a number of political essays. A lesbian and a Jew, she was sentenced to death by the Nazis then spared at the end of the war. She died in 1954.

The other artists in the exhibition were Louise Bourgeois, Emily Carr, Thesesa Hak Kung Cha, Lygia Clark, Hanne Darboven, Lili Dujourie, Ellen Gallagher, Gego, Mona Hatoum, Nathalie Hervieux, Eva Hesse, Susan Hiller, Hanna Höch, Ann Veronica Janssens, Katarzyna Kobro, Yayoi Kusama, Bracha Licthenbert Ettinger, Anna Maria Maiolino, Agnes Martin, Ana Mendieta, Avis Newman, Carlo Rama, Martha Rosler, Charlotte Salomon, Mira Schendel, Lynn Silverman, Nancy Spero, Jana Sterbak, Sophie Taeuber-Arp, Nadine Tassel, Ana Torfs, Joëlle Tuerlinckx, Cecilia Vicuña, Maria Helena Vieira da Silva, Carrie Mae Weems and Francesca Woodman.

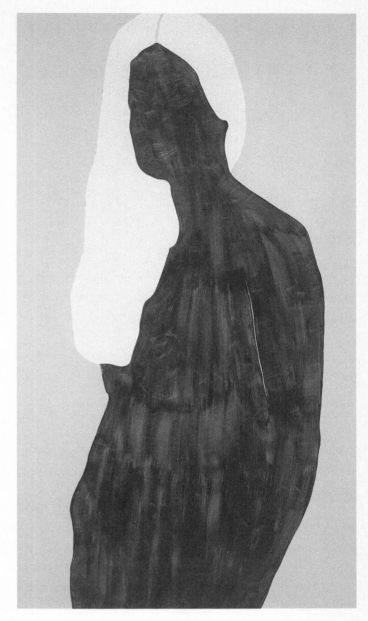

Gary Hume *Purple Pauline*, 1997, gloss paint on aluminium panel, 208.5 x 117 cm. Private collection, London

In 1999 Gary Hume represented Britain at the *Venice Biennale* with a selection of work from 1995 onwards. For his Whitechapel exhibition, programmed by Judith Nesbit, seven *Large Angel Heads* were brought directly from his Hoxton studio. Hume memorably provided 1,000 hand-drawn plane tree leaves for sale at a reduced and affordable price; half of the proceeds went to support the show.

The lower gallery was converted into a place of worship with the *Large Angel Heads* flanking one alter piece called *Yellow Angels*. The sources of this work are the concrete angels suspended from the ceiling in Oscar Niemeyer's cathedral in Brasília and the *Large Angel Heads* are massive enlargements of details in this painting.

The remaining selection included his *Water Paintings* and a combination of 'flora, fauna and portraiture', mainly in his trademark gloss paint on aluminium panels, with the Upper Gallery divided up by several paintings suspended back-to-back from the ceiling.

The portraits of favoured models like Mari and Pauline recur in Hume's works, their outlines traced from photographs onto acetate and projected onto the aluminium support, in a variety of poses and colours. In *Purple Pauline*, Hume appears to deviate from his usual smooth surfaces and experiments with a *trompe-l'oeil* device in imitation of expressionist brushstrokes.

CONVERSATIONS WITH FAMOUS ARTISTS I HAVE KNOWN
(but who don't necessarily know me)

What is a life?

Stop asking me that.

Why do you write?

I write to hold life in a trap of words hang on my baby girl is balancing a cupboard on her little finger hmmmmmkisshmmm are you alright darling what were you saying?

You are a mother and you have lost introspection and you have lost your freedom but I have lost something too.

What have you lost?

I have fought to be free but I am so free I have no ties to the world, except my art. I have lost commitment, love, children, ties, ties to the world.

Really? But you are special. You've got special energy. Artists have special energy. You send messages into the world. You make worlds. Your art is a magnet. It pulls like minded people towards you. It pulls strangers towards you. Your art makes you shine in the dark. You insist that what you think and how you think and what you feel and how you look at things and why you look at things and what makes you laugh and what makes you nervous is important. And it is important. You are important because you are skilled and brave and you find form and you are lucky because you do what you're best at.

You do what you're best at too.

What am I best at?

Life.

Oh no. Really? Aren't I best at writing?

Yeah. But you're better at life.

I think I'm going to kill myself.

Go on then.

Alright I will.

Tell me what a life is first.

Writing smoking sun children love work sea – and a nice blue lilo.

Okay. So tell me what you think about on your lilo.

I think about why I've got so fat. My lilo keeps sinking. There is so much of me to tan. I'm a porker on a plastic airbed. A writer without bones is like a hysteric without a spa town or Austria without a fascist I'm thinking about Oskar Kokoschka who once drew the nervous system outside the body I'm thinking I must make sure my body returns to me. Must get back stamina and hunger. I have no hunger. You make art because you're empty. People don't make art because they're full.

But I make art and I'm still empty. So I make some more. And I'm still empty. I feel disappointed. Sometimes I feel bitter.

Listen, don't make an appointment with bitterness. No you don't want to turn up on time for that appointment. No No No No No No No. Think of the rrrrroar you sometimes feel in you heart at art. The sad stroppy radiance of those who do what they do, beautifully. Like me.

You don't have a sad stroppy radiance.

Oh.

You're just sad.

What happened to my radiance?

Life probably. Heh heh heh. I'll hold your baby for you if you like.

Thanks. Will you be her godmother?

She's already got four godmothers.

I know. Plenty of baby sitters. Heh heh heh. Where were we? Art is being in and out of life at the same time. Isn't it? Hello? Are you still there? Whooo hooo! Hullo? Bring my baby back. Okay don't. I'll write about one hundred years of art at the Whitechapel instead.

Deborah Levy is a writer. Her novels include BEAUTIFUL MUTANTS, SWALLOWING GEOGRAPHY, THE UNLOVED, (Vintage) BILLY AND GIRL (Bloomsbury). Deborah is writing The Joseph Beuys Lectures for Ruskin College, Oxford.

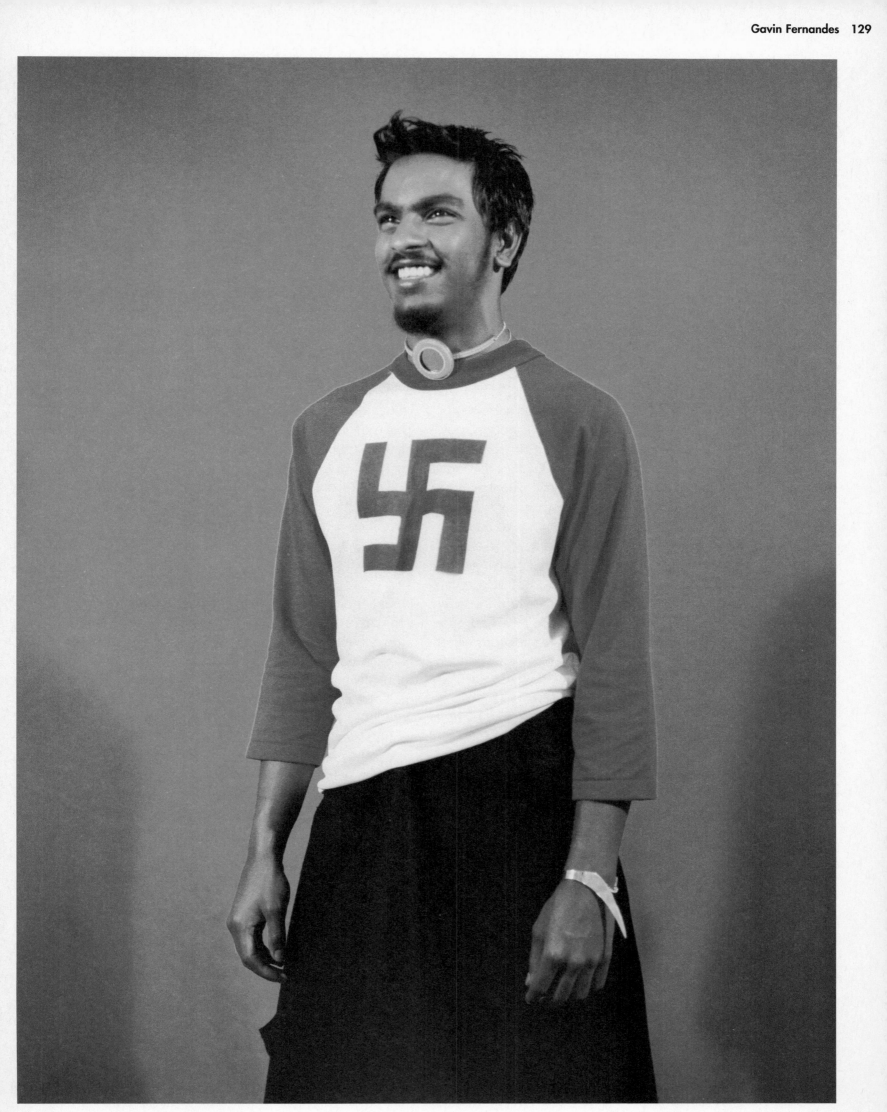

21st Century Swastika, 1999, photograph, 180 x 150 cms

Without

22 September 1977. I was in the Whitechapel Gallery doing a soundcheck for the reading from my *Diary* which was to be recorded by Audio Arts that evening. A local family: mum, dad and two kids, came into the gallery laden with supermarket shopping. They put the bags down, gazed around them, then mum said to dad, "We must have got the dates wrong Steven, the exhibition's not on yet, they've only just got the display panels up. We'll come back next week when it's ready." Then they picked up their shopping bags and left.

But the exhibition was on, it had opened the day before. The 'display panels' were Robert Ryman's white on white paintings. And as the disappointed family trudged out, I thought how sad it was that this ordinary, likeable East End foursome, unselfconsciously at ease in what was obviously their local public gallery, had not seen the exhibition. I guessed that they visited the gallery regularly, so they would have seen a wide variety of modern art made by artists who would never compromise their work to court popular approval. Some of which work that family would, no doubt, have disliked, or been surprised, shocked or even baffled by, but also much they must have enjoyed enough to pay repeated visits. I wonder whether Ryman, an artist of undeniable integrity, had ever considered a public perception that, quite apart from either liking or disliking, his resolutely material work was not even there?

If the unawareness of presence succinctly expressed by that family was one benchmark of public perception, then the difficulties of the concurrent BBC TV arts programme's attempt to make visually interesting television out of Ryman's hard won, but essentially plain white, artworks was unintentionally comical. Having made television programmes which featured my own artworks, I knew some of the televisual difficulties involved, and I chuckled sympathetically as the camera operator strove to interpose the self-effacing Ryman between the camera and his paintings, so that at least a shadow might fall on the blank white surfaces, before, clutching at straws, being reduced to lingering camera pans up and down the staples on the edges of the canvases. Anything to avoid the ultimate goggle-box taboo: the blank white screen.

There is no theoretical subtext to Ryman's paintings, no illusions or allusions outside the pigment, usually white, which is applied in varying densities on canvases or wooden panels which display paint that speaks for itself alone. And certainly, for Ryman is an intensely serious artist, there is no provocative nor mocking intent such as that in the three exhibits, arguably the first abstract paintings, which the French cabaret satirist and humorous writer, Alphonse Allais, showed in the Salon des Incoherents exhibitions in Paris in the 1890s. The first of the trio, from that bygone age of political incorrectness, was an absolutely black canvas entitled *Negroes Fighting In A Cave At Night*; the second a completely red canvas called *Apoplectic Cardinals Harvesting Tomatoes By The Red Sea*; and the third a totally white rectangle entitled *Anaemic Young Girls Going To Their First Communion In A Blizzard* (which is reproduced on the opposite page).

These musings on whiteness, blankness and lack of tangible presence, came back to me when I saw again, after many years, the visual typewriter poems by the late dom sylvester houédard in the Whitechapel's *Live In Your Head* exhibition in February 2000. I remembered when I was living in Bristol in 1967 and working in a theatre. In the daytime I helped with Front of House odd jobs and in the evening I served behind the bar. This meant that I didn't get to see the plays, though I wasn't missing much, just the same old English theatre of words, stick-on side whiskers and papier maché thighboots. However, I did enjoy sitting in the empty auditorium during my lunch break, looking at the unpopulated stage sets and imagining what might occur. The dullest domestic sitcom interior, with backlit French windows, could become the setting for surreal scenarios in my imagination.

I mentioned this pastime to an intriguing man who came into the bar one night in dark glasses beneath a shaven head, atop a black, floor-length cloak fastened with a tasselled rope. He introduced himself as dom sylvester houédard, a Benedictine monk from nearby Prinknash Abbey, and enquired what might be onstage at the moment. I said I didn't know, possibly very little, unlocked the theatre, switched on the lights and wound back the curtain to reveal the proscenium stage completely empty except for a large stepladder, the shadow of which was cast onto the white backdrop. houédard sat in the front row and talked uninterruptedly for the next twenty minutes about the references to perception, whiteness and the void. Fascinated though I had been by uninhabited stage tableaux, I was nevertheless deeply impressed by his erudition and said so. "Yes, yes" he replied. "But think how much more interesting it would be without that set of steps."

Ian Breakwell has exhibited at the Whitechapel in *Art For Society* 1978, *Live In Your Head* 2000, and his *Continuous Diary* was recorded live in the gallery by Audio Arts in 1977.

Opposite: *Anaemic Young Girls Going To Their First Communion In A Blizzard*, Alphonse Allais *c*.1890.

© Ian Breakwell 2000

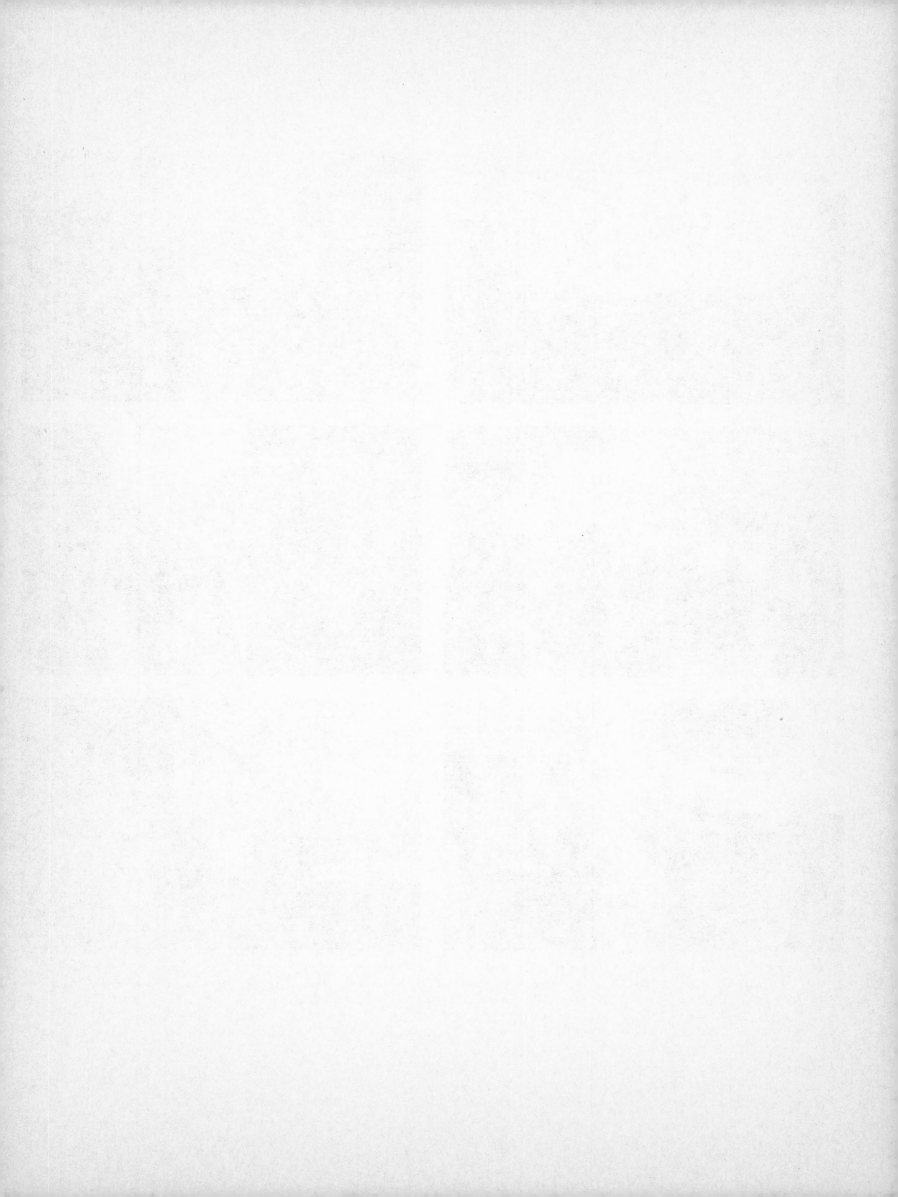

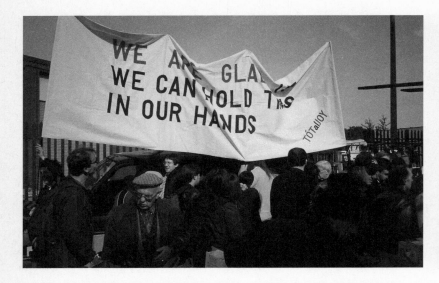 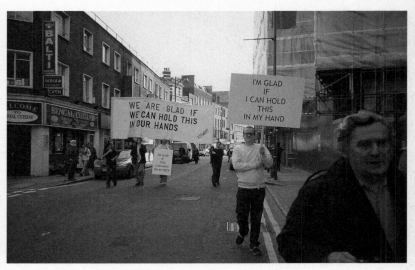

 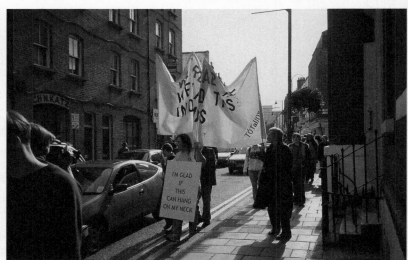

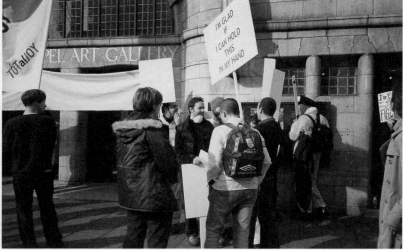 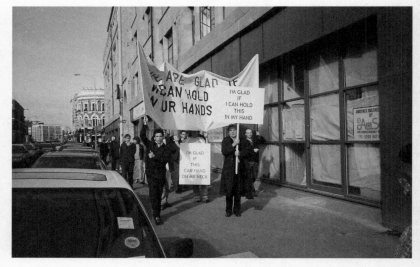

Demonstration demonstration. A re-enactment of Endre Tót's street actions, originally conceived under a dictatorial regime in Hungary in the early seventies and fulfilled a few years later. A march was led by Endre Tót from the Whitechapel Art Gallery, up Brick Lane, down Sclater Street, underneath the arches of Wheeler Street, south down Commercial St as far as Fashion St, back on to Brick Lane and then home to the gallery. This took place on a busy market day Sunday. Placard holders were asked to participate. Come the day, participants were outnumbered by a disgruntled public who gathered outside the gallery to demonstrate against the *demonstration*. Many consid-

ered Tót's pronouncements like 'I am glad if I can hold this in my hand', too simple and directionless. This more likely represented a subconscious acknowledgement of how little public space there is to make 'protest' statements, and therefore leads to a puritanical, 'no messin' around with the agit-prop' attitude, a kind of hierarchical censorship. *Demonstration demonstration* took place as part of *Protest & Survive*, curated by Paul Noble and Matthew Higgs in 2000.

Photographs by Clive Phillpot

206 Henry Wood
 Office Thief
 Age 15
 5 ft 2 in high
 Hair Brown
 Eyes Grey
 Complexion Pale

 4 Months M. H. June 1873

Rev. Cannon Barnett
Founder

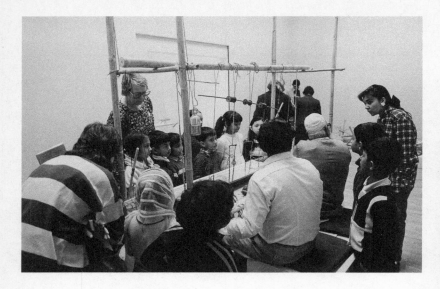

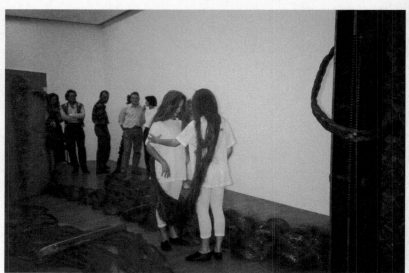

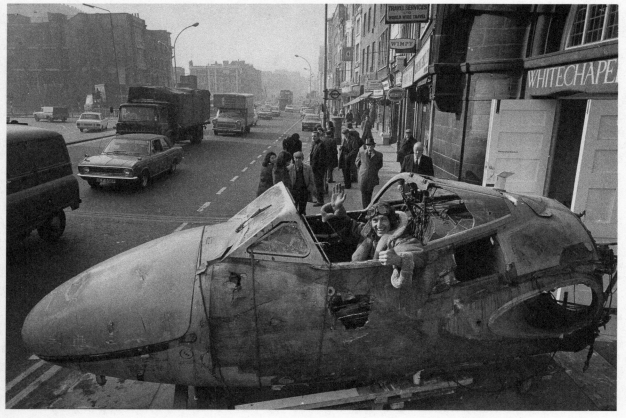

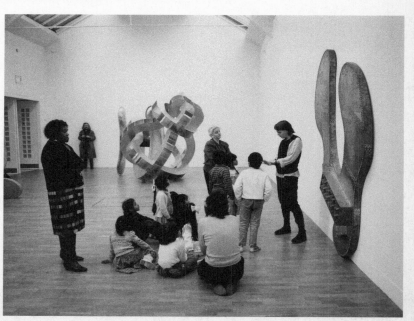

Clockwise:
Weaving workshop during *Woven Air*, 1988 (photo: Sarah Ainslie);
Performance in *Tunga* show, 1989; Jo Stockham leading *Deacon*
workshop, 1988; Bruce Lacey, 1975 (photo: Alisdair MacDonald)

Clockwise:
Sean Scully, 1989; Silvia Ziranek
leading performance walk during
Live in Your Head, 2000; Kathy
McCarthy and students at St. John
the Baptist Primary School with
the new gate-sculpture; Catherine
Lampert, Susana and Clémentine
Deliss planning *Seven Stories about
Modern Art in Africa*, 1995; Visitors
to *This is Whitechapel* 1972
(photo Ron McCormick)

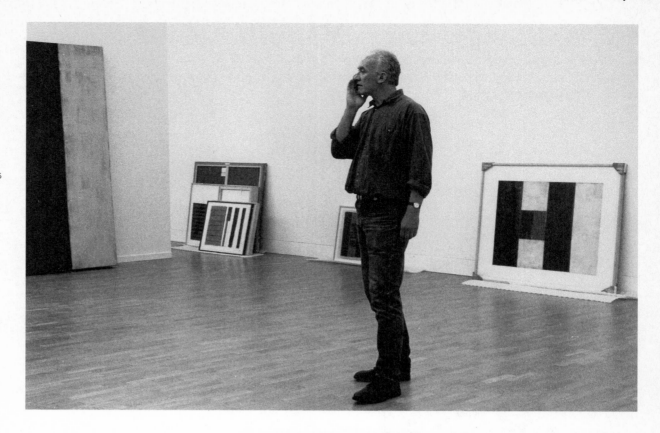

Clockwise:
Pat Kiely, Nick Chapman, Denny Long, Richard Long, 1969;
Talvin Singh at *Grosse Geister* party during *Thomas Schütte*, 1998;
Music performance and Ansuman Biswas sculpture, *000zerozerozero*, 1999.
School workshop during *Eva Hesse*, 1979;

Clockwise:
Dance from sculpture, Lisa Gregory in *David Smith*, 1986;
Whitechapel staff February 2001 (photo: Richard Okon);
Jefford Horigan and Simon Granger leading workshop for the
visually impaired in *From Two Worlds*, 1986;
Between sets of *000zerozerozero*, 1999.

Works in the Exhibition

Unknown
Buddhist Lion, Tang Dynasty
Stone
Height: 34 cm
Private collection, London

Unknown
A Lokapala or Guardian King, Tang
Dynasty, 618-907
Marble Sculpture
122 x 53 x 41 cm
Eskenazi Ltd, London

Unknown
Guanyin Seated on a Rock, Song
Dynasty, 12th Century
Wood
Height: 58.5 cm
Eskenazi Ltd, London

Unknown
Archaic Food Vessel, Gui, Late Shang-
Early Western Zhou, c.11th Century BC
Bronze
18.5 x 38.5 x 27 cm
Eskenazi Ltd

Unknown
Standing Ganesh, Chola Period, Late
11th/early 12th Century
Southern India, Tamil Nadu
Bronze
Height: 57 cm
Private collection

Unknown
The Female Deity Salabhanjika,
Mid-10th Century
India, Rajastan
Polished white marble
Height: 98 cm
Private collection

Francis Alÿs
Le temps du sommeil, 1995 – ongoing
Oil on wood
50 paintings, each 11.5 x 15.5 x 1.5 cm
Collection the artist

Michael Andrews
The Cave 'Laughter', 1983
Watercolour and sand from Ayers Rock
20 x 28 cm
Jacqueline and Marc Leland

David Bomberg
Vision of Ezekiel, 1912
Oil on canvas
114.3 x 137.2 cm
Tate. Purchased with assistance from
the Morton Bequest through the
Contemporary Art Society 1970

Sonia Boyce
*She Ain't Holding Them Up, She's
Holding On (Some English Rose)*, 1986
Oil and pastel
218 x 99 cm
Middlesbrough Museums and Galleries

Arthur Boyd
Red Dog, Black Pond and Nude, 1961
Oil and tempera on board
124 x 131 cm
Private collection

Edward Burne-Jones
Perseus Series: *Death of Medusa II*,
1890s
Body colour on paper
152.5 x 136.5 cm
Southampton City Art Gallery

Claude Cahun
Self-Portrait, 1932
Gelatine silver print
11 x 9 cm
Jersey Heritage Trust

Anthony Caro
Lock, 1962
Blue painted steel
88 x 536 x 305 cm
Private Collection, London

Patrick Caulfield
Portrait of Juan Gris, 1963
Oil on board
122 x 122 cm
St. John Wilson Trust

Vija Celmins
Untitled (Large Desert), 1974
Graphite on acrylic ground on paper
48.3 x 36.2 cm
Collection of the Chase Manhattan Bank

Lygia Clark
Animal 1, 1969
7 hinged aluminium sheets
Hypotenuse of each sheet: 15 cm
Unlimited edition
Arts Council Collection, Hayward
Gallery, London

Animal 2, 1969
8 hinged aluminium sheets
25 x 25 cm
Unlimited edition
Arts Council Collection, Hayward
Gallery, London

Animal 3, 1969
16 hinged aluminium sheets
25 x 25 cm
Unlimited edition
Arts Council Collection, Hayward
Gallery, London

Joseph Cornell
Untitled (Compartmented Box), c. 1958
Box construction
43 x 26 x 6 cm
The Joseph and Robert Cornell Memorial
Foundation, courtesy C&M Arts, New York

Tony Cragg
Angels and other Antibodies, 1992
Wood
240 x 245 cm
Private collection

Richard Deacon
There and Here, Here and There, 1987
Laminated wood and wax with screws
202 x 161 x 122 cm
Kunstmuseum Luzern, Switzerland

Peter Doig
Young Bean Farmer, 1991
Oil on canvas
186 x 199 cm
Collection Warren and Victoria Miro

Barry Flanagan
Lack of Civility, 1982
Bronze, cast 5 from an edition of 7
66.6 x 80 x 30.5 cm
Collection Waddington Galleries

Lucio Fontana
Concetto spaziale 'Attese', 1959
Painting on canvas
91 x 121 cm
Thinned ink on canvas, nine times incised
Stedelijk Museum, Amsterdam. A gift
from the artist's wife, Mrs T. Fontana

Lucian Freud
Parts of Leigh Bowery, 1992
Oil on canvas
50 x 104 cm
Mr and Mrs Kennaway

Antony Gormley
Exercise Between Blood and Earth,
1979-81
Chalk on wall
Diameter: 184 cm
Courtesy the artist and
Jay Jopling/White Cube

Juan Gris
Still Life with Playing Cards and Siphon,
1916
Triplex wood with oak upper layer
73 x 117 cm
Kröller-Müller Museum, Otterlo, The
Netherlands

Philip Guston
Painting, Smoking, Eating, 1973
Oil on canvas
197 x 263 cm
Stedelijk Museum Amsterdam, acquired
with support of the Vereniging
Rembrandt and Mrs Musa Guston

Richard Hamilton
*Just what is it that makes today's homes
so different, so appealing*, 1956
Black and white poster
76.4 x 51.9 cm
Whitechapel Archive

Nick Hedges
Unemployed Sisters, 1970
Black and white photograph
25 x 38 cm
Courtesy the artist

Barbara Hepworth
Talisman II, 1960
White marble
76 x 53 x 43 cm including base
The Trustees of the Estate of Barbara
Hepworth

Eva Hesse
Tomorrow's Apples (5 in white), 1965
Painted concretion, enamel, gouache,
varnish, cord on wire and papier-mâché
on hard board
65.4 x 55.6 x 15.9 cm
Tate. Purchased 1979

David Hockney
The Hypnotist, 1963
Oil on canvas
214 x 214 cm
Private collection

William Hogarth
The Happy Marriage, c.1745
Oil on canvas
69 x 89 cm
Royal Cornwall Museum, Truro

Gary Hume
Purple Pauline, 1997
Gloss paint on aluminium panel
208.5 x 117 cm
Private collection, London

Runa Islam
Turn (Gaze of Orpheus), 1998
Video Projection (DVD)
Dimensions variable
Courtesy of the artist and Jay Jopling /
White Cube, London

Ishikawa Jozan
Letter to Hayashi Razan, early 1640s
Japanese yokomono hanging scroll
31.5 x 86.5 cm
Sydney L. Moss Ltd

Chen Juzhong
Falconer and Horse, 13th Century
Ink and colour on silk, mounted on board
25 x 26.5 cm
Private collection, London

Frida Kahlo
Self-portrait, 1940
Oil on masonite
59.7 x 40 cm
Private collection, courtesy of Mary-Anne
Martin/Fine Art, New York

Basket of Flowers, 1941
Oil on metal
Diameter 64.5 cm
Private collection, courtesy of Mary-Anne
Martin/Fine Art, New York

Willem de Kooning
Trembling Woman, 1963–4
Charcoal on paper
60.6 x 45.4 cm
Private collection, courtesy Matthew
Marks Gallery, New York

Guillermo Kuitca
The Tablada Suite V, 1992
Graphite and acrylic on canvas
181 x 126 cm
Brondesbury Holdings Ltd – Private
collection

Bob Law
No. 62 (Black/Blue/Violet/Blue), 1967
Acrylic on canvas
167.6 x 175.3cm
Tate. Purchased 1976

Markéta Luskačová
Children in Battered Women House,
1977
Band white photograph
50 x 60cm
© Markéta Luskačová

Children Playing on Blenheim Crescent,
1984
Black and white photograph
50 x 60cm
© Markéta Luskačová

Agnes Martin
Untitled No 10, 1990
Ink on paper
22.8 X 22.8 cm
Courtesy John Berggruen Gallery,
San Francisco

Kenneth Martin
Chance and Order (Green), 1970
Oil on canvas
122 x 122 cm
Private collection

Mario Merz
Che fare [What to do], 1968
Wax and neon tube in metal tub
14.4 x 45 x 17.8 cm
Galleria Civica d'Arte Moderna e
Contemporanea, Torino – Fondazione
Guido Ed Ettore de Fornaris

Henri Michaux
First Mescaline Painting, c.1954
Oil on wood
17.7 x 13.5 cm
Private collection

Piet Mondrian
The Red Tree, 1908
Oil on canvas
70 x 99 cm
Lent by The Gemeentemuseum Den
Haag, The Hague, The Netherlands

Composition with Colour Planes Nr.3,
1917
Oil on canvas
48 x 61 cm
Lent by The Gemeentemuseum Den
Haag, The Hague, The Netherlands

Henry Moore
Goats Head, 1952
Bronze
20.8 x 9 x 14 cm, on a wooden base
2.3 x 10 x 19 cm
The Henry Moore Foundation: Gift of
Irina Moore, 1977

John Hamilton Mortimer
*The Rev Charles Everard Booth, DD
and Capt. Griffith Booth, RN playing
billiards*, c.1770
Oil on canvas on wooden frame
99.7 x 122 cm
Upton House, The Bearsted Collection
(The National Trust)

Bruce Nauman
Untitled, 1965
Fibreglass, polyester resin
61 x 335 x 12.7 cm
Collezione Prada

Ben Nicholson
June 1937, 1937
Oil on canvas
159.4 x 201.3 cm
Tate. Purchased 1955

Emil Nolde
Paradise Lost, 1921
Oil on rough canvas (sackcloth)
106.5 x 157 cm
Nolde-Stiftung Seebüll

Robert Rauschenberg
Aen floga, 1961
Combine painting
152.5 x 107 cm
Collection the artist

Rembrandt van Rijn
*The Angel appearing to Joseph in
a Dream*, c.1652
Reed-pen and bistre
17.9 x 18.1cm
Rijksmuseum, Amsterdam

Bridget Riley
Shuttle 1, 1964
Emulsion on board
112.5 x 112.5 cm
Fundação Calouste Gulbenkian/
CAMJAP, Lisboa

Mark Rothko
No.11/No. 20 (Untitled), 1949
Oil on canvas
238 x 134.6 cm
Collection of Christopher Rothko

Robert Ryman
Untitled, 1969
30.5 x 30.5 cm
Taped drawing
Courtesy Konrad Fischer Galerie,
Düsseldorf

Blue Line Drawing, 1969
Taped drawing
30.5 x 30.5 cm
Courtesy Konrad Fischer Galerie,
Düsseldorf

Cindy Sherman
Untitled #229, 1987–90
Colour photograph
121 x 187 cm
Collection Pierluigi and Natalina Remotti

George Stubbs
Lady Reading in a Park, c.1768–70
Oil on canvas
62.2 x 76.2 cm
Private collection

Mares and Foals Under an Oak Tree,
1773
Oil on panel
78.7 x 99 cm
Her Grace Anne, Duchess of Westminster
and the Trustees of the Grosvenor Estate

JMW Turner
Death on a Pale Horse, c.1825–30
Oil on canvas
59.7 X 75.6 cm
Tate. Bequeathed by the artist 1856

Reclining Venus, 1828
Oil on canvas
175.3 x 248.9 cm
Tate. Bequeathed by the artist 1856

Cy Twombly
Untitled, 1983
Painted bronze
142 x 23 x 41 cm
Private collection, Rome

Untitled, 1984
Painted bronze and wood
121 x 36 x 56.6 cm
Private collection, Rome

Euan Uglow
Pepe's Painting, 1984–85
Oil on canvas
45 x 90 cm
Jose Sebastian

Bill Viola
Heaven and Earth, 1992
Two-channel video installation,
edition 1 of 2
56 x 26 x 33: 20 x 88 x 30 cm;
Space between monitors fixed at 7 cm
Collection Museum of Contemporary
Art, San Diego; Museum Purchase,
Contemporary Collectors Fund

Jeff Wall
Diagonal Composition, 1993
Transparency in lightbox
40 x 46 cm
edition of 10
Collection of the artist

Andy Warhol
Jacqueline Kennedy no. 2, 1965
Silkscreen on paper
68 x 82 cm
Rosemarie Trockel

Jean-Antoine Watteau, 1684-1721
*Woman in a Striped Dress, Seen from
Behind, Reclining on the Ground*
Red and black chalk and graphite
14.6 x 18.1 cm
The British Museum, London

Seated Woman in Long Dress
Red chalk and graphite
15.5 x 9.4 cm
The British Museum, London

Jack B Yeats
Roundstone Quay, 1911
Oil on canvas
23 x 36 cm
Pyms Gallery, London

Death for Only One, 1937
Oil on canvas
61 x 91.5 cm
Private collection, New York

Wang Zhenpeng
The Palace of Prince Teng, 1312
Ink on silk
36 x 71.5 cm
Private collection, London

List of Lenders

Arts Council Collection, Hayward Gallery, London
John Berggruen Gallery, San Francisco
The British Museum, London
Brondesbury Holdings Ltd
Chase Manhattan Bank
The Joseph and Robert Cornell Memorial Foundation
John Eskenazi Ltd
Konrad Fischer Galerie, Düsseldorf
Galleria Civica d'Arte Moderna e Contemporanea, Torino
Haags Gemeentemusem
Fundação Calouste Gulbenkian
The Barbara Hepworth Estate
Jersey Heritage Trust
Mr and Mrs Kennaway
Kröller-Müller Museum, Otterlo
Jacqueline and Marc Leland
Kunstmuseum Luzern
Middlesbrough Museums and Galleries
Warren and Victoria Miro
The Henry Moore Foundation

Sydney L. Moss Ltd
Nolde-Stiftung Seebüll
Pyms Gallery, London
Collezione Prada
Pierluigi and Natalina Remotti
Rijksmuseum, Amsterdam
Christopher Rothko
Museum of Contemporary Art, San Diego
José Sebastian
Southampton City Art Gallery
Stedelijk Museum, Amsterdam
Royal Cornwall Museum, Truro
Tate
Upton House, The Bearsted Collection (The National Trust)
St. John Wilson Trust
Waddington Galleries
Her Grace Anne, Duchess of Westminster and
the Trustees of the Grosvenor Estate
Artists and estates
and those who wish to remain anonymous

Acknowledgements

We would like to express our heartfelt thanks to the many who have made this ambitious project possible, in all its different expressions. The artists foremost, for once again responding with generosity and enthusiasm to our requests, and the lenders and contributors to the review. Our sincere thanks also go to Susie Allen, Curtis Anderson, Francis Atterbury, Stefania Bonelli, Ivor Braka, Dorothée Brill, Andrew Dempsey, Nick Digance, Gregory Eades, Mark Glatman, Nicholas Grindley, Janeen Haythornthwaite, Stephen Hill, Robert Hiscox, Anish Kapoor, Herman Lelie, Robert Littman,
Mary-Anne Martin, Jon Newman, Lorcan O'Neill, Monica Portillo, Bryan Robertson, Laurence Sillars, Sir Nicholas Serota, James Slaughter and Rosemarie Trockel.

Many more have, in different ways, lent time, advice or help to the celebrations. Among them are: Robin Airey, Dr Mario Andreas Luttichau, David Anfam, Caroline Archer, Michelle Archer, Dore Ashton, Julia Barker, Peter Bass, R. Anning Bell, Gianfranco Benedetti, Anita Feldman Bennet, John Berggruen, Jennifer Berry, Anne Berthoud, Peter Berwick, Laura Bloom, Bloomsbury Publishing, Scot Blyth, Victoria Bolton, Sir Alan Bowness, Christine Brachot, Irene Bradbury, Richard Calvocaressi, Pier Giovanni Castagnoli, Rosita Chalem, Catherine Clement, Teresa del Conde, Daniel Congdon, Philip Constantinidi, Tim Craven, Patrick Cunningham, Andrew Dalton, Martine d'Anglejan Chatillon, Tamsin Daniel, Hugh Davies, Molly Dent Brockelhurst, Cornelia Dietschi, Louise Downie, Joanna Drew,

Susan Dunne, Bill Feaver, Dorothea Fischer, Siri Fischer Hansen, Helen Heyward, Andreas Fluck, Richard Francis, Larry Gagosian, Kate Gantz, Mark Glazebrook, Manuel Gonzalez, Marian Goodman, Clare Grafik, Robert Graham, Antony Griffiths, Claudio Guenzani, John O'Hallaran, W.S van Heusden, Sarah Hickey, Alan Hobart, Antonio Homem, Beatrice Hosegood, Carol Hubbard, David Hudd, Barry Jackson, Jay Jopling/White Cube, London, John Johnston, Mary Johnson, Isobel Johnstone, Marion Kahan, Anna King, Kris Krokosz, Wim van Krempan, Sofia Lacayo, Oliver Lane, Victoria Lane, R. de Leeuw, Tracey Lew, Jeremy Lewison, Robert Littman, Dr J.L Locher, Ulrich Loock, Peter Loorij, Catherine McFarlane, Matthew Marks, Jason McCoy, O Mensink, Maria Beatrice Merz, Alison Miles, Jorge Molder, David Mooregwyn, Margaret Nab, Sandy Nairne, Val Nelson, Vivian Oyarbide, Jenny Page, Ame Parsley, Dr Micheline Phankim, Penguin Books, Yuki Puar, Stefan van Raay, Janice Reading, Manfred Reuther, Phil Rogers, Nicola del Roscio, Giulio San Giuliano, Peter Schatborn, Karsten Schubert, Stephen Snoddy, Antonella Soldaini, Vic Sowerby, Hazel Standen, Sarah Staniforth, Camilla Stephens, E.J van Straaten, Timothy Taylor, Tracey Taylor, Asmund Thorkildsen, Danielle Thornton, Antonio Tommasini, Ana Vasconcelos, Jennifer Vorbach, Robin Vousden, Leslie Waddington, Cindy van Weele, Angela Westwater, Sir Christopher White, David White, Dave Williams, Paul Williams, Colin St John Wilson, Natica Wilson, Godfrey Worsdale and Karen Wright.

Sponsors & Donors

The Whitechapel Art Gallery has survived and thrived through the commitment and generosity of many individuals and organisations. The essay 'Rollercoasters and Helter Skelters …' gives a brief history of patronage and funding. The Whitechapel wishes to thank all of our past supporters, named in earlier print and especially those supporting us in our Centenary year.

Principal Centenary sponsors & donors

Herbert Smith
Hiscox
Sunday Telegraph

With additional support from:

Horace W. Goldsmith Foundation
Financial Times

Centenary Patrons

Ivor Braka
Anthony d'Offay
Robert & Susan Summer

Marlborough Fine Art (London) Ltd

6 Albemarle Street, London W1S 4BY
Tel: +44 (0)20 7629 5161
Fax: +44 (0)20 7629 6338
E-mail: mfa@marlboroughfineart.com
www.marlboroughfineart.com

Founded in 1946, Marlborough Fine Art is one of the world's leading contemporary galleries featuring the best in modern art in London.

Matthew Marks Gallery

523 West 24th Street
New York, NY10011
Tel: +1 212 243 0200
Fax: +1 212 243 0200
E-mail: gallery@mmarks.com

Phaidon Press Limited

Regent's Wharf
All Saints Street
London N1 9PA
Tel: +44 (0)20 7843 1000
Fax: +44 (0)20 7843 1010
www.phaidon.com

Phaidon's acclaimed Contemporary Artists series continues this Spring with three new titles: Dan Graham, key figure of the Minimal/Conceptual generation, is influential worldwide; internationally admired young artist from the US Tom Friedman sculpts exquisite forms from everyday detritus; and cult Californian graphic artist Raymond Pettibon's long awaited retrospective is at Whitechapel Art Gallery this summer.

UK Public funding

London Arts
Tower Hamlets
Arts Council of England
Arts & Business
Cityside Regeneration
English Heritage

Major support for Whitechapel Art Gallery refurbishment 1997–1998

Arts Council of England – National Lottery Grant
The Clore Foundation

Current & recent project sponsors & donors

Alimus
Britart.com
Bloomberg
Nancy Balfour Charitable Trust
The Baring Foundation
The Bawden Fund
The Big Issue
The Bridge House Estates Trust Fund
The Department for Education & Employment
E D & F Man Limited Charitable Trust
The Elephant Trust
Embassy of The Kingdom of The Netherlands
Fomento Cultural Banamex, A.C.
The Glass House Trust
The Golden Bottle Trust
Paul Hamlyn Foundation
Heritage Lottery Fund's Millennium Festival Fund
Michael Hue-Williams
Hunter Gather
Lloyds Community Programme
Lloyds TSB Foundation for England and Wales
The Paul Mellon Centre for Studies in British Art
Merchant Taylors' Company
The Mexican Embassy
Ministry for Foreign Affairs, Mexico
The Mondriaan Foundation
The Monument Trust
The Henry Moore Foundation
Morgan Stanley International Foundation
The Observer
Time Out
The Rayne Foundation
Sainsbury's
Sol Group
St Katherine & Shadwell Trust
The Stanley Picker Trust
UBS Warburg

Corporate Members

Abstract Select
Ambac Assurance UK
Beeley & Co
Bloomberg
Blue Circle Industries
Catlin
Christian Aid
Galatea – Contemporary Art Advisors
Great Eastern Hotel
McKinsey & Co
N. W. Rothschild & Sons
Herbert Smith
Richards Butler

Whitechapel Patrons

Heinz & Simone Ackermans
Tom Bendhem
Brian Boylan
Marlene Burston
David Cohen
Glen Davis
Noel & Geraldine Gottesman
Robert Graham
Donald B. Marron
Keir McGuinness
Dominic Palfreyman
William Palmer
Harry B. Pollak
Alan Safir
Peter & Flora Soros
Hugh & Catherine Stevenson
William de Quetteville
Cecilia Wong

Whitechapel Group Members

The Agency Contemporary Art Ltd
Art Space Gallery – Michael Richardson Contemporary Art
Doris Ammann
Richard Attenborough
James Bartos
Tony & Gisela Bloom
Benjamin Bonas
Dan Brooke
Evelyn Carpenter
Melanie Clore
Neville & Carole Conrad
Michael Craig-Martin
Lance Entwistle
Bryan Ferry
Winston & Jean Fletcher
Eric & Louise Franck
Nicholas Fraser
Edward Gardner
Lord & Lady Gavron
Laure Genillard
David Gill
Michael Godbee

Piers Gough
Judith & Richard Greer
Walter Griessman
Susan Harris
Ariane Hegewisch
Christoph Henckel
Houldsworth Fine Art
Kathleen Kapnick
Jeremy Levison
Ruth & Stuart Lipton
Barbara Lloyd
Richard MacCormac & Jocasta Innes
Joshua Mack
Matthew Marks
Penny Mason
James Mayor
Melvin & Elaine Merians
Victoria Miro
Frances Mossman
Mr & the Hon Mrs Guy Naggar
John Newbigin
Carlos & Vivien Oyarbide
Alice Rawsthorn
David Rhyder
Karel Röeu
Alex Sainsbury
Jonathon Shaw
Kaveh Sheibani
Dasha Shenkman
Monika Sprüth Galerie
Eddie & Euzi Tofpik
Christoph Trestler
Helen van der Meij
David Wilkinson
Brian Wolkind

We also receive help in kind from many sources – including artists, other art organisations, legal professionals, retailers and caterers. The realisation of the Centenary has benefited from those listed in the acknowledgements and Artwise, George Fame Business Design Group, Hulton Getty, Marks & Spencer, Kirin Beer, BDG McColls Fritz Hansen, Howe UK, Vitra, Knoll International, Hille (London), Charles Wells Ltd and Atrium

The Sunday Telegraph

is proud to be a sponsor of Whitechapel Art Gallery's Centenary Exhibition

Sundays to a T

Detail from *Blackfriars to Westminster* (oil on canvas) by Sharon Beavan (1990)

Congratulations to the Whitechapel Art Gallery for 100 years of innovation.

Herbert Smith is pleased to support the Centenary artists' commissions as part of our ongoing relationship with the Whitechapel.

HERBERT SMITH

www.herbertsmith.com

If your insurer thinks Klein blue is the colour of designer denim

you're with the wrong people.

Hiscox plc, Europe's leading specialist insurer, has over 60 years experience of insuring high net worth individuals and their valuable homes. The company also offers a wide range of other specialist insurance for high net worth customers including cover for fine art, thoroughbred bloodstock, classic cars, private aircraft and yachts.

Hiscox plc are the lead sponsors of The Whitechapel's Centenary exhibition.

One Hundred Years of the Whitechapel

1961
Contemporary Art Society
Pictures for Schools
Vanishing Stepney: Paintings by Rose Henriques
Edmond Kapp
Recent Australian Painting **R. Hughes, Underhill, Tucker**
Mark Rothko
Derek Hill

1962
East End Academy
Barbara Hepworth Sculpture 1952–1962
Pictures for Schools
Mark Tobey
Keith Vaughan
Arthur Boyd
Hallmark Collection **Clavé, Hartung, Wyeth, Greaves**
Thelma Hulbert

1963
Marzotto Prize
Philip Guston
Serge Poliakoff
British Painting in the Sixties
Anthony Caro
Robert Medley

1964
Young Commonwealth Artists
Robert Rauschenberg **The Dante Drawings and Paintings**
The New Generation 1964 **Boshier, Caulfield, Hoyland, Jones, Riley and others**
Franz Kline
Painting and Environment: Nigeria, Uganda
Mary Potter
Jasper Johns

1965
Marzotto Prize
The New Generation 1965 **Annesley, King, Piché, Scott, Tucker**
Harold Cohen
Morris Louis
Lee Krasner
Peter Stuyvesant Foundation: collection in the making

1966
Robert Motherwell
Bryan Kneale
Plastics: Exploration in Design
Richard Smith
The New Generation 1966 **Cina, Knowles, Lancaster, Newsome**
Women's International Art Club
Printmaking: Exeter College of Art

1967
East London Open
John Craxton
John Hoyland
Tim Scott
The Face of London
Gertrude Hermes
British Sculpture and Painting from the collection of Leicestershire Education Authority

1968
Contemporary Art Society: Recent Acquisitions
New British Painting and Sculpture Peter Stuyvesant Collection
The New Generation 1968: **Interim – Carter, Newsome, Jones**
Ghika
Phillip King
Betty Parsons

1969
Shalom of Safed
Hélio Oiticica
Helen Frankenthaler
Robert Downing
Yves Gaucher
Three Israeli Artists: Agam, Lifshitz, Zaritsky

1970
David Hockney
Robert Graham
Modern Chairs 1918–1970
Don Judd
3-00: New Multiple Art **Arman, Apple, Beuys, Christo, Finlay, Li Yuan-Chia, N.E. Thing Company, Pistoletto, Wall**

1971
Jack Smith
East London Open
Michael Upton
Douglas Binder
Mary and Kenneth Martin
Dali: Art in Jewels
Alexander Hollweg
Gilbert and George
Richard Long

1972
East London Open
Leon Kossoff
Strike for Kids under 12
Joseph Beuys
Systems
David James
John Peck
Pre-Raphaelites
John Davies
Patrick Heron
This is Whitechapel (Ian Berry)
Bill Woodrow
Alan Charlton
Peter Logan – Recent works of water dances and mechanical ballet
Decade 40s **Roberts, Medley, Lanyon**
Evelyn Williams

Spike Milligan
Michael Perton
Prints and how they are made
Llewellyn Xavier

1973
James Coleman
Neville Boden
Patrick Hayman
Sweets
Crackers at the Popular Palace
East London Open
John F Holland
Norman Adams
Derrick Greaves
The Ashington Group 1932–1972
Banner Bright: Trade Union Banners
Claude Rogers
Brian Shaffer
Tess Jaray and Marc Vaux
Ed Meneeley
Inside Whitechapel **Ian Berry**
Dan Jones
Derek Boshier
Four Painters **Stephen Amor, Christopher Davies, Keith Dean, David Kay**
Trevor Bell
Gareth Jones
Elsie Few
The London Group

1974
G F Watts
Earth Images: Ceramic Sculpture
East London Open
Albion Island Vortex
Tim Head
Euan Uglow
Ray Atkins
Henri Chopin
David Hepher
ILEA Art Colleges
Frank Collins
Present Printing Pastime
Printed in Watford: Watford School of Art
Floris van den Broeke
Seiichi Niikuni
Karl Weschke

1975
Belle Epoque – Belgian Posters, Watercolours and Drawings 1892–1914
Alan Cox
Ray Exworth
Michael McInnerery
Barrie Cook
Bruce Lacey
Norman Mommens
Pedro Uhart
Peter Cunliffe's Colour Cubes Playpiece
East London Open
Fifty Drawings by the Blind
Women and Love
Magdalena Abakanowicz
Luis Fernando Benedit
City Poems and City Music **McGough, Henri, Betjeman**

Francis Hewlett 'Big Hand'
John Lifton 'Green Music'
Dianne Setch
Peter Dent
Sculptures from London Art Schools
Brian Nissen
Deanna Petherbridge
Peter Schmidt
Franciszka Themerson
Colin Lanceley
Anthony Austin 'The Toymaker'
John Davies
Pury Sharifi: Knitted Costumes and Wall Hangings
Yolanda Sonnabend
NH Werkman

1976
Flower Show of Tower Hamlets
Liz Harrison
Andrew Logan
Participation Projects including ILEA
Cockpit Arts Workshop
Word-Images by Pupils of Cayley Primary School
Michael Druks
Leopoldo Maler
Tom Norton
Norman Toynton
Derek Goldsmith
Beryl Cook
East London Open
Madelon Hooykaas
Elsa Stansfield
Tapestries from the Royal College of Art
Les Lalanne: François Xavier and Claude Lelanne
Saskia de Boer
Chris Orr
Charlie Meecham
Inner London Education Authority Arts Schools
Embroidery and Fashion: Goldsmith's College and St. Martin's
Tadeusz Kantor
Michael Chilton
Tower Hamlets Arts Project

1977
Stanley Brouwn
Richard Long
Pearly Kings and Queens
Nicholas Hawksmoor
Kilims: Plain Weave tapestries from Persia, Turkey and the Caucasus
Keith Arnatt
Walter Pichler
Robert Smithson
Morton Feldman and the Creative Associates
Graphic Design Works
Whitechapel Open **Robin Klassnik, Albert Irvin, Peter Logan, Mali Morris**
Robert Ryman
Working Party: Böhmler, Brehmer, Helms and Polke, Rückriem, Rühm, Walther
The Fairground